MW00612395

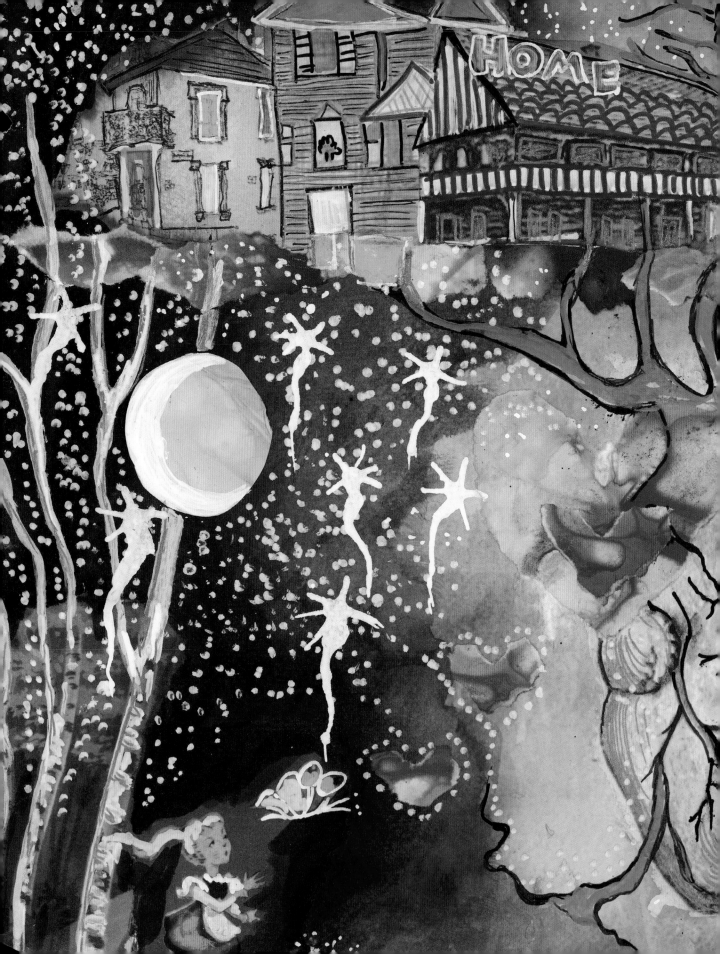

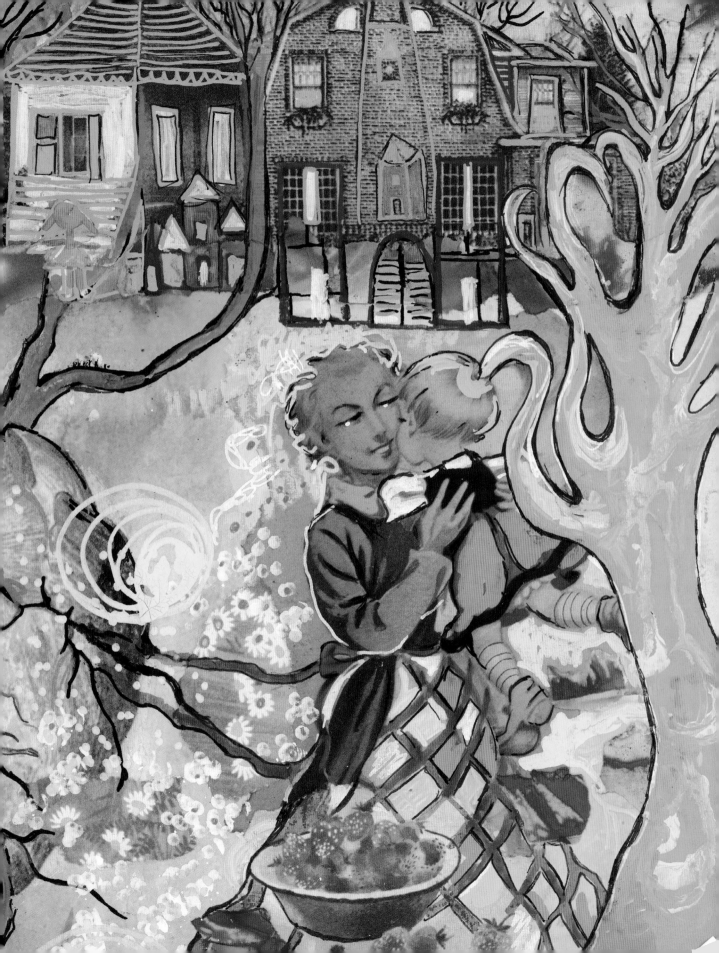

STACKPOLE BOOKS

An imprint of Globe Pequot, the trade division of
The Rowman & Littlefield Publishing Group, Inc.
4501 Forbes Blvd., Ste. 200
Lanham, MD 20706
www.rowman.com

Distributed by NATIONAL BOOK NETWORK

Copyright © 2021 Rakefet Hadar

Translated from Hebrew: Dalit Shmueli
English editor: Michele Berner
Graphic design: The green man studio
Photographers: Rafi Venetian, Hadar Seifan

www.rakefethadar.com
rakefetlink@gmail.com
Facebook: The Visual Journal Tribe Group
Instagram: rakefethadar

All rights reserved. No part of this book may be reproduced in any form
or by any electronic or mechanical means, including information storage
and retrieval systems, without written permission from the publisher,
except by a reviewer who may quote passages in a review.

British Library Cataloguing in Publication Information available

Library of Congress Cataloging-in-Publication Data available

ISBN 978-0-8117-7014-9 (paper : alk. paper)
ISBN 978-0-8117-7015-6 (electronic)

∞™ The paper used in this publication meets the minimum requirements
of American National Standard for Information Sciences–Permanence
of Paper for Printed Library Materials, ANSI/NISO Z39.48-1992.

Layers
of Meaning

ELEMENTS OF
Visual Journaling

RAKEFET HADAR

STACKPOLE
BOOKS

Guilford, Connecticut

To my late parents
Who taught me the power of healing in art
And taught me curiosity, perseverance, and passion

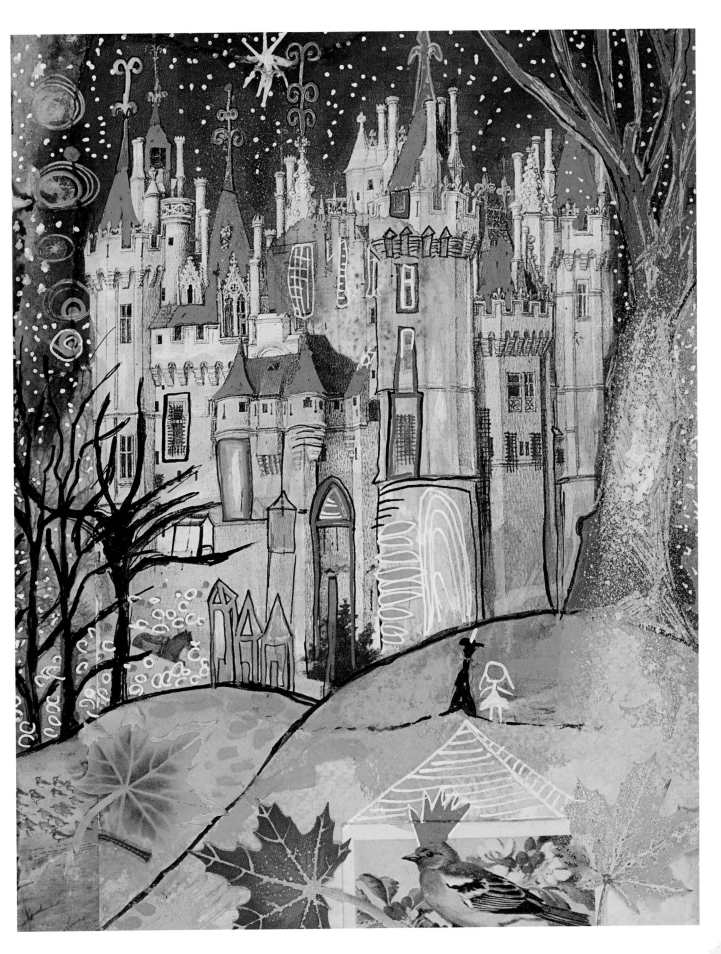

Table of Contents

Introduction

What makes us feel happy and satisfied with our life? Meaning is one of the vital elements for happiness and satisfaction. To feel fulfilled and gratified, we have to connect with our inner self and understand what makes us happy.

A visual journal is a tool that helps us learn the language of meaning in our lives. Through journaling, we discover ourselves and find ways to get closer to our inner self and understand what is important to us.

Intention, magical coincidence, background, image, line, color, and text - these are the seven elements of the visual journey journaling method. What does each one of them teach us? That's what we'll learn in this book.

I want to start with a short story that illustrates the connection between the visual journal and magical coincidence. Six years ago, in my final year of studies for a graduate degree in art therapy, I met a good friend of mine for lunch. She pulled an old children's book out of her purse, and when she opened it, I saw that between its covers, instead of regular pages, there were thick sheets that were hand-sewn together. My friend had drawn on the pages in pencil and markers, pasted snippets of newspapers, and written her inner thoughts.

"What is this?" I asked her, feeling its magic start to permeate me.

"It's called art journaling," she said. "It's a kind of art that you create in a journal; anyone can do it, anything goes, no rules, and it's a lot of fun."

I went home, not knowing that this meeting would be life-changing. I felt an overpowering need to create a book of my own, and that same day I sewed myself a journal with the covers of an old book. And I haven't stopped since...

"It's a kind of art that you create in a journal; anyone can do it, anything goes, no rules, and it's a lot of fun."

Today, six years later, I teach the method I developed for visual journaling, a method designed to empower freedom, meaning, and connection to passion, self-acceptance, and love.

Over the years, many people have asked me to explain visual journaling and why it's good for them.

The best way to explain the meaning of the journal is to invite people to a session and see how the magic takes shape. But that isn't always possible, so I responded to the internal and external call to release the soul of the visual journal to the world.

And when I say "soul," that's exactly what I mean; the journal is unadulterated soul. Using it correctly can change lives. Over the past few years, visual journaling has changed my life, and I hope it will change yours, too.

The visual journal is a never-ending source of giving. It's an amazing tool for deep healing and change, a good friend that accompanies me wherever I go, a vessel into which I can release whatever is pent up inside me.

It allows me to create in a way that's right for me, to explore and reveal the inner layers of my soul, just waiting for the light of awareness and the magnificent colors to render on the pages of the journal.

The journal enables all kinds of processes within me and with others. It helps me to plan projects, dream dreams, and realize them.

The journal lets me document everything that happens to me daily so that I can gain insights and understand the bigger picture. It also enables me to connect with my roots, my extended family, recall bitter-sweet moments of childhood, devote time to loved ones who have passed away and who still accompany me in one way or another.

The journal develops the ability to use the imagination, metaphors and imagery; it enhances our inherent creativity and enables us to use it in ways we never dreamed were possible.

Above all, the journal helps me to connect to a very special place within me - the inner, enthusiastic child, that same four or five-year-old inquisitive child, whose main language is that of colors and shapes.

This magical child sees the world through bright eyes and feels that the world is a playground just waiting to be explored.

That place is where I want us to begin our journey together. This book will take you on an inner visual journey through journaling. You'll learn about the elements that most of the projects in the visual journal are composed of. My hope is that as you learn, you will start to create your own journal with the help of the exercises in each chapter. And that leads me to the next insight.

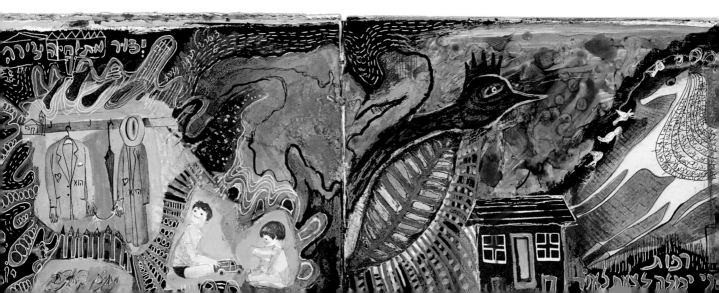

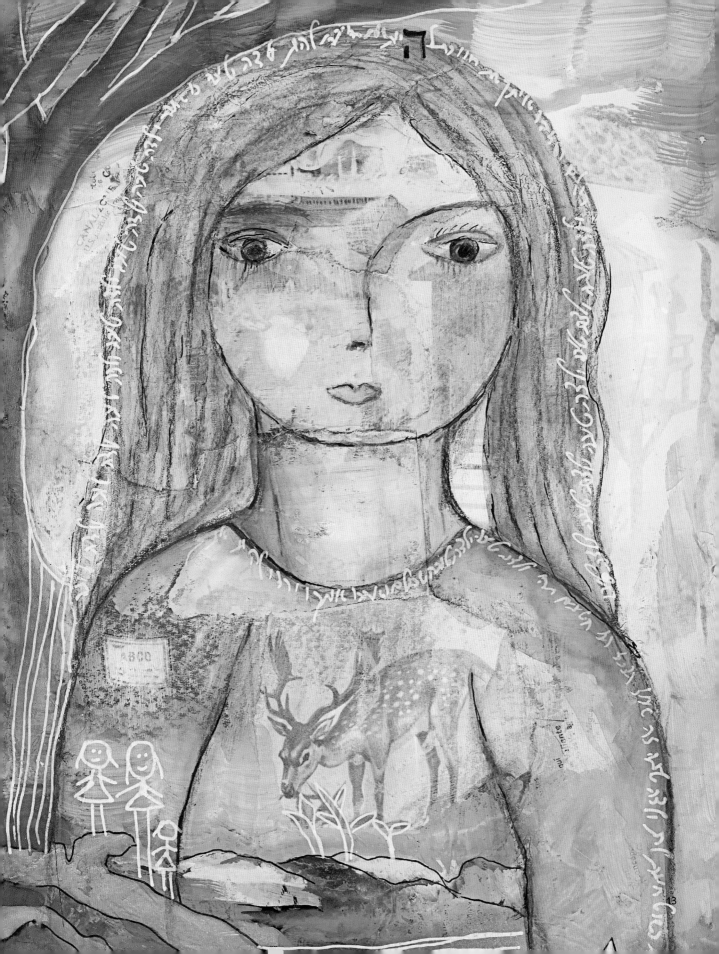

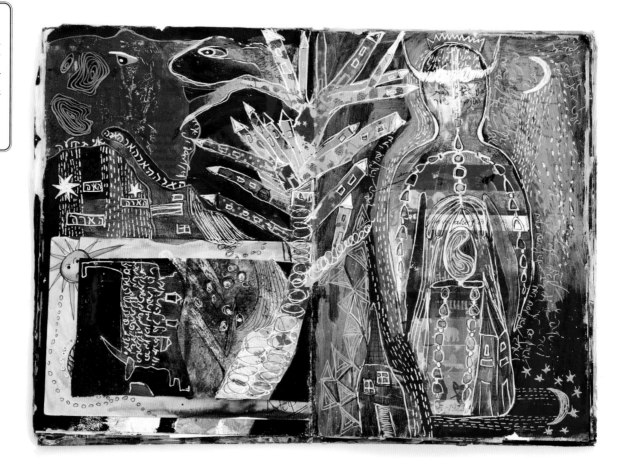

We are all born with an inner artist

Before we begin the journey, I'd like to share a significant insight that I hope you will choose to adopt into your own life - we are all born with an inner artist. The language of art and creativity is inherent in us. What's more, we need creativity in our life; it nurtures us and adds meaning.

Babies start to explore the world as soon as they're born, and as soon as they physically can, they grab onto objects and start to make signs. The drive to leave a mark of your own, to express yourself through symbols, is an innate need. We've all drawn pictures when we were children and stopped at around the age of eight or nine due to social pressure, the feeling of not being good enough, or because we compared ourselves to others.

The ability to express our inner world in another language, the language of art, symbols, color, and materials, is ingrained and healing. We just have to rediscover it. Creativity is a gift to ourselves. To create something visual, something from nothing, is the ability of the inner dream child - the artist within us.

Many people live their lives without the unique joy of creativity, without the excitement of using different materials and colors, without the magic that is enabled thanks to creativity and imagination.

The purpose of this book and the courses I teach is to connect people to that essence of the artist - their inner child - what I call the "inner dream child." Art isn't necessarily a vocation or profession, it's our soul's inner need, like the need to eat, move, and breathe. Connecting to that essence or inner energy makes our lives richer, more colorful and creative, and filled with meaning.

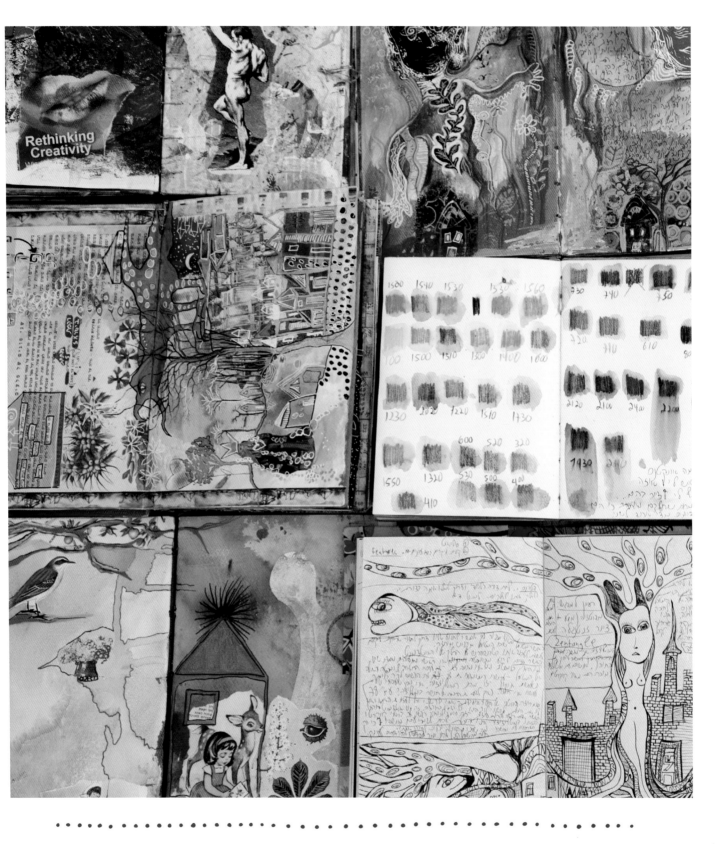

The ability to express our inner world in another language,
the language of art, symbols, color, and materials, is ingrained
and healing. **We just have to rediscover it.**

The Creative Journeys School

and Visual Journey Journaling (VJJ) Method

In 2014, with the help of my long-time student Rakefet Berger, I opened the Creative Journeys School. I wanted to share the joy of creating that I had discovered within me. It took me a year to develop dozens of fascinating lessons on the visual journal. From the moment I opened my first group and until today, five years later, I'm surprised to discover again and again the magic that happens when people meet the visual journal for the first time.

Teaching or facilitating visual journaling is not like teaching a regular art course - it's a field that touches the soul and walks the fine line between therapy and art. That's why it became necessary to hold special training sessions for visual journaling instructors. And so, the Visual Journey Journaling method came to be, a method that integrates a powerful tool together with processes that enable transformation and healing.

In 2016, I opened the training program for guidance through "visual journey journaling." I wanted to establish a special course in Israel for professionals who facilitate groups and inner processes, to master the artistic language of the visual journal.

The "Visual Journey Journaling" (VJJ) method is based on three pillars - a deep understanding of the elements of visual

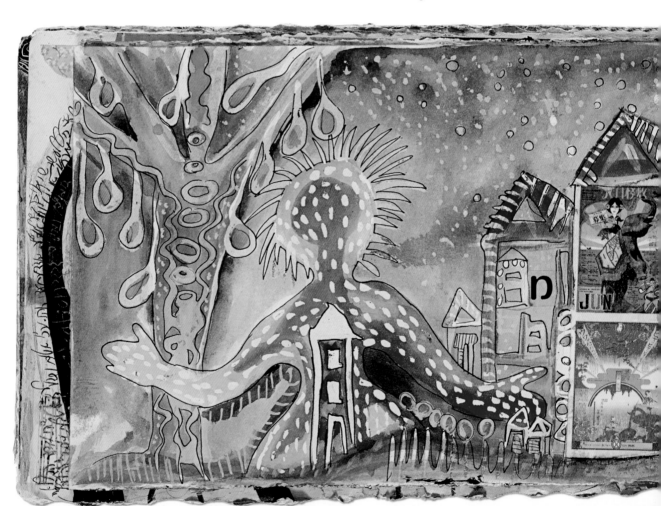

journaling; the ability to integrate those elements to create experiential processes; and connecting to our unconscious mind as we use the language of metaphors and symbols. In this book, you will learn the elements of the visual journal and experience the process of journaling.

The group facilitator puts together the creative process of journaling. These processes integrate an inner process, based on the content chosen by the facilitator, and the techniques and materials appropriate for the process.

The facilitator becomes familiar with the journal through the training course and experiencing the process, which then develops a way to create meaningful processes from personal experience and inner worlds of content.

The product of each meeting is a two-page "spread" in the journal that reflects the process that the participant in the group experienced during the session.

In this book, we'll take an in-depth look at the seven elements that enable us to easily create journal spreads: intention, magical coincidence, background, images, line, color, and text. Together, they create "layers of meaning" on each page of the visual journal. The method is appropriate for everyone: children, women, men, adults and youth, and can be incorporated as a valuable tool in any therapeutic approach. No previous knowledge is necessary.

This book does not constitute training for group facilitators, but it will familiarize you with the visual journal and the inherent experience of visual journaling.

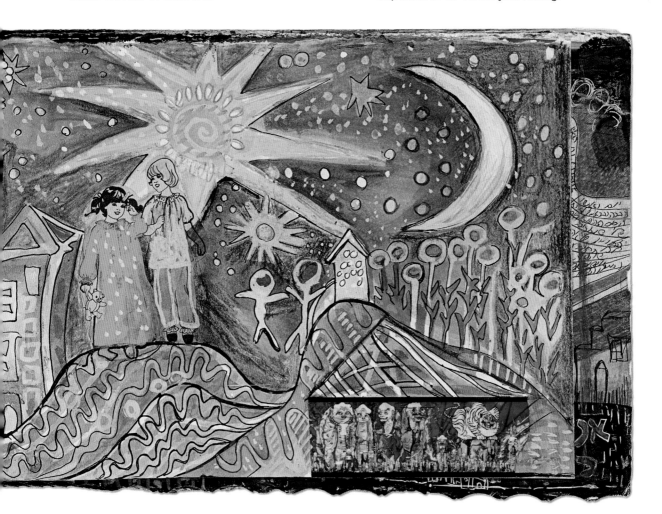

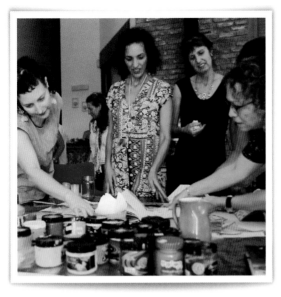

What really heals?

That's a question that I've always asked myself.

When I first started my own visual journaling, I was in one of the most difficult periods of my life. My mother was dying of cancer, and I knew her days were numbered. I sat by her side or in the hospital hallways and found some small escape for my soul in the pages of the journal. Through the colors, lines and images, I managed to connect with myself and express some of the pain within me that had no other way of expression.

In the years since her death, I've realized the healing power of creating within an intimate format such as the visual journal. The journal enabled significant healing that touched on the complex relationship with my mother, and the pain and guilt I felt when she passed away at a relatively young age.

This journey, which started six years ago, has not yet ended, and I hope it will continue for a long time to come. It has helped me to realize that one of the most healing processes in existence is the journey of discovering, exploring, and understanding the soul. Connecting to that childlike energy of curiosity and exploration is one of the foundations of a healing method that developed naturally.

So, let's set out on a visual journey in the pages of the journal and get to know the seven elements.

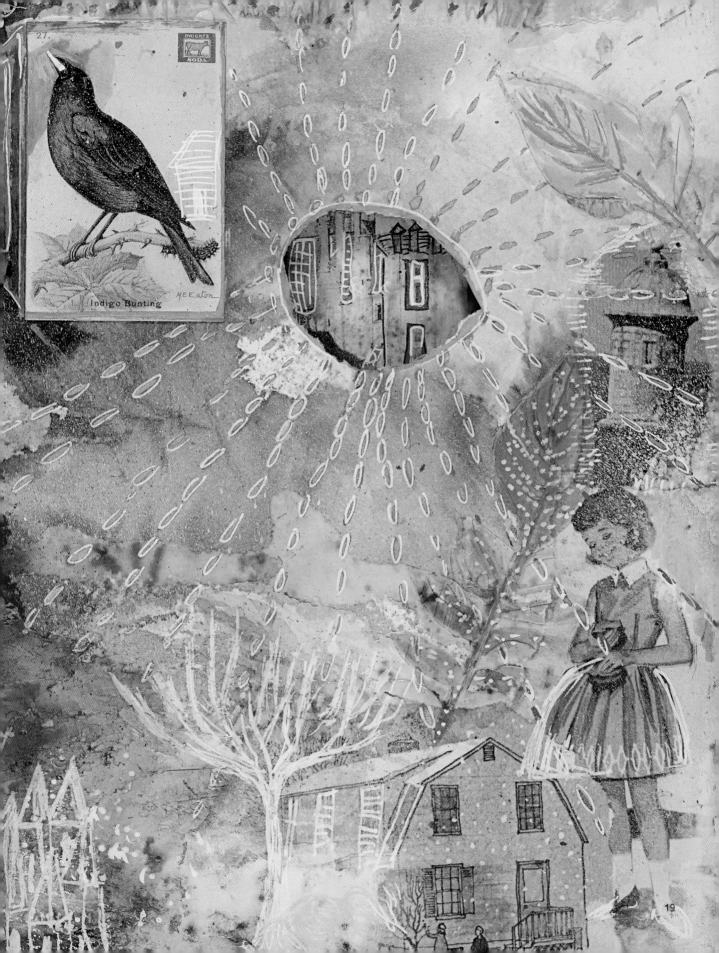

Indigo Bunting

27.

DWIGHTS SODA

M.E.Eaton

19

Part 1

The Seven Elements

What are the seven elements that compose every spread in the visual journal?

From chaos to order, from the unconscious to the conscious, a back and forth flow from the inner to the outer; this is the essence of creation in the visual journal. It gives us freedom and beauty and magical coincidence that lead to meaningful work and connection with inner passion.

Over the years of my work with groups and individuals, I've tried to understand the building blocks of visual journaling.

I tried to understand what led to the creation of each spread in the magnificent journals of the soul that I saw taking shape before my very eyes.

Looking through hundreds of my own and my students' works, I began to see elements that repeated themselves in each of the spreads that we call "visual journaling" or "art journaling." These elements are in fact layers. Each layer adds more meaning to the developing work, and in the end, the visual journal spread has as many meanings as there are layers.

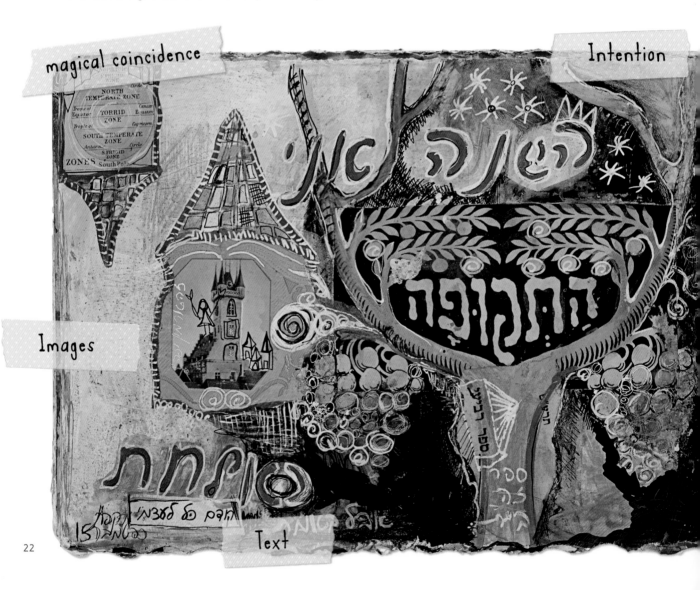

magical coincidence

Intention

Images

Text

Intention, magical coincidence, background, images, lines, color, text - these are the seven elements that make up the visual journal as I create it and that I teach in the Visual Journey Journaling (VJJ) method.

These elements are not simple, nor are they one-dimensional. Each one is a world of its own, and it's the combination or integration of all or most of these elements that create work that reaches inside and forms new connections.

You can think of these seven elements as seven layers of meaning - each element has a unique meaning in the creation of a journal spread. Visual journaling creates connections between the elements. In each spread that we create, we connect between the elements/layers in different ways.

Two of the elements, intention and magical coincidence, are meta-elements; that is, very central elements in journaling. They are also expressed visually but mostly as part of an inner process. I view magical coincidence and intent as the "mother and father" of all the other elements.

Background, images, lines, colors, and text are the five visual elements of every journal spread. They are called visual elements, but each one has a role in the inner process.

The magic happens in the alchemy of all the elements together, and in the countless ways they can be connected to create exciting possibilities.

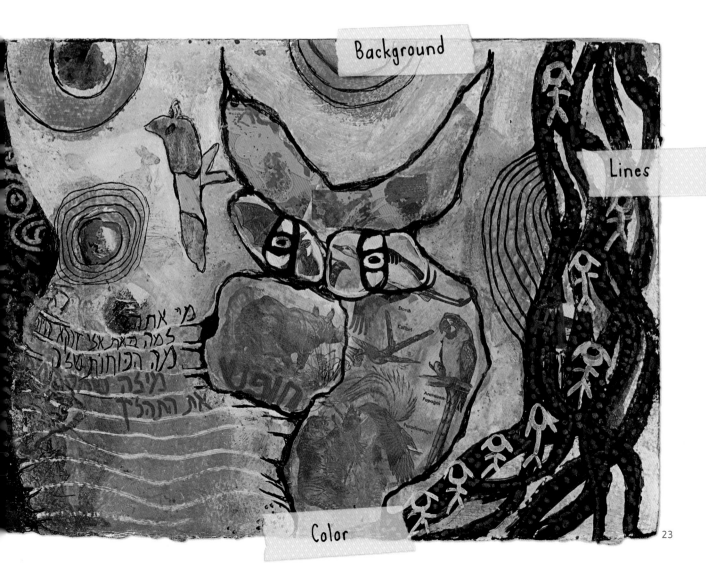

Background

Lines

Color

The processes in visual journaling:

How to create a spread

The visual journal is an individual process. When I started journaling, I wasn't aware of the variety of tutorials and classes available on the Internet; I started my work from an inner passion and without planning. I quickly realized that there are myriad ways of journaling, but most people don't have access to them. Most people feel blocked, not connected, or feel that they can't or don't know how to start.

I started to develop journaling work processes for the groups I taught and over the years, I discovered that these processes have great healing properties. They created unique alchemy between the use of stimulating materials and techniques and my own inner process. For example, I started to teach my students to have conversations with inner voices, in the style of the Voice Dialog method that I learned in a group facilitator course.

The participants in the group held a conversation with an inner critic and then worked on creating the image of their inner critic in a journal. Almost immediately, often by the end of the class, they discovered that the inner critic that they initially perceived as being mean and harsh was actually looking out for their best interests and had good intentions. The resulting healing came through creativity infused with passion.

I developed other processes following pieces that I created after my mother passed away. I used photographs that I found in her house and worked with poetry that my mother wrote. I tried to create a "visual translation" of the lines of her poems, my own interpretation of them. This created a connection between me and my dead mother, through our combined creative work.

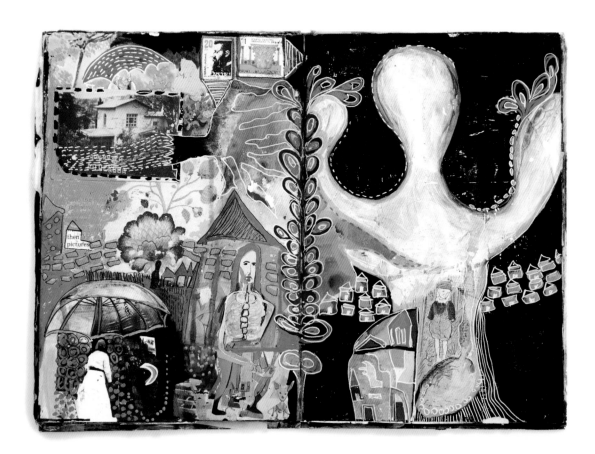

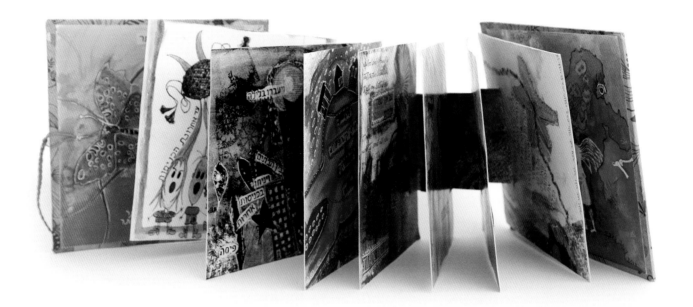

This personal experience led me to develop a series of classes called "visual poems," in which each of the women in the group created a spread from a line in a poem. Together, we created a visual journal composed of the work of all the women in the group, a moving memento for them of the unique power of group work. These are just two of the ways in which I create processes for my students.

I start journaling from my own personal space. I discover and address meaningful and universal topics, and then create a process of artistic experiences and transformation. In this way, the journal lets me develop as a person and an artist in countless ways and enables me to share my insights with others.

The internal techniques that I work with (voice dialog, poetry, fairy tales, shamanic journeys) all come from the power of healing through symbols and metaphors. Over the years, I've researched various methods and reached the conclusion that to achieve real change, I have to talk with my unconscious mind in its own language - the language of imagination and metaphors. That is also the power of art - using symbols to express emotional situations.

That's why the added value of visual journaling is in learning the language of your own unconscious.

Deep understanding of the seven elements will enable anyone to create intuitive processes in the journal based on their own life experiences, without the need for external guidance. It's in the simple ability to connect with our unconscious mind, which hides great treasures. One of the powerful forces of the unconscious mind is the "inner dream child." I call it that because it's something inside us that is connected with childhood and the ability to see the world with bright eyes, as if for the first time. It's a part of me that is not damaged; it's connected to the forces and beauty of the world, a part that can be inspired and can see the beauty of each moment, even in the painful and less attractive parts of existence.

Food for thought

What are the challenges that occupy your thoughts these days?

What is the most important issue that you would like to explore in the visual journal?

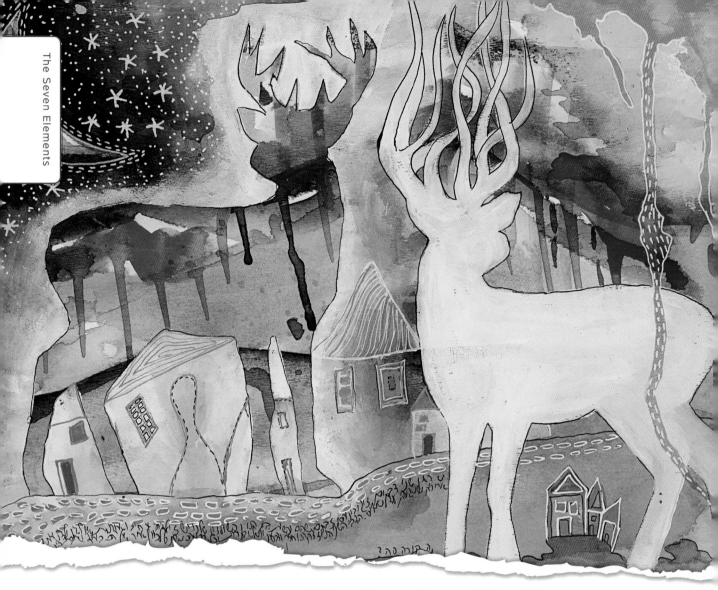

Giving ourselves a life of magic and healing:

The unconscious mind and visual journaling

Imagine if someone offers you the key to a new, mysterious, and fascinating world, a world of magic, excitement, passion, and life energy. It is incredibly beautiful with wonderful memories and fables that you can listen to from morning to night. It has magical gardens and creatures, and an abundance of love for you and for others.

Sometimes, you can also find darkness and dragons there and evil creatures, but you can always get the help of a loving guide or hero who brings out powers you didn't know you had in you. This world has everything you desire, and sometimes also everything you fear. And best of all - this world is inside you; all you need is a set of special keys to unlock the gate.

That's the whole story, learning the sequence of keys that open the door to our unconscious mind. Once we get there - the magic will fill our lives.

These keys are the seven elements that we'll learn about in this book.

Our unconscious mind directs our lives, at times out of conditioning and pain. But it

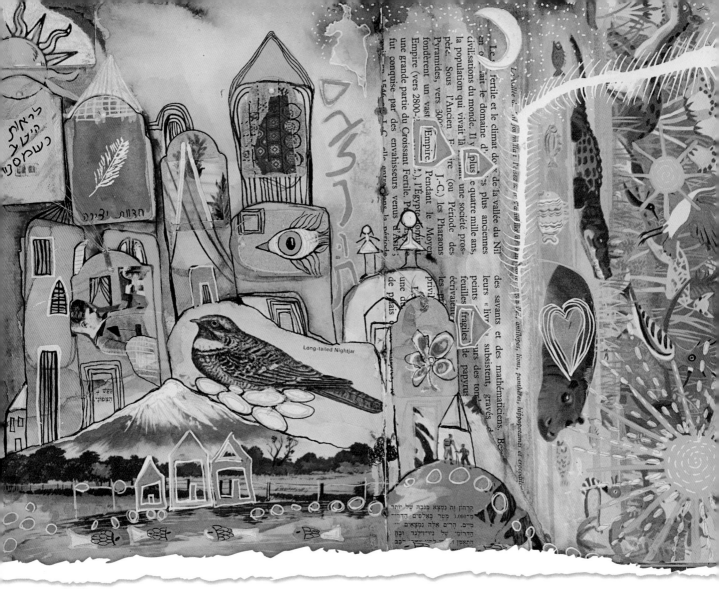

Long-tailed Nightjar

also has a range of beauty, creativity, and gifts we didn't know we had. All you need is the passion to get to know them.

The unconscious mind speaks in symbols, metaphors, and imagery; the language of a child's imagination, a language we have long forgotten. Using the seven elements, we can enter the world of imagination that exists in our unconscious mind and use its hidden treasures.

The inner dream child, that same pure childlike energy that exists within us, is familiar with our unconscious mind, with all the inner landscapes and all the treasures we have yet to unearth. The inner dream child is ready at any moment to go on a journey of discovery and investigation with a fresh perspective, always seeing the world as if for the first time. The inner dream child can be moved by the beauty of the sunset and knows when the tree in the backyard is feeling sad. He pays attention to the cracks in the sidewalk and the beautiful spots on the wall, constantly crosses the bridge back and forth between the known and the unknown and can safely escort us to meet our inner guides and discover hidden power. And he also loves visual journaling.

In the rare moments that I succeed in connecting with my inner dream child - I get wonderful inspiration and can "move mountains," fulfill dreams and create with a sense of time flying by.

That is the special connection that I hope you will discover through visual journaling.

So let's get started and let the magic happen.

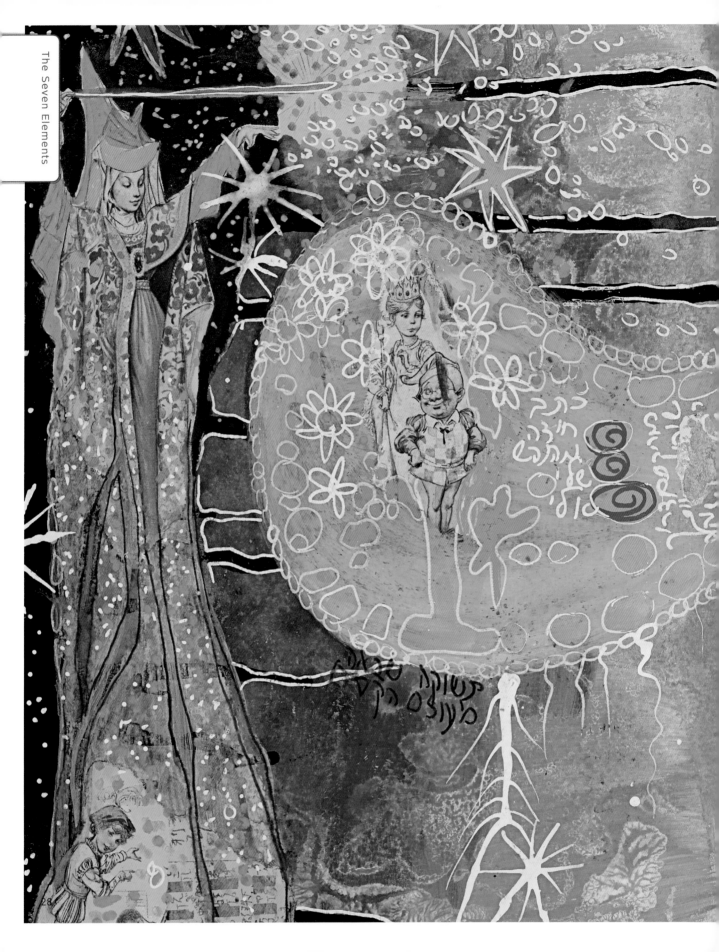

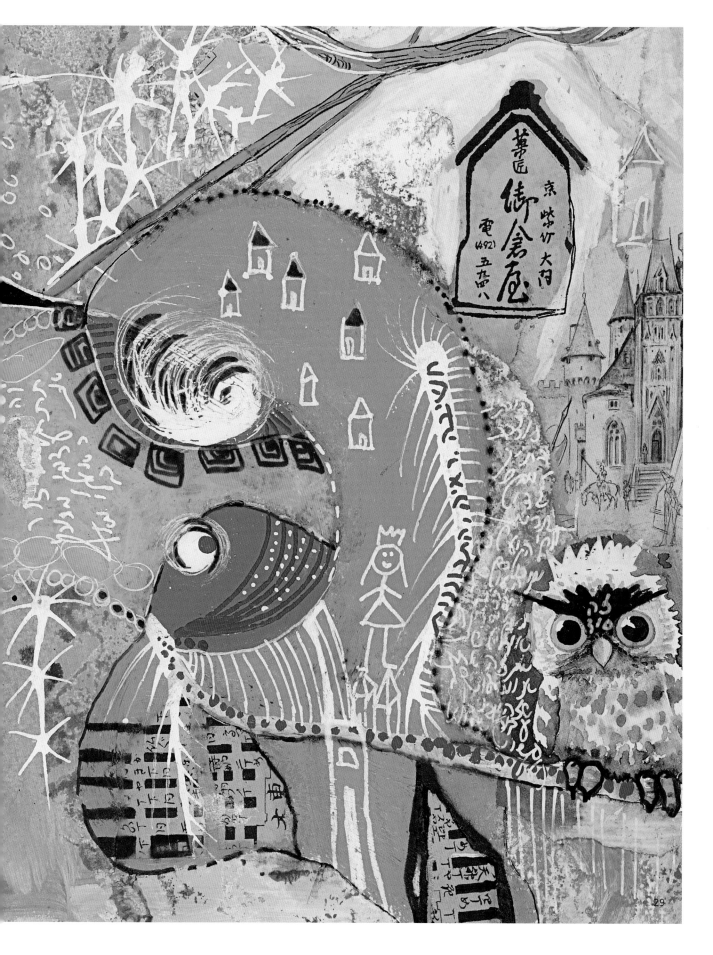

帯匠

京染竹大内

衛倉屋

電 (492)
五五四八

Materials we will need ★

(although you can use anything you have at home)

A block of high-quality paper for watercolors or poster paper

- -

White gesso - a mixture of white paint, chalk and glue, used to strengthen the page and create a foundation for other materials. We use it mostly to cover layers when we want to work inside an existing book, to cover most of the background and create a uniform layer.

- -

High-quality watercolors (at least 24 colors)

- -

Caran d'ache Neocolor II or Gelatos crayons

Distress or Distress Oxide ink pads

- -

Acrylic markers (such as Molotow or Posca)

Watercolor markers - Tombow or Zig

- -

Watercolor pencils - Inktense or other brand

Black Pilot pen

- -

White gel pen

- -

Gel pens in various colors

- -

Washi tape

- -

Scissors

- -

White glue

- -

Needle and thread

- -

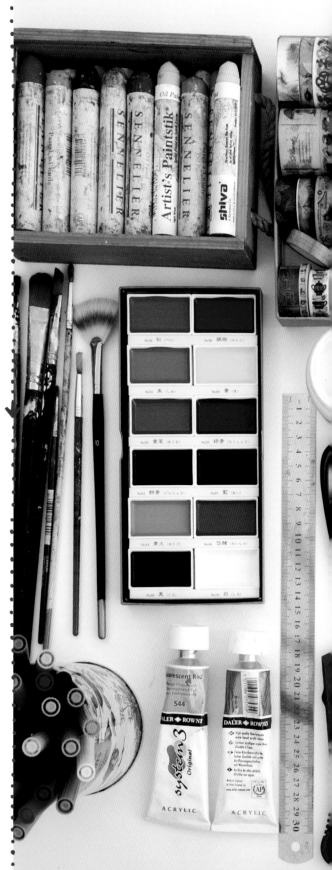

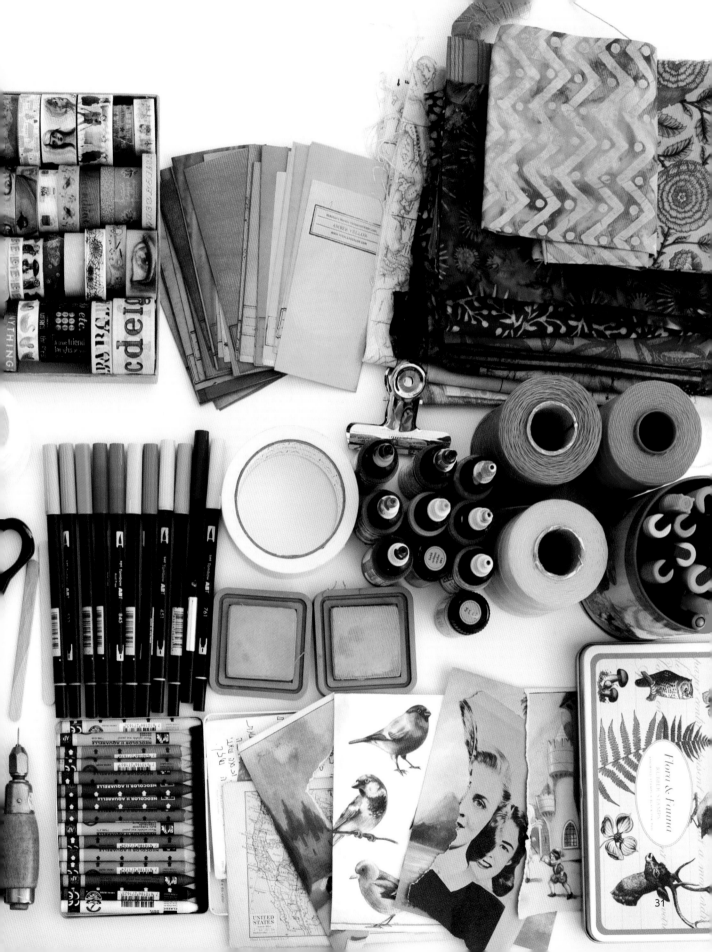

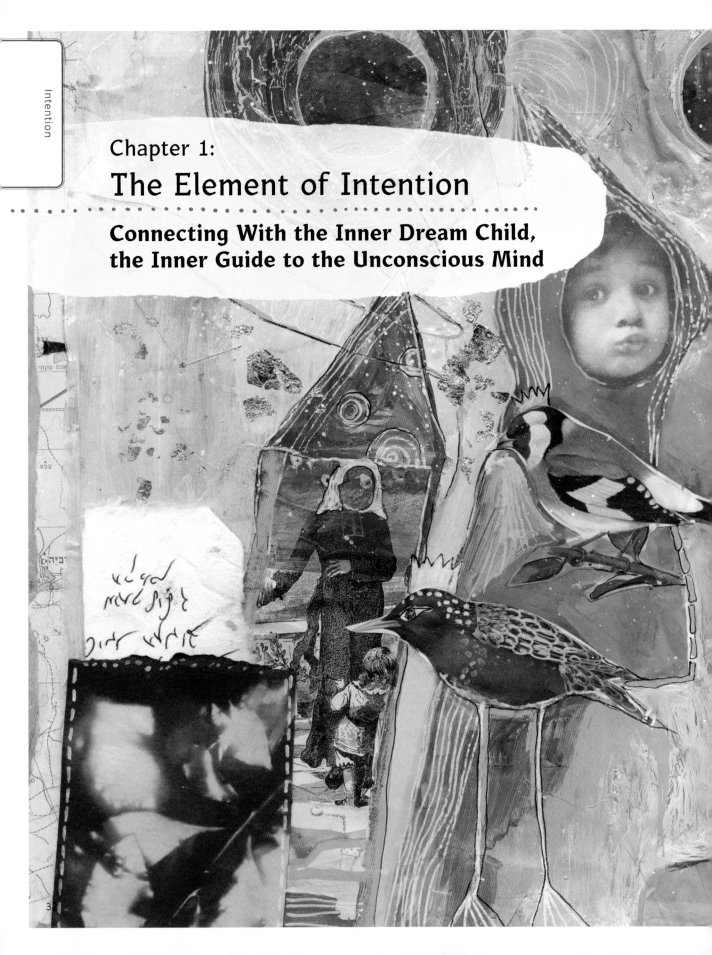

Chapter 1:
The Element of Intention

**Connecting With the Inner Dream Child,
the Inner Guide to the Unconscious Mind**

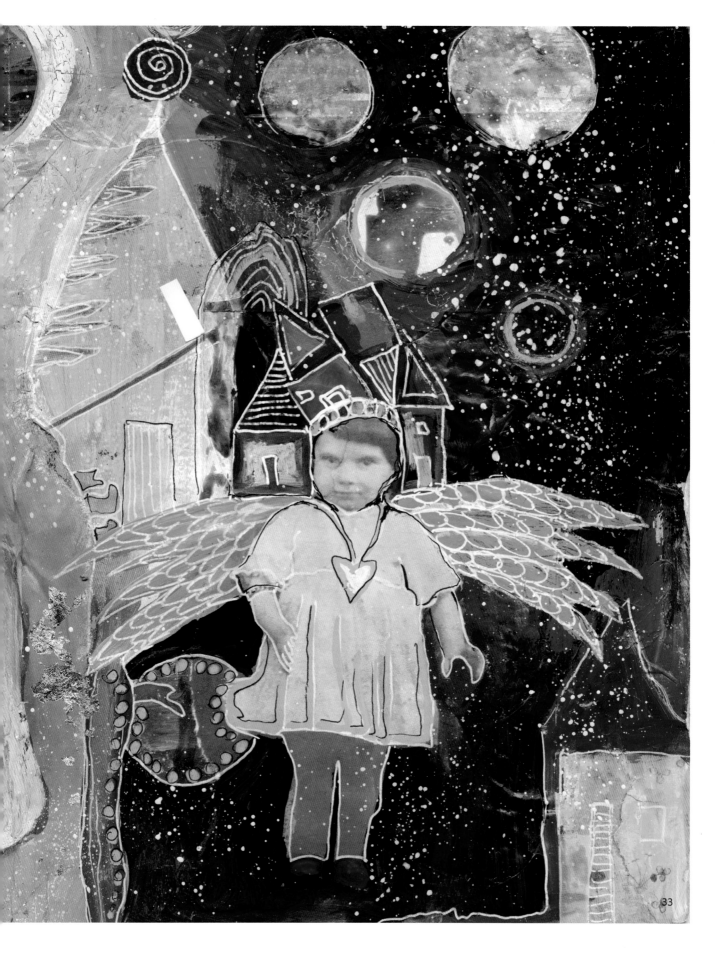

כֹּחָה שֶׁל הָרוּחַ

The Power of the Soul

Intention is the heart of the artistic process, and it plays an especially important role in the visual journal. The primary intention of all visual journal spreads is to connect to the soul, and the desire to express all of its parts without being bound to rules of beauty and aesthetics.

Every spread of the journal starts with intention or a desire to express something. Sometimes, the intention is clear to us right at the start, and sometimes we start creating intuitively and discover the intention deep into the process.

Therefore, the element of intention may be misleading. Do we not have intention when we create intuitively? Can we say that the element of intention is always there whether or not it's intuitive? We always intend to create a meaningful connection to the soul in the moment, to know it here and now through our work.

The natural way for me to create is to start intuitively, and through the process, discover the intention of my inner dream child. Creating is the way to communicate with the higher parts of me; it's the only way that it can communicate with me, through lines and colors and the magical mix of the seven elements.

So, for me, intention comes from my unconscious mind, from the higher, hidden parts of myself. At a certain point, usually when I add a few layers to the page, I start to understand the message, and then I connect with what has emerged from the spread and continue to create with intention.

For some people, intention has to be clear and known in advance. They can only create when the element of intention is clearly defined for them. In such cases, you can connect to your intention but maintain the freedom to think of the idea that you want to express, while also enabling the unconscious mind, the mysterious, coincidental, and the magical to do their thing.

Intention is like a cloud that always hovers over us when we work on our visual journal. The higher intention is to express ourselves in a new language, a visual language that touches us, a language that lets us create something from nothing. That is the higher intention of every spread in the journal.

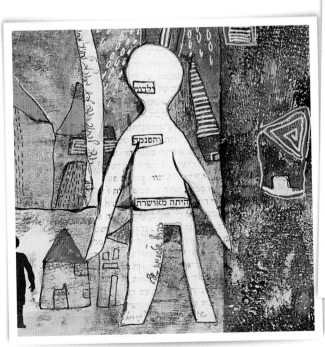

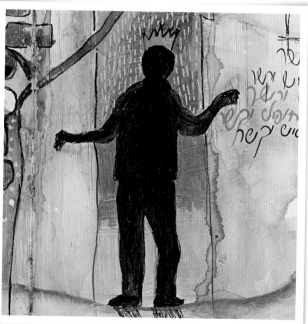

Prompts

Prompts are for people who find it hard to create something from nothing. They need some kind of lead to help them get started, and then the wellspring of creativity bursts forth. Prompts help us to channel our intention into action.

Prompts are the verbal instructions for visual journaling. You can find many prompts on the Internet on websites devoted to art journaling. Today, almost every teacher of art journaling posts their work on personal blogs and shares prompts for creating spreads with their followers.

Open prompts provide students with the stimuli to start working on the journal.

That's why prompts by teachers of art journaling give students the freedom to step out of their own thoughts for a time and immerse themselves in the inner process that someone else created.

An artist or teacher that creates a visual journal process, in effect, gives students a learning experience; to investigate and gain insights while expressing the process in a journal spread. In many cases, there is an emphasis on teaching students techniques that let them find their own visual and artistic language.

The essence of a good visual journaling process is the ability to ask questions that we wouldn't have asked ourselves. An artist who creates a visual journal process is an expert in asking such questions.

For example: Create a page that describes the connection between you and your parents.

These prompts don't give clear instructions on what to do; they just give a general direction.

The journaling process is a puzzle of higher-intentions, of prompts and instructions for the use of techniques and materials in a way that enables a meaningful inner process.

An accurate and correct process that leads to completing a spread in the visual journal is a unique art that demands a great deal of work on the part of the teacher and includes many prompts to bring the student, step-by-step, to create a complete and evocative spread.

Working according to the prompts of an artist or teacher

Prompts are a very significant layer of the journal because they enable inner freedom. When we work according to someone else's prompt, we don't think about the big picture but rather about the next step. The ability to create without thinking about the next step or "How will the page look?" "How not to mess it up" is very liberating for students.

Describe what you feel right now using colors and shapes.

Journaling processes can include meditation or guided imagery, various techniques of intuitive writing, and mindfulness. Other processes can start from a poignant poem, literary text, or be inspired by nature or the surrounding view.

Whether or not we work from our own intention or from prompts, it's important to remember that intention is not a visual layer; it is what shapes the content of each layer of the journal. You can see it in the text, the colors we choose, the images we use, the techniques we work with. Intention is like air; we can't see it, but without it, it's hard for the spread to "breathe."

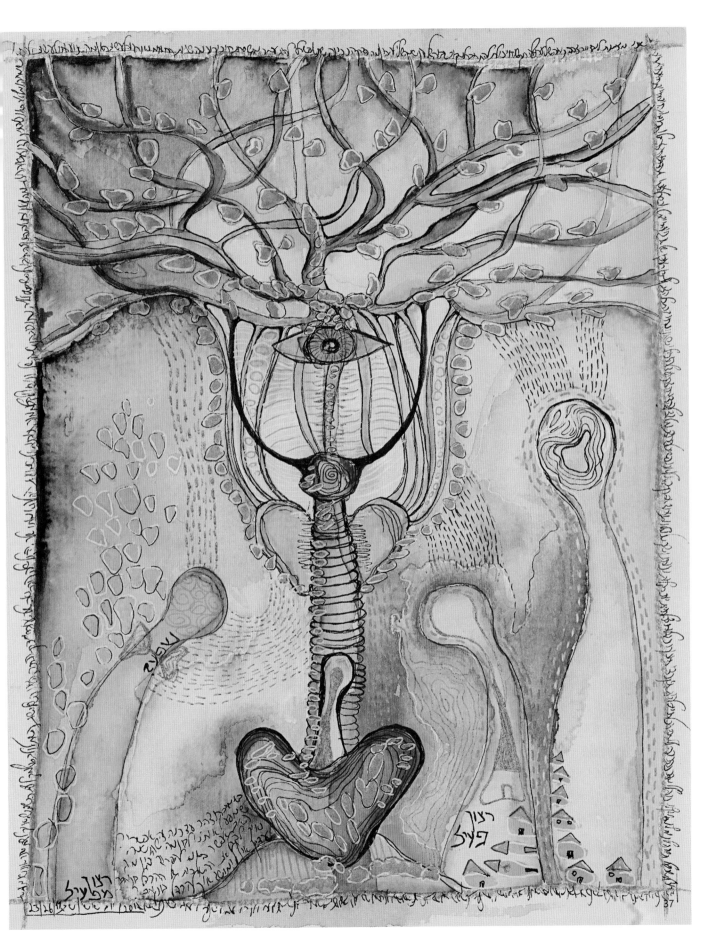

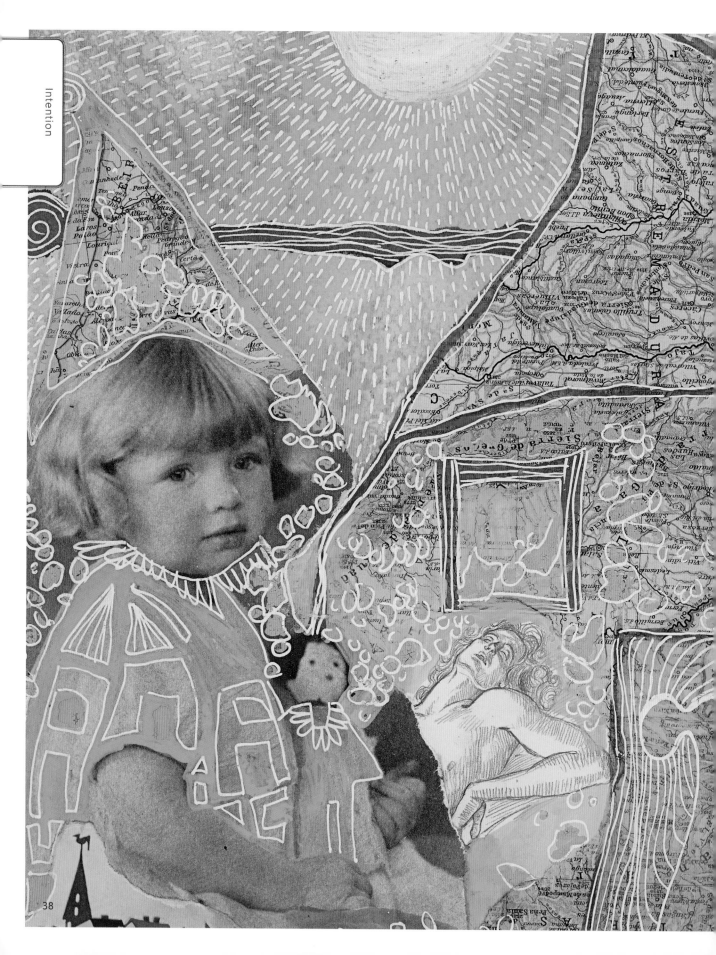

38

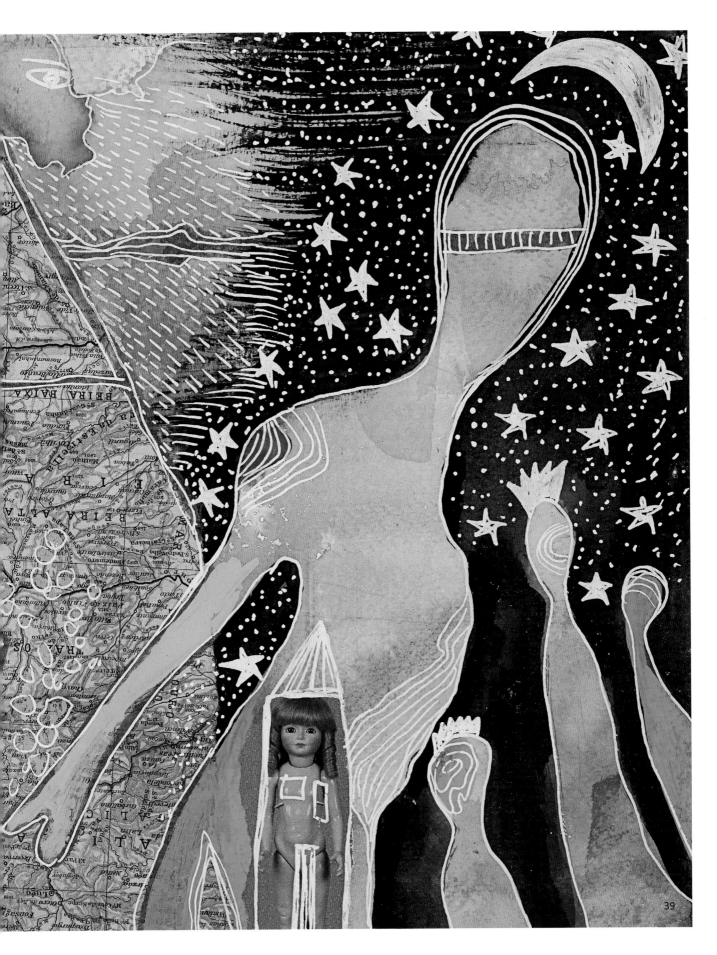

Dream child meditation

Close your eyes and take a few deep breaths. Feel all the parts of your body relax. Scan down your body and notice how it's filled with light, feels calm and still. Move your attention through the seven chakras; from the crown chakra to the root chakra (root, sacral, solar plexus, heart, throat, third eye, and crown). Go back to the crown chakra and imagine it opening like a door.

Invite the dream child inside you and feel him come out through the crown chakra. Imagine the childhood dreamlike essence flowing out from the crown chakra. He is connected to us like an umbilical cord of light and slowly comes out until he's standing before us.

"What do you want for me?" you ask the child. Let the child respond and continue to talk with him for a few minutes.

After your conversation, let the dream child back inside and let his energy infuse your body.

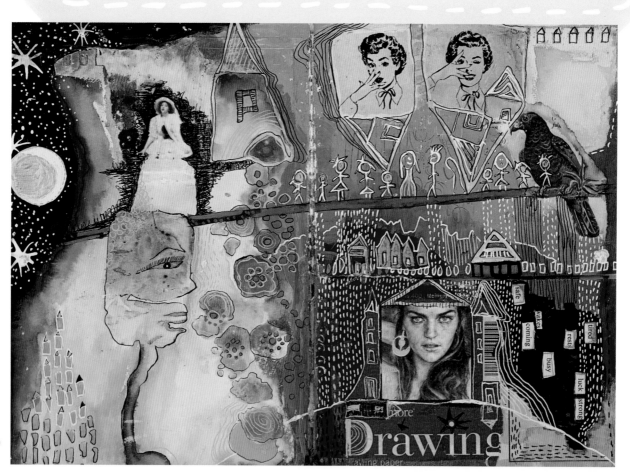

Writing exercise

In a lined notebook, write down everything you experienced in your imagination. Fill up the entire page; write your thoughts and feelings when you met the "dream child."

Activating imagination exercise

Connect with the energy of your inner dream child and go on a journey to find inspiration: take pictures, gather images and interesting snippets from magazines, look for old books and catalogs, cut out pictures that you are drawn to. Make inspiration boxes of story-telling images and photographs.

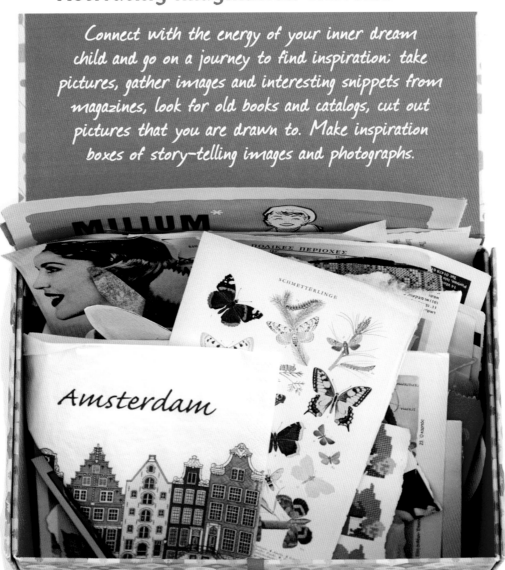

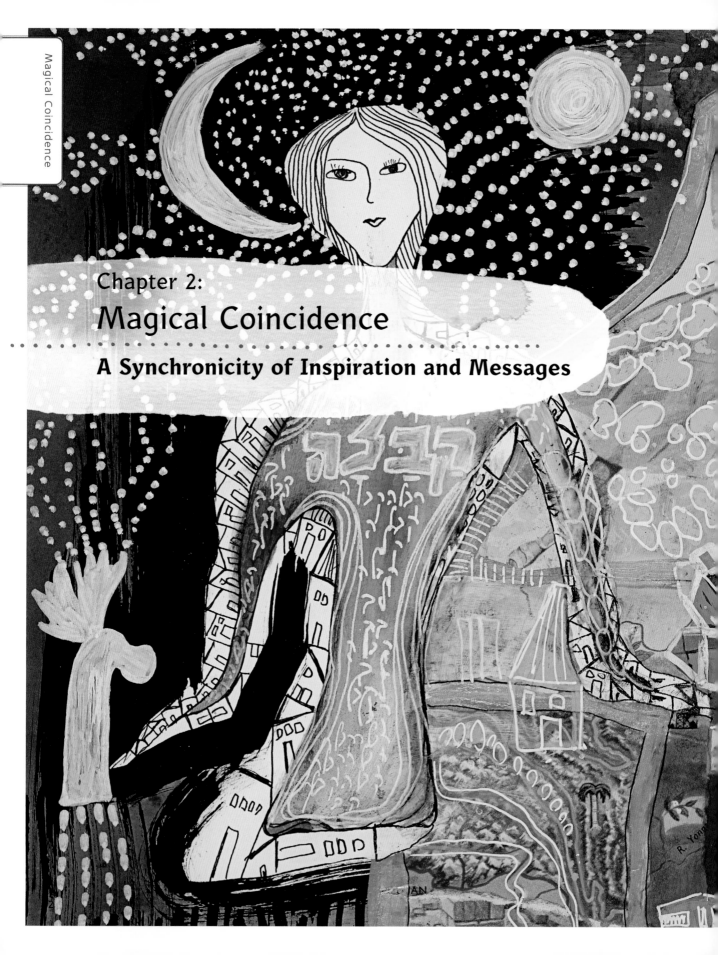

Chapter 2:
Magical Coincidence

A Synchronicity of Inspiration and Messages

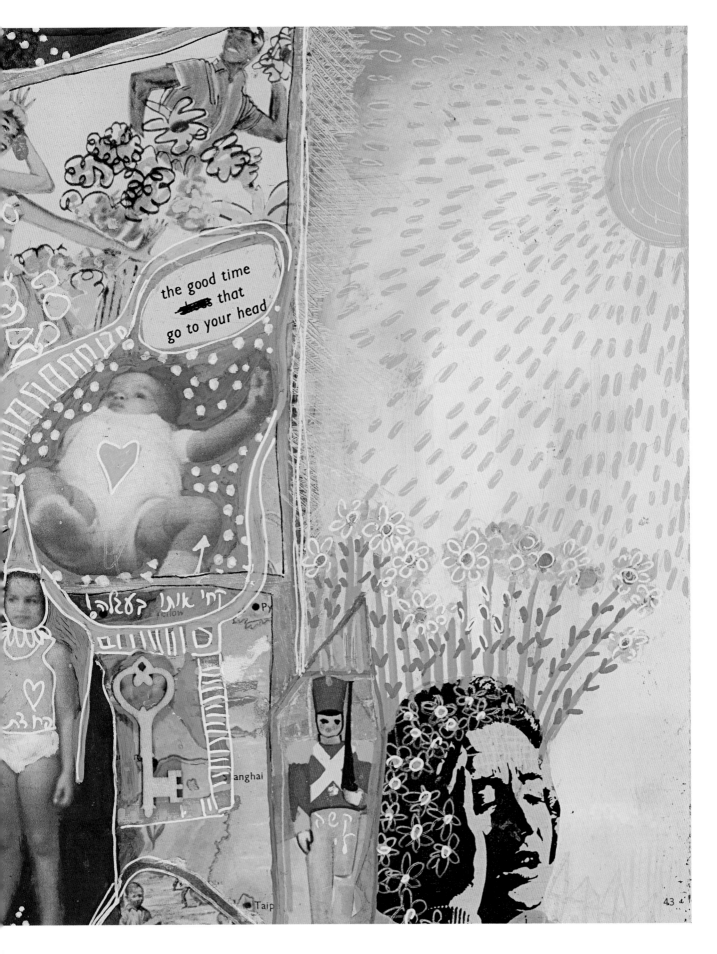

the good time
~~blues~~ that
go to your head

43

If the element of intention is the father of all elements, magical coincidence is the mother. To feel a sense of freedom and inner passion as you create in your journal, you have to love and accept the surprise that magical coincidence offers. Looking at the world through the eyes of a child lets us discover wondrous ways of creating, ways that we wouldn't have discovered otherwise.

Our inner dream child dearly loves magical coincidence; he knows where you can go, and there's nothing he likes better than to wander around in new places and get to know them. The inner child loves to gather inspiration as he wanders and then makes unique connections to create in a way that only he can.

If we can connect to that part inside us, our world will grow and expand, and we will feel connected to a new and exciting world of inspiration. Sometimes, the feeling is like a curtain opening, suddenly seeing the world differently from the eyes of the dream child who looks for magical coincidence everywhere he goes.

I discovered magical coincidence when I "played around" with one of my favorite techniques - creating colorful "magical pages" with watercolors. The magic happened when I saw wondrous creatures in the splashes of color, and they had a message for me. The joy and passion I felt when I started to play around with the watercolors made me realize that there is a part of me that yearns for the surprise of discovery, the beauty of working with no detailed plan.

The mixed media language that we use in the visual journal opens the doors to many fascinating combinations of techniques that are sometimes unexpected, but the results lead each person in the right direction. I call these techniques magical coincidence because they enable our inner dream child to get excited and keep going.

Magical coincidence is expressed in every stage of creativity:

★ Use your imagination and play with the techniques and materials.

★ Create without judgment and let your heart and hands lead the creation process

★ Accept that the creative journey is setting out on a new path – some parts of it may not be pretty, but the process is what's important and not necessarily the final product

★ Techniques that bring results we have no control over

★ Gather inspiration from the world and use it in visual journaling

There are many techniques of magical coincidence and even more that you can discover. Some of the main techniques that I teach are:

All these techniques inspire the imagination and touch us deeply in places that beg to let go. Each one of them lets us relax and let coincidence guide us. The results usually amaze us and give us the sense that magic happened, that we were inspired by a message from the universe.

Sometimes, the results are disappointing, and we have to face letting go of the result and moving on with the process. Magical coincidence teaches us dedication to something that is bigger than us, the surprises that life brings, the ability to let go and devote ourselves to the creative process.

These techniques are usually based on the use of specific materials in a certain way that enables an unexpected outcome. The motif of surprise enables a connection to our artistic side and takes us to unforeseen and fascinating places.

Integrating "magical coincidence" techniques in the journal spreads

In visual journaling, magical coincidence is not just a technique for backgrounds; for every moment of creation, there is potential for magic.

Magical coincidence is not just a way to use materials and techniques; it's a way to look at the world through our inner dream child, the child who's connected to our true desires and strengths. It's the ability to see everything around us as inspiration to create. Autumn leaves falling, cracks in the sidewalk, the beauty of a piece of peeling bark, the light of dawn, capturing a child's smile in a photograph – all these are moments of inspiration that can be expressed in the journal.

Magical coincidence is manifested when we allow ourselves to play, to imagine, to connect with fairytales, the world of fantasy, dreams, to work on our inner self, or exercises that incorporate our inner dream child's world of imagination.

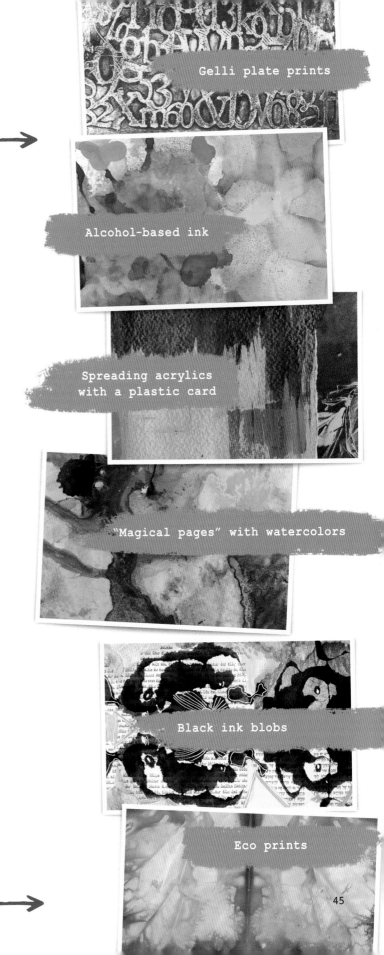

Gelli plate prints

Alcohol-based ink

Spreading acrylics with a plastic card

"Magical pages" with watercolors

Black ink blobs

Eco prints

45

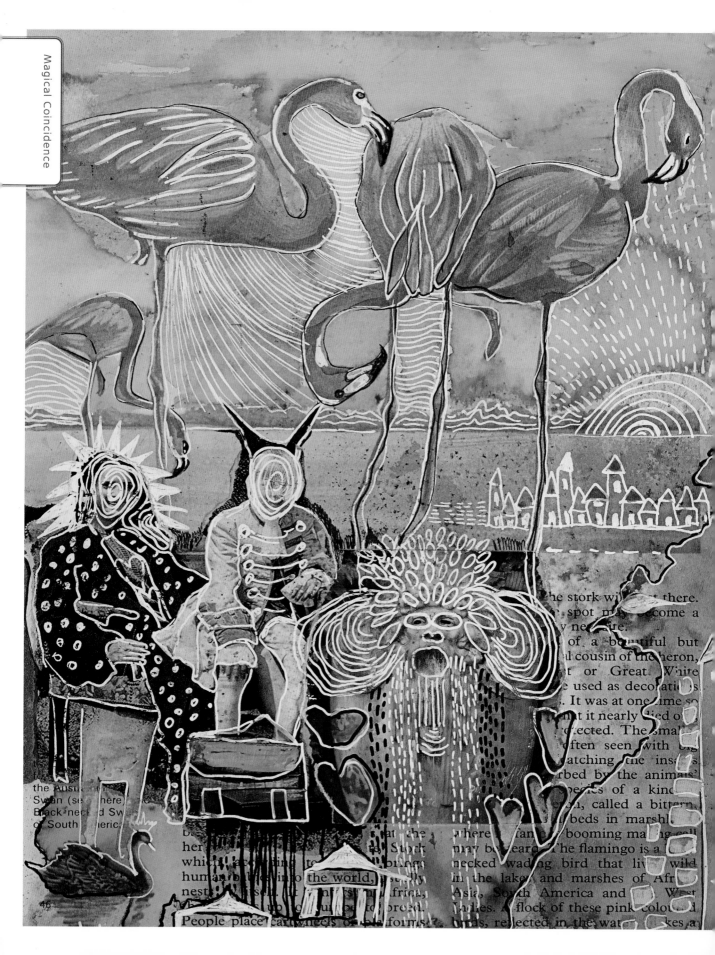

their sharp talons and tearing them
to pieces with their curved beaks.
Most majestic
the king of
many people
power and
national bird
found only
its hood of wh
sight.
 The Golde
in both Euro
wingspread of
have extraordi
can spot their
great heights.

Ha
other
small birds
named
feathers
known hawks
is a fish-b
seacoa near lakes

 the Gy falco
 and
 sport falco
 men

In warm countries vultures can
soar and soar for hours, lifted by the
warm air currents. The Griffon V
of Africa has a wingspan of almost
two and a half yards, but the largest
vultures – in fact the largest and
heaviest of all flying birds are the
A size
these birds and others will
wait until an animal dies or will over
the remains of another animal kill.
The eyesight and
source d. As one
drops to earth a mile
over. This
until
a number are gathered at the
Although they are despised,
tures – like crocodiles – play a use-
part as scavengers.

take over when the hunters
sleep. The ev the owl
for night vision and its
is so acute that it can hear
est rustlings of a mouse
the leaves. Because of its

Swans are large, graceful swimming
birds with long necks for probing
underwater in search of food. In
Europe swans are called the 'royal
bird', and at one time no one could
own a swan in England without royal
permission. The common European
swan is known as the Mute Swan
because it never uses its voice in
captiv
Mute Swans are found America,
too but the two most tive
specie are the rare r p
larges all American
and common
Swan. orth b
fly farther south for the Sou
America has a Black Swan,
and Australia has its own ck Swan,
which gave its name to

Ducks are small relativ swans
he well-known Mallar friendl
an common bird in pa e drake
ha bright colours, whe mate is
a d brown – for a go Like
ot birds which nes ound
sh must not give hers hile
si g, so she is well amouflaged.
ne duck species travel to arctic
as do the w ge The
Goose, largest in North Amer-
north in large fl rs in the
sp d south in the fa n the
s rn flights ma are ed by
hunter ut uges been
to protect em
of prey are the inter ong

Above (top to bottom)
1 Mallard, which
dips in the water with
up in
the air when searching
for food. **2** Mandarin,
wh s from east
Asia and Japan and is
often bred in captivity.
3 Barrow's Goldeneye
from North America,
Greenland and Iceland.
4 Hooded Merganser,
which lives in North
American ters.
5 Shoveller wh is
common all over the
northern hemisphere.
6 Shelduck, which is
large and looks
rather like a goose.

oveleft Owls are
noctu birds of prey,
hat is hey unt at
night, and their silent
flight enables them to
pounce on a victim
without giving warning
of their approach.
This is the Screech
Owl wh lives in

Creating a "magical page" with watercolors

A few ground rules
for working with watercolors:

✳ Use contrasting colors to make
it more interesting

✳ Add white gouache paint to add some
of the white back onto the page

✳ If the page is too wet and the colors
start to mix _ stop,
let it dry, and then continue

There are two basic techniques
for working with watercolors:

Wet on dry – wet the brush and touch it to a color,
then add water to create transparent surfaces.
Wet on wet – on the still wet surface, add touches of
another color with a thinner, wet brush.

The process of making the journal cover is very significant and always involves intention and magical coincidence.

It's important to create the cover before sewing the journal because the cover is the first step in which we let magical coincidence take shape, creating a vibe within us that will influence our entire work.

The cover doesn't have to be like a spread in the journal; it's simply the creation of a "binder" to protect the content that you are about to create. That is why playfulness is an important factor in creating it and letting the magic happen.

Splash some watercolors on the page and let yourself go with no intent or experience; use the box of watercolors as if you're a small child who has discovered the box in a closet and just has to try them out.

Embellishing the cover

Create an interesting play of drips of color using different brushes.

Turn over the page you wrote on.
(**dream child** Writing exercise, pages 40-41)

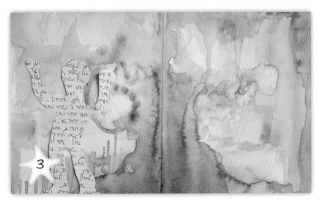

Draw a simple figure of a child, cut it out, and paste it on the cover.

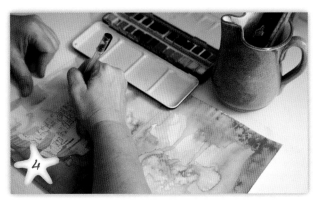

Black out poetry - mark the words that you like on the child's body.

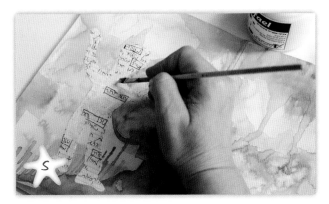

Color the rest of the body with **white gesso**, leaving in the words you marked. **Check:** Do the words come together to form an important message?

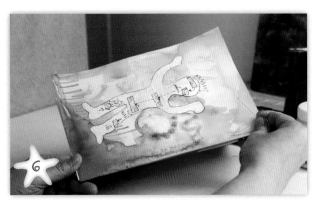

That is magical coincidence!

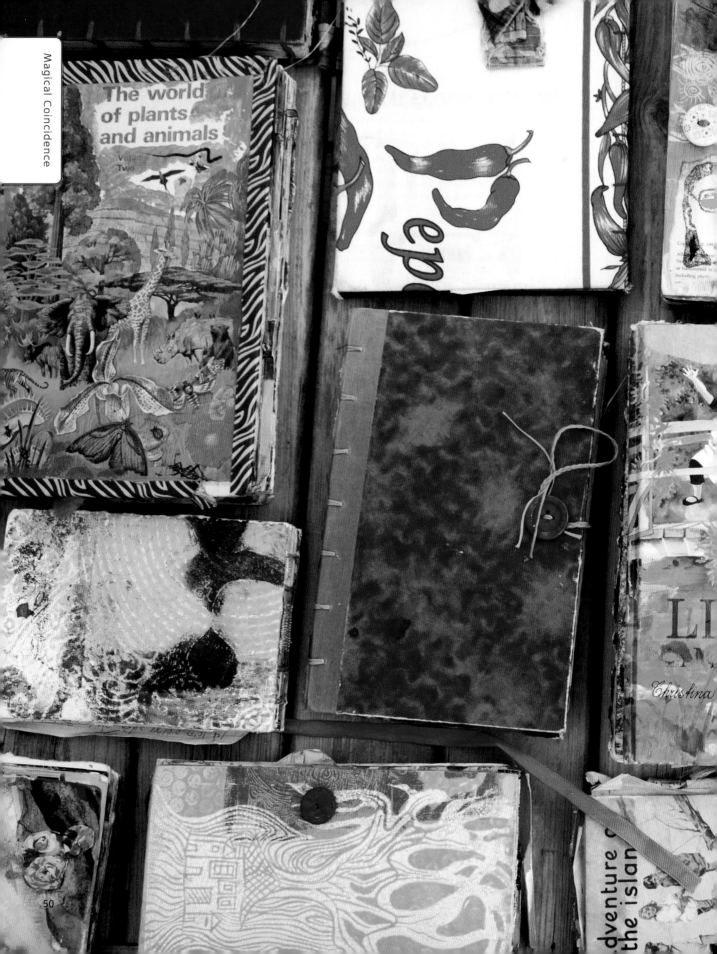

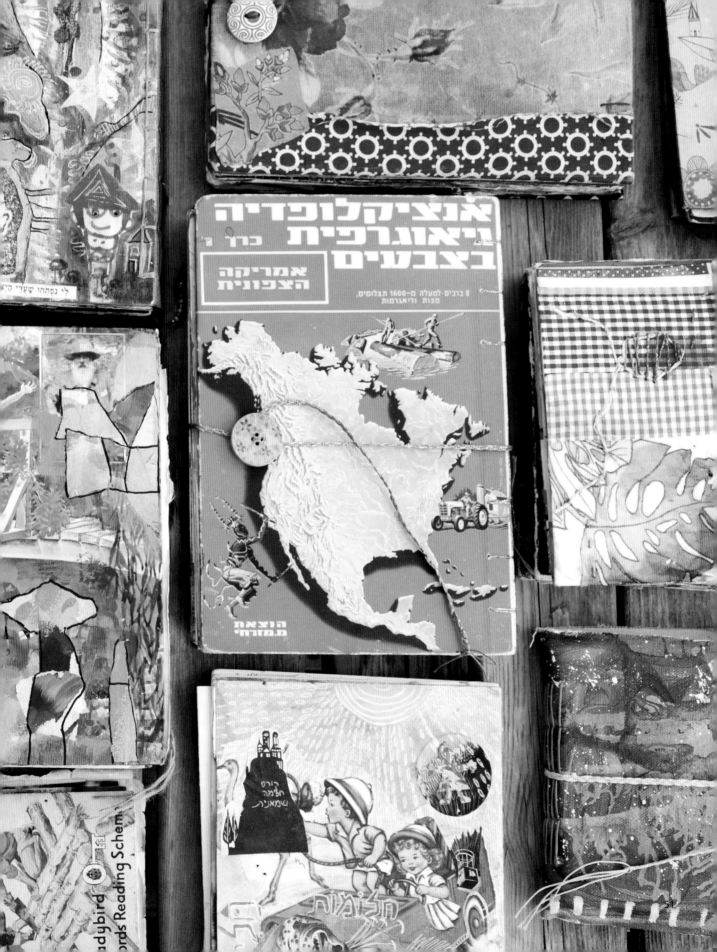

The cover of the journal itself is a process of creating something from nothing.

The creative process

Sewing a seven elements journal

Many people create in store-bought notebooks. I believe that making the journal from scratch is a significant process of building a vessel for the soul. We start with basic materials: paper, cardboard, colors and thread, and bind them together in a process of preparing to start the visual journal.

The cover of the journal itself is a process of creating something from nothing. It is an important process that ignites passion and joy and the desire to create in the journal. The emotional attachment to the journal is stronger when you create it yourself; gather the materials, color the book covers, express intention for them and bind them to make art. Even before we start journaling, we pour into it all our hopes and aspirations for change and development. For many, the visual journal becomes a meaningful transformative object that they can take with them anywhere.

Steps to make the seven elements book cover

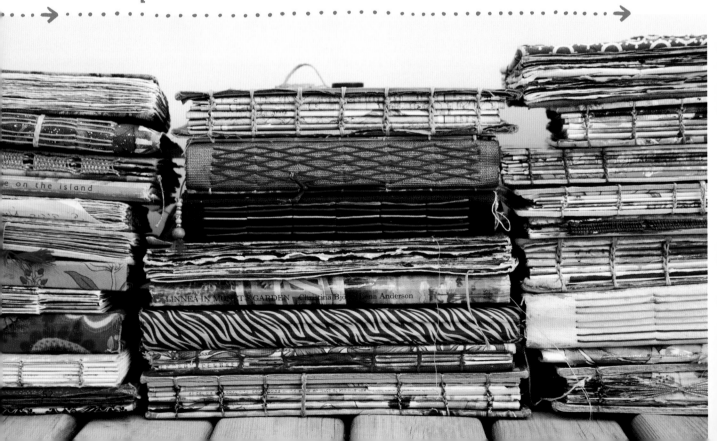

Fold the cover and three additional pages in half. Bundle them together (each page is inserted into the previous page) with the colored page enclosing the blank pages.

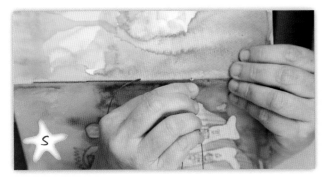

Measure and mark two more holes on each side at a distance of 4.5 cm (1.8 in.) between each hole (5 holes total). **Use a hole puncher** to create the holes in all 4 pages.

From the inside, thread outward through the next hole, and **repeat until the end of the row.** At the end of the row, go back in the other direction to the starting point.

Tie the ends of the thread together.

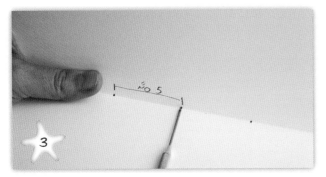

Open the book at the center page and use a ruler to **mark the mid-point** of the fold.

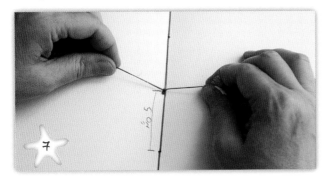

Use waxed thread and insert the threaded needle from the inside of the pages outward through all the pages, and then insert through the next hole from the outside in.

When you're done, insert the needle under the first stitch.

You can add a button or ribbon or anything else you can think of to hold the book closed.

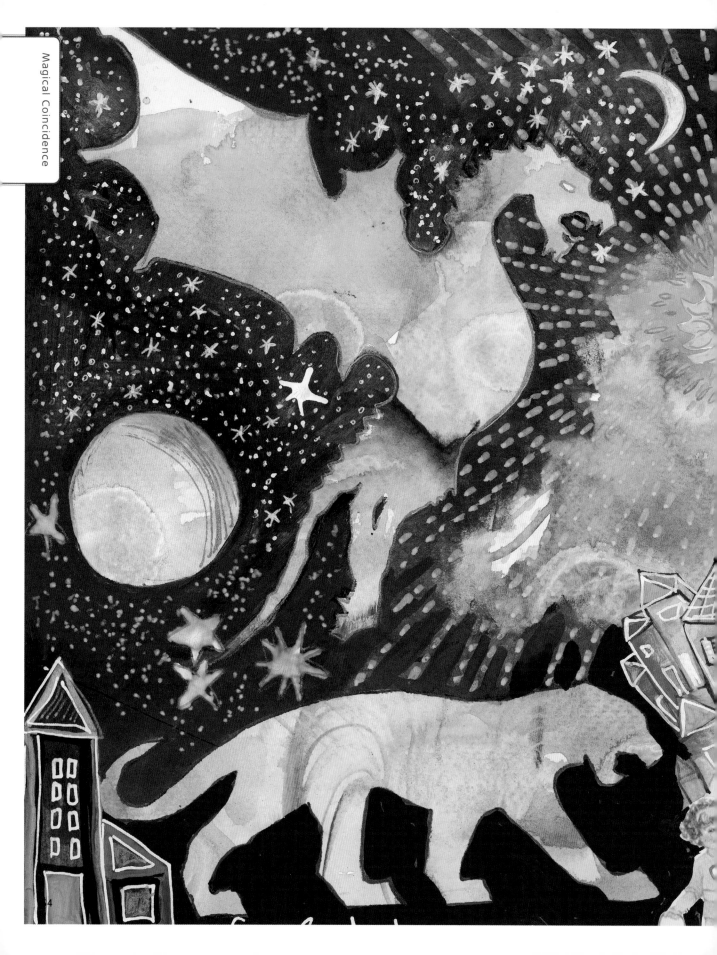

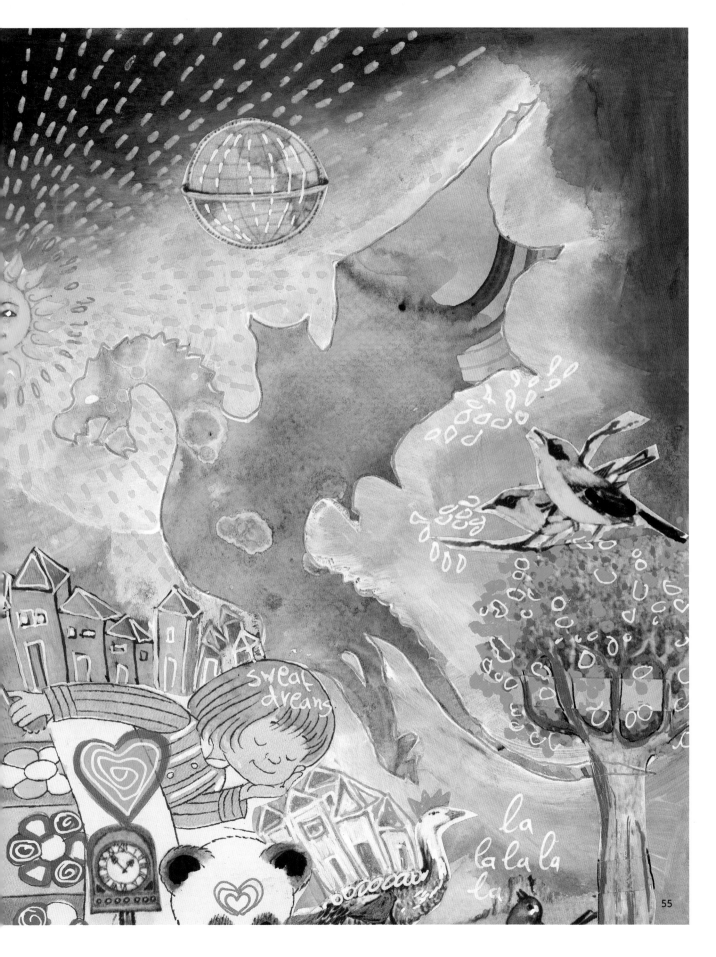

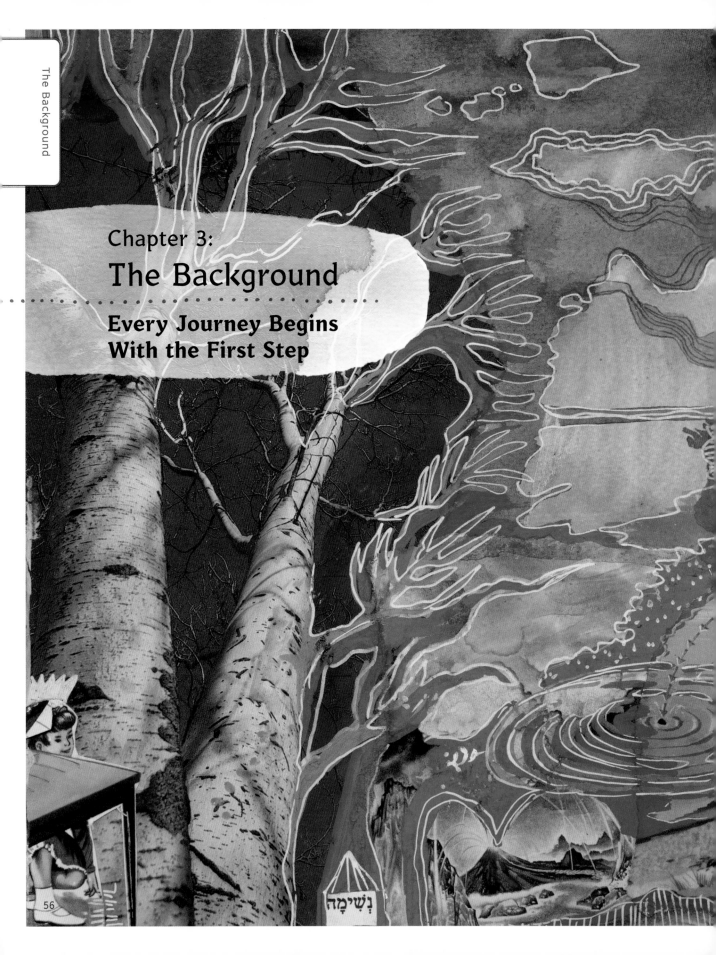

Chapter 3:
The Background

**Every Journey Begins
With the First Step**

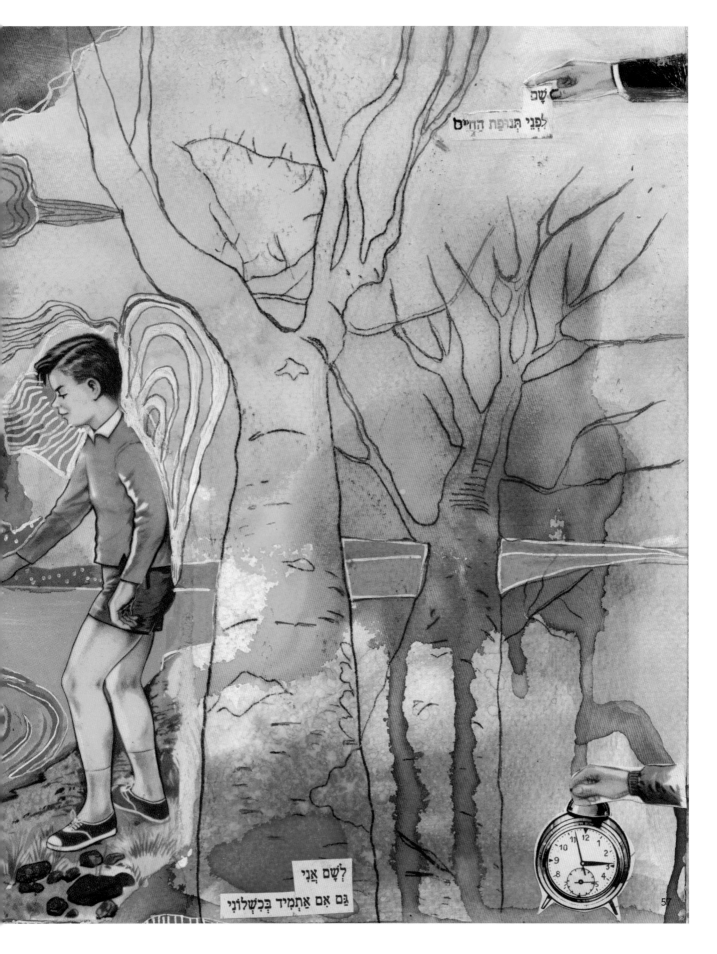

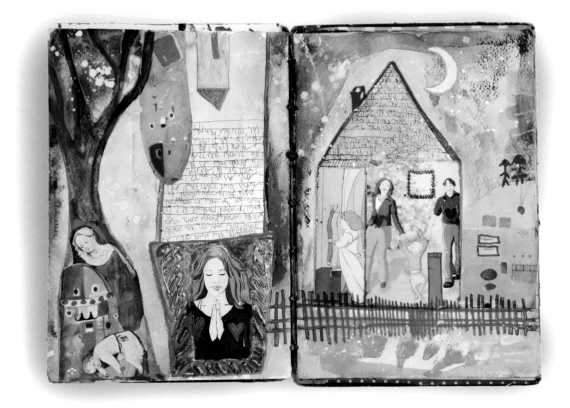

The background layer is not just a basis. The background is the first layer of the book. It can be a page from a children's book, a color blot that you smeared by accident on the blank paper or an image that you pasted in several months ago. The background is the first layer of meaning created on the page; it's the first thing we consider when we open a journal spread. It can also be the blank page itself.

The background creates the foundation of the spread. In my creative process, the background doesn't start with conscious intention; it's more like the soil on which I place the seeds. I work on journal spreads in parallel; I paste and color, and sometimes bind the books with pages that contain image or texts that I'm drawn to.

The background is the first step that I take with a spread. It can be pasting an image that I like, or a doodle, or even intuitive writing. The background is the first thing to break the blank page.

The creative process - parallel journaling

In this and the next chapters, we will learn and experiment with parallel creative processes in the journal - working on several pages at the same time, adding another layer of meaning to each one.

In this exercise, we will work on three different spreads. We will use various techniques for creating the background; with all of them, we create the background quickly and without thinking, simply letting our hand guide us.

In the previous chapter, we described techniques of magical coincidence that can be used to create backgrounds for the journal spreads, but sometimes, we will create more subtle and tranquil backgrounds that will just be a platform on which to start our creation.

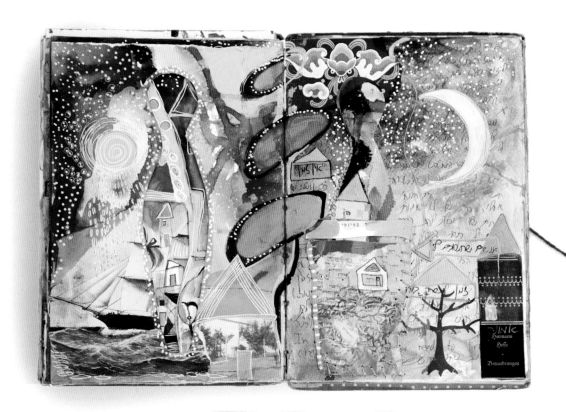

You can liken the background to the concept of reverie.
Reverie is daydreaming, an association that starts to take shape on the page. One addition leads to the next, without any conscious intent. Finally, it takes an interesting direction that will dictate the rest of the spread.

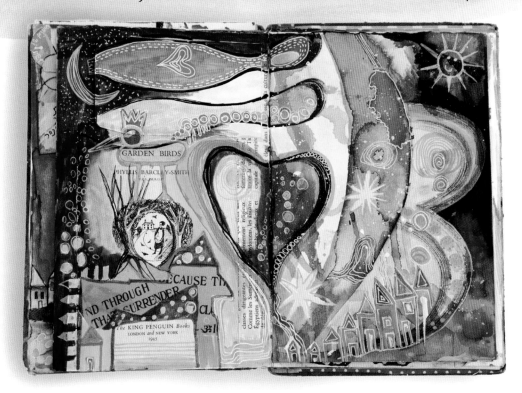

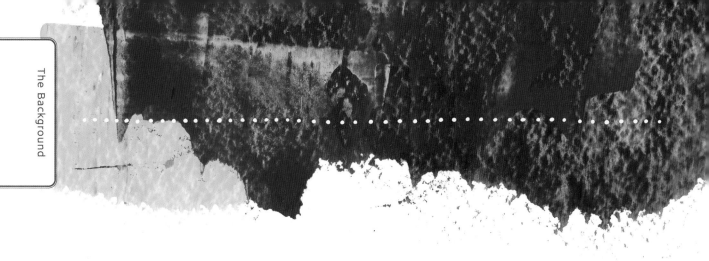

"Collage carpet"

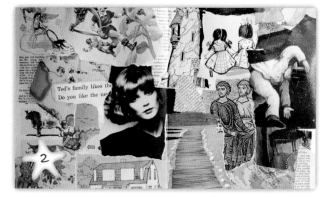

Paste torn-out pieces from newspapers, books, or magazines across a spread. Choose text, images, and some pieces of different-colored paper of any type. Choose pictures that you like but remember that a significant part of journaling is not to become too attached to one thing, but rather to work in layers. Sometimes, we paste images on the first layer that can't be seen in the last layer. Paste the pieces on each spread so that they overlap a bit.

Paste under and on top of each image to create a homogenous collage that looks like a patchwork carpet.

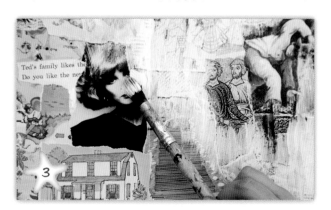

Brush some white, diluted gesso on the spread. Use a wet-wipe to wipe off areas that you want to reveal, or only part of an image.

Complete the spread so that it looks harmonious, like a "carpet of images."

Acrylic brushing

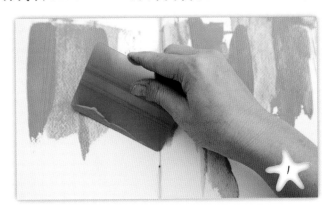

Choose 2-4 colors and dab a bit of each color on a plate. Do the colors match? If not, you can choose another color. **Using a hard plastic card**, dab a little bit of color on the page, and spread it with upward strokes. Continue until you cover the entire page.

Let the colors cover one another. Make sure that there are layers of color in some places. **Continue to fill the background** until it looks finished to you.

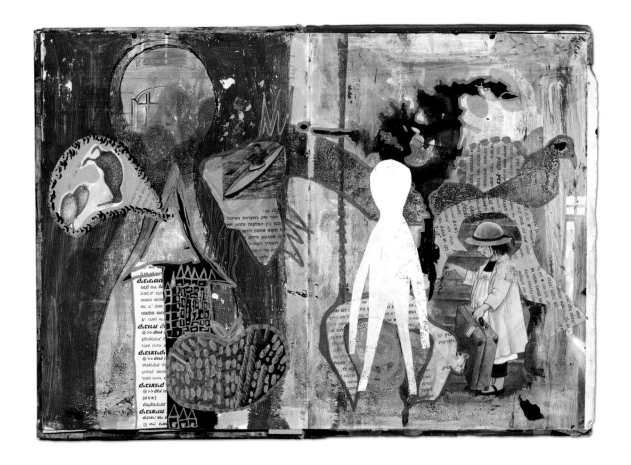

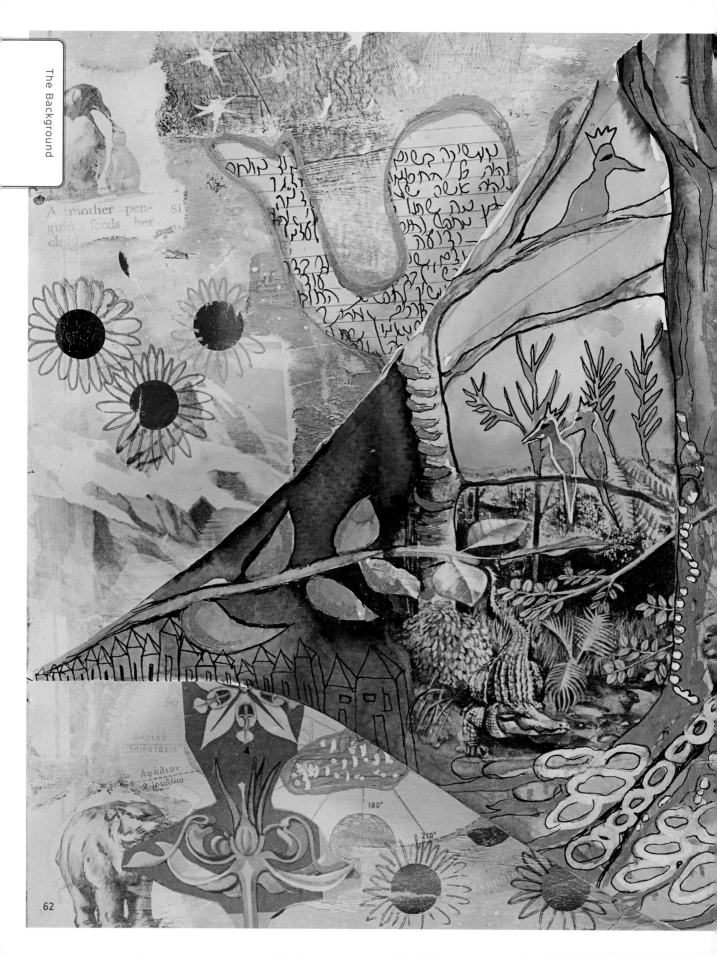

A mother pen-
guin feeds her
ch...

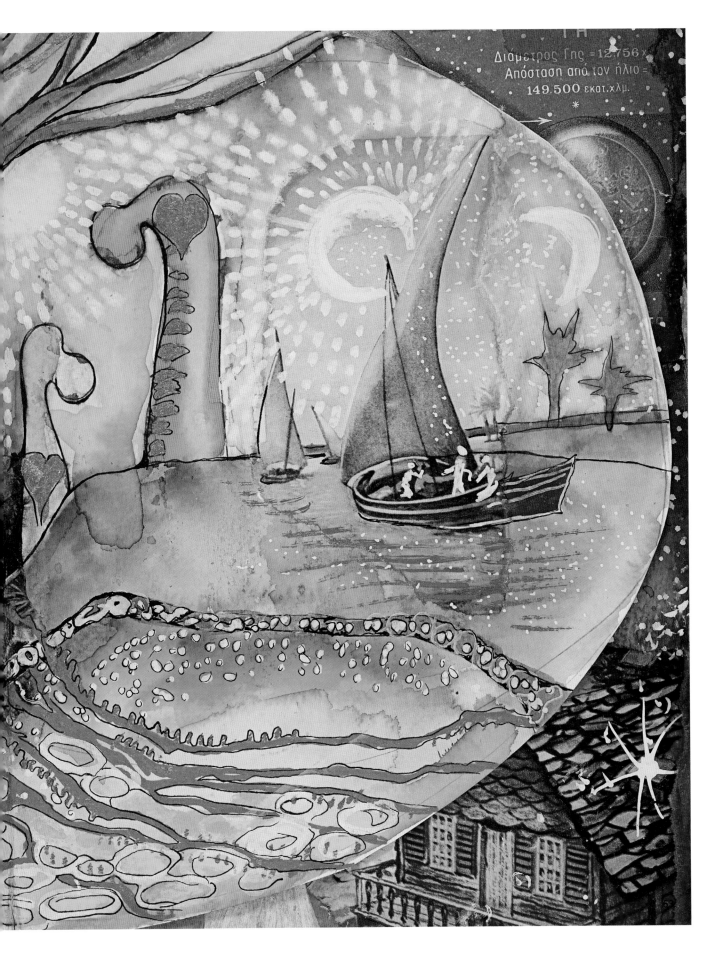

Διάμετρος Γης =12.756 χ
Απόσταση από τον ήλιο =
149.500 εκατ.χλμ.

Harmonious watercolor background

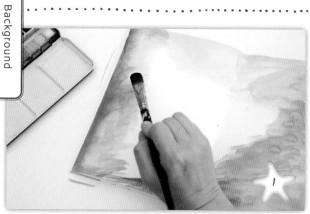

Choose three shades of the three primary colors: red, yellow, and blue. It could also be pink, light orange, and turquoise.
Start from the corner of the page. First, use the "wet on dry" technique; add water to keep lightening the color.

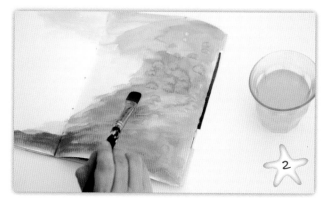

Dip the brush in the color and dab on the areas that are still wet; use the "wet on wet" technique to create spreading areas of color.

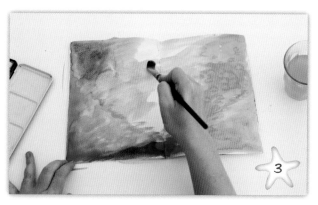

Repeat with the two remaining colors.
Dip a large brush in water and create a background of delicate color combinations, adding color diluted in water where the colors meet, and let the colors mix.

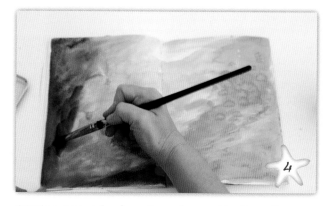

Create a new color from the color combinations. For example, green created from the combination of yellow and blue.

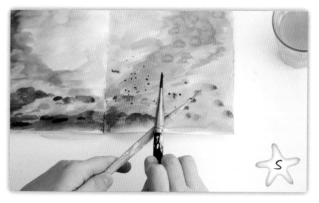

Dip a brush in paint and tap on it with another brush to create star-shaped splashes.

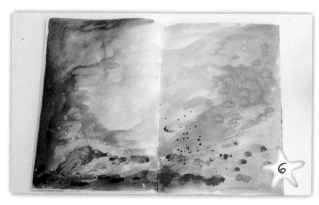

To finish - add highlights of a darker color on one side of the background to create contrast.

Additional backgrounds:

Gelli plate prints

Gelli plate is a wonderful printing technique using a gel printing plate and a roller. Each print is unique; you can print with acrylics, watercolors, and gouache.

Gelatos

These water-soluble, lipstick-shaped crayons create quick backgrounds.

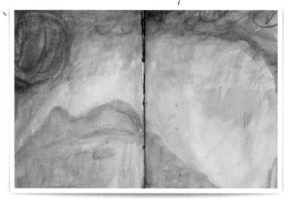

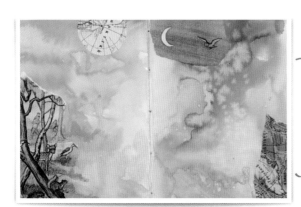

Distress Oxide Ink Pads

Distress is a type of ink sold in ink pads and can be used to create a variety of backgrounds by adding water. The colors are very bright and similar to beautiful watercolors.

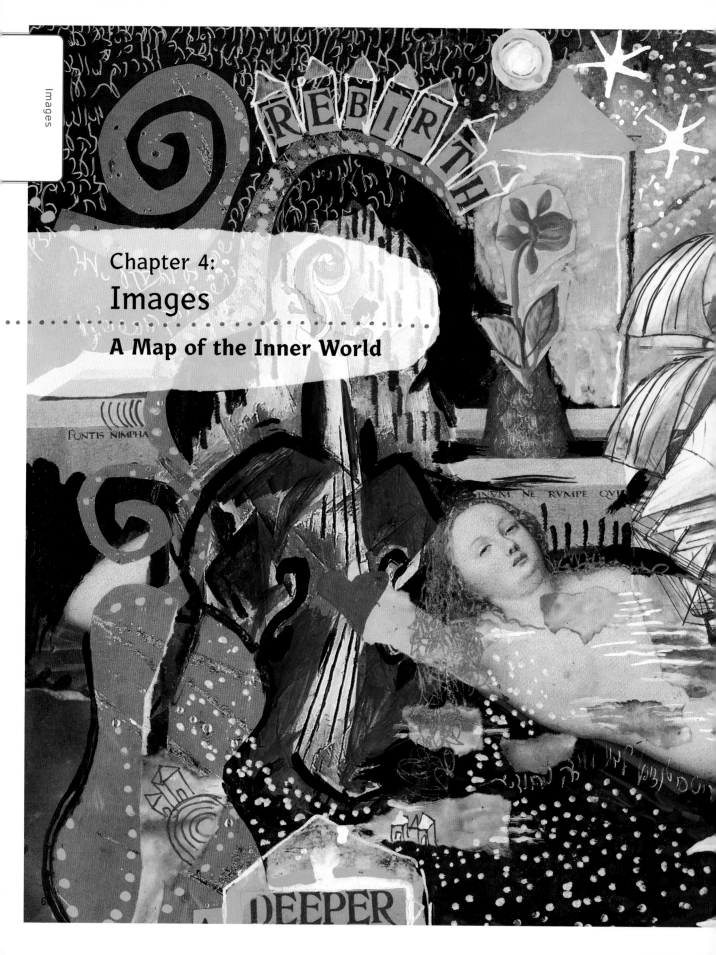

REBIRTH

FONTIS NIMPHA

Chapter 4:
Images

A Map of the Inner World

DEEPER

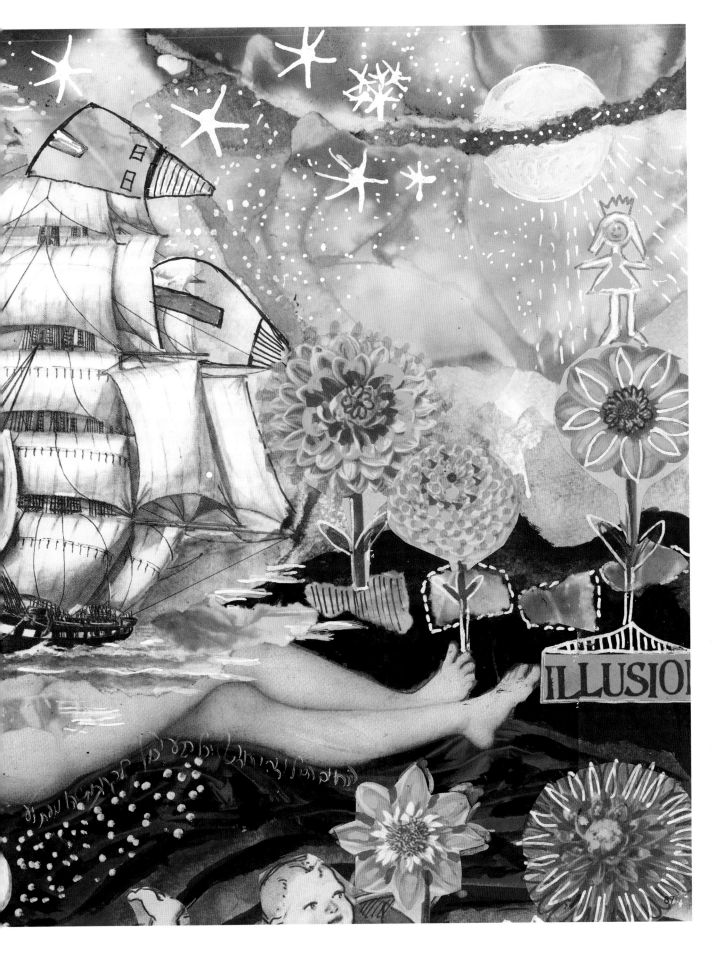

Images are a world of their own. They are the heart of the artistic process in the visual journal, the visual representation of our inner world.

Images are a visual expression for metaphors, dreams, memories, and emotions. They are a visual translation of our inner world.

Our unconscious mind thinks in metaphors and images. Before a baby learns to talk, he sees his mother's breast in his imagination and dreams about it. Fantasy, dream, and imagination - our entire inner world is built of images. These images, whether they're concrete and real, or metaphorical, enable us to create a map of our inner world. Every journal spread is a map of a specific moment, a specific topic, a feeling that we have enabled to be manifested. Once the map is in our hands, we can examine it, understand its underlying message, and sometimes, we may decide to hide it.

Working with images in a visual journal is healing, provides insights and enables true magic to happen. Images are the visual aspect of our individual symbols. We each have personal symbols, images that mean something to us. Sometimes, we're drawn to things as if with a magical bond, like children's fairytales, certain trees, or animals. The psychoanalyst Carl Gustav Jung talked about a layer of the soul called the collective unconscious, a layer populated with many archetypal symbols that affect each person differently. These images are manifested in dreams, in life events, through literature and art, and sometimes in random events called synchronicities. In a way, Jung's "synchronicity" is similar to "magical coincidence," magical occurrences that impact our lives and have no explanation.

Images can be manifested in the journal in many ways - in a picture, a drawing, a splash of color, or abstract shapes. You can take a photograph and then paste it in, cut images out of old books or magazines, even draw a picture or copy from a photograph. There are many techniques for using images in visual journaling: collage, drawing techniques, or combinations of collage and drawing.

There are many images in a visual journal. The background itself may be created of images, but usually, there are some central images that compose each story.

The main concept behind working with images is to integrate them into the background and create a continuing story or highlight them from the background and create some distinction or statement.

The image always comes as an additional layer that "communicates" with the background layer. The image has a relationship with the background. Is it integrated in the background? Does it stand out? Is there a relationship between the images on the page? Does the image create a sense of depth on the page or a flat feeling that makes the page look like a carpet?

Images are the main characters of the spread we've created, and the connections between them are what create the nuances of the story.

Exercise _ what does the word "joy" make you feel? Find five images in magazines, newspapers, the Internet that you associate with that feeling.

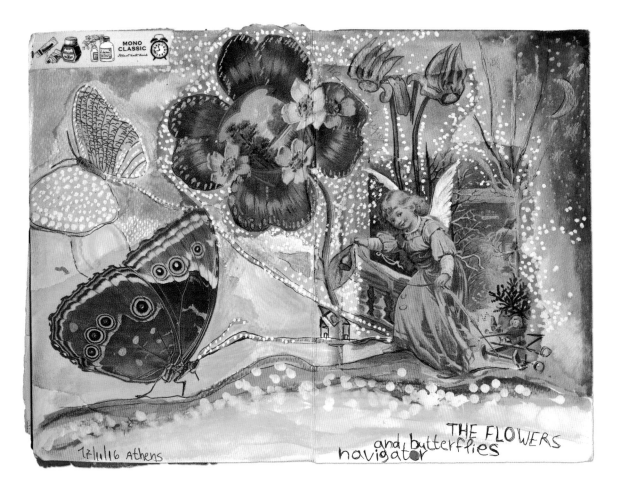

MONO CLASSIC

17/11/16 Athens

navigator and butterflies THE FLOWERS

Methods of working with images

There are three main ways to work with images: you can search for an image, discover an image, or draw an image.

We will mostly work with images that we search for, cut or tear out of books, magazines, the Internet, napkins, or any other medium.

The search for an image - Finding an image with conscious or unconscious intention

There are two ways to search for images: find an image that matches the theme we've chosen to work with, or let our unconscious mind choose the images for us and start from there.

After we paste images in the journal, we can draw on them, change them, and make them our own.

You can cut out images with scissors or tear them out, so that part of their background remains, making it easy to integrate them.

The journal is a riddle - start with a question and let your unconscious mind send you messages.

When you start with a certain intention or theme, you should begin with a certain question or a phrase. Usually, we find that phrase in a guided imagery exercise, through intuitive writing or simply from the desire to work on a certain topic.

I believe that deciding on a certain phrase or topic that we want to start out with opens a channel within us that lets the unconscious mind take over and guide us in the rest of our creative choices.

From this point on, let your unconscious mind choose for you.

How will you know? You'll have a gut feeling when you want to do something specific, let that intuitive feeling lead you, let your hand guide you. Try to ignore thinking in terms of "pretty" or "not pretty." In the end, you'll understand why you chose those images.

Complex techniques for working with images

Using elements of line and color

Discovering the image

Another fascinating method is to let the images come up from within a background. For example, you can find images in a background of watercolors, in inkblots, Gelli plate prints, and other techniques that enable letting go of control. In many cases, we can find images that seem to come out of nowhere. These images have a great deal of power that stems from the observer's sense of surprise.

Draw from your imagination (and let go of your inner critic)

Many students say to me, "I don't know how to draw!" What they mean is that they don't know how to draw a realistic picture that looks "pretty." But in the visual journal, we try to break free of the need to create a "masterpiece."

The main goal of journaling is to develop the ability to look at the world from the perspective of a child and allow ourselves to draw like a little child, from within, not from looking out and trying to "copy" what we see. A child draws from imagination, from senses and emotions. From that inexhaustible "well" of imagination, a child draws with no self-criticism or judgment.

Everyone has their own way of creating with images

One of the most fascinating things about visual journaling is seeing up close how people work with their own images. When we look at a completed spread, we don't know the process that drove the individual to create that specific spread. Each decision has unique significance. The process we go through from choosing the images, through connecting between them and the finished spread - is the heart of the journaling work process.

Many artists collect images that mean something to them in folders. Some collect old books and work in them. In what we call an "altered book," the artist can use pages of the book that are filled with images as a background to stimulate the imagination and infuse the pages with new meaning.

Artists with technical abilities draw their own images or create them with techniques that integrate collage and drawing.

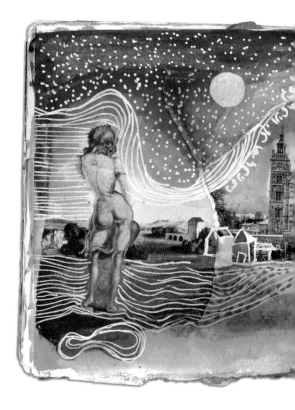

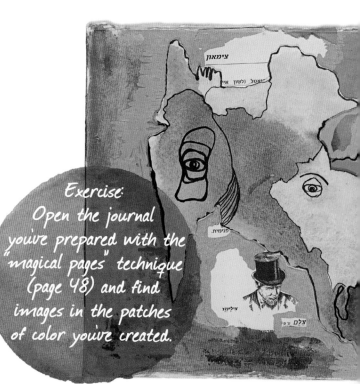

Exercise:
Open the journal you've prepared with the "magical pages" technique (page 48) and find images in the patches of color you've created.

Exercise: Open a page in your journal that
has a few images - add something of your
own to enrich it and make it yours.

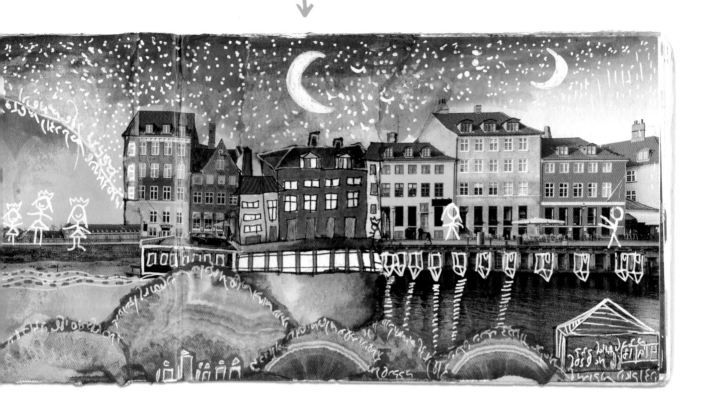

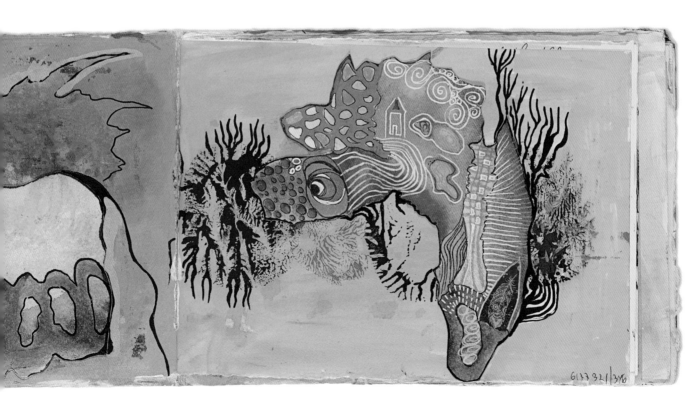

I believe that in the visual journal, the importance of the image is not in its artistic value but rather as an expression of what's inside us. There is no need to work with classical drawing techniques, but rather in techniques that enable short cuts like collage.

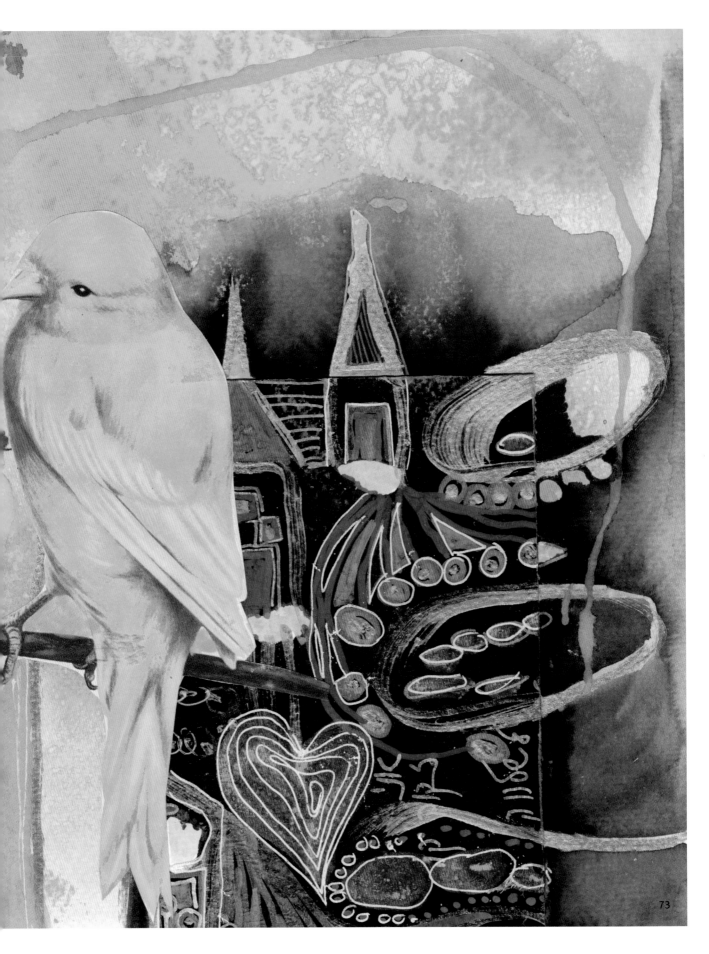

"Happiness box"

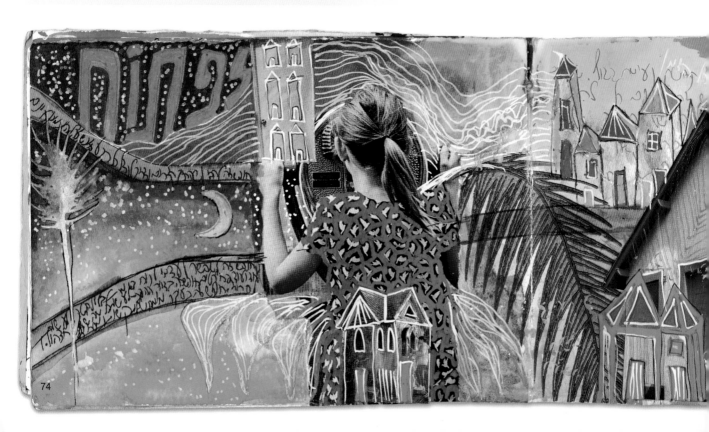

Compositions of images

Find images that you like, cut out five images precisely on the line, and tear out another five, leaving in some of the background.

Paste the images on the backgrounds you've created, any way you choose. You can connect some of the images and leave some of them separate.

Remember that the way you paste the images creates the story; the composition of the images is important. See the various types of composition on the right.

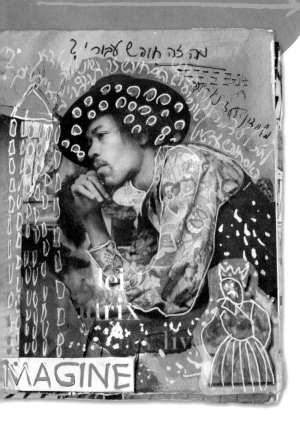

Simple composition

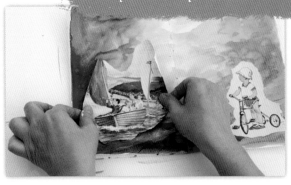

Two images pasted on a watercolor background. The images have no intentional connection, and the purpose of the spread is to connect between them and create a story.

Complex composition

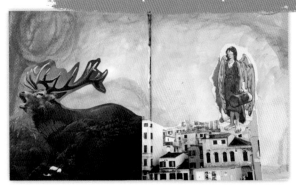

Three images connected on a gelatos background. The composition is surrealistic, in which one image is a continuation of another. This composition gives a sense of depth, of a near and a distant landscape.

Depth composition

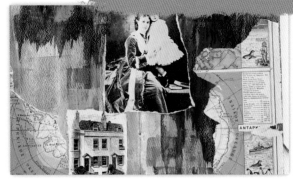

Four connected images that create a story on a background of acrylic paint. The complexity is created by the effect of tearing an image in half and pasting it on two corners of the spread. Another image is pasted at the top and creates interesting asymmetry.

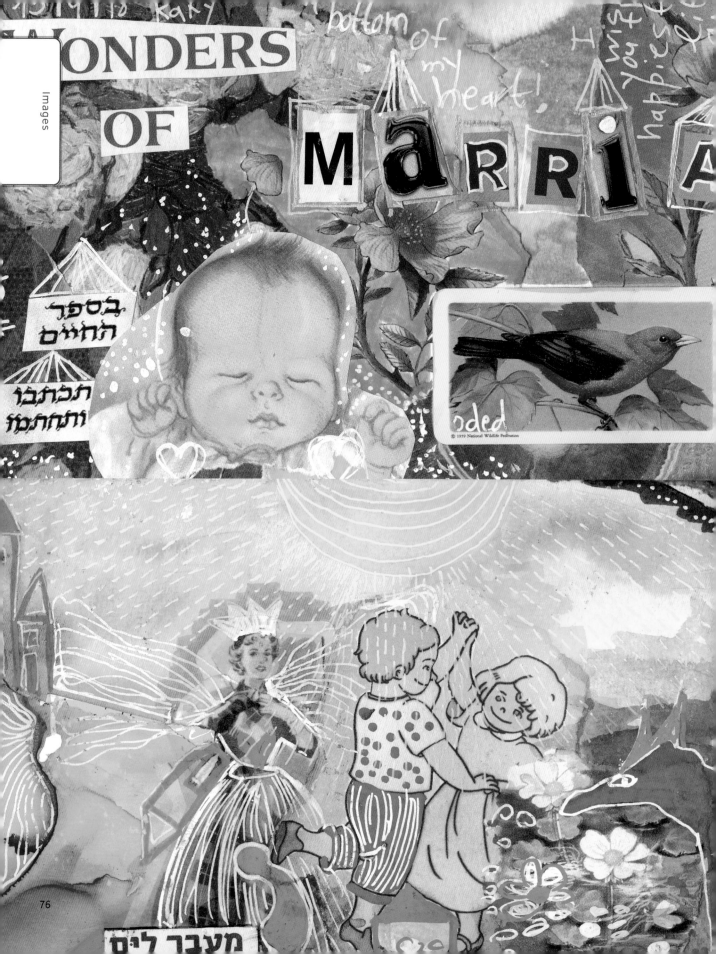

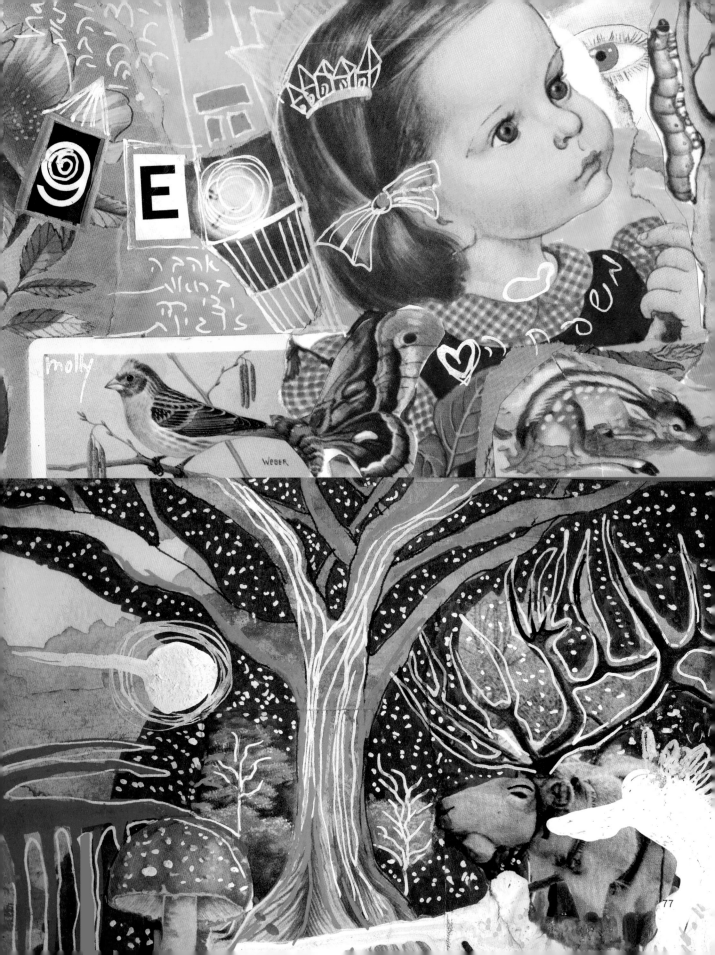

molly

E

77

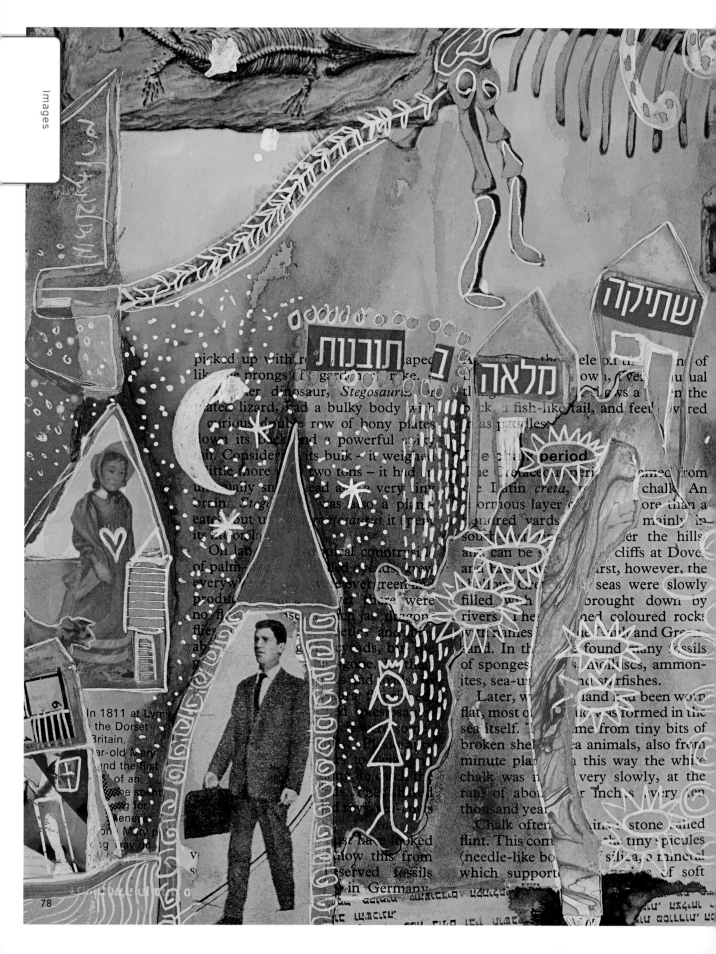

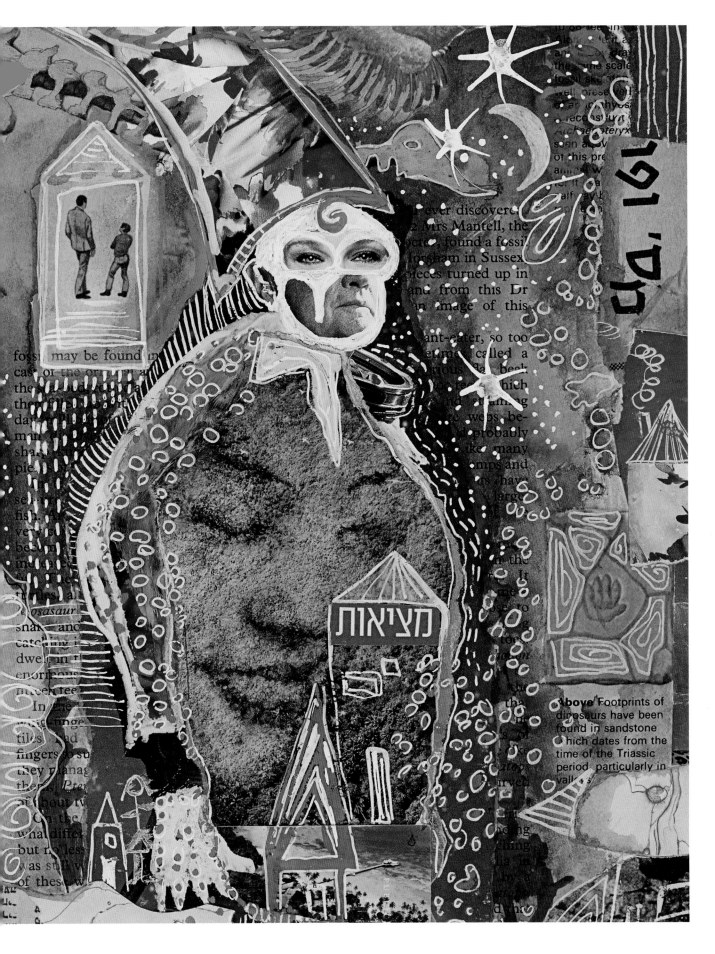

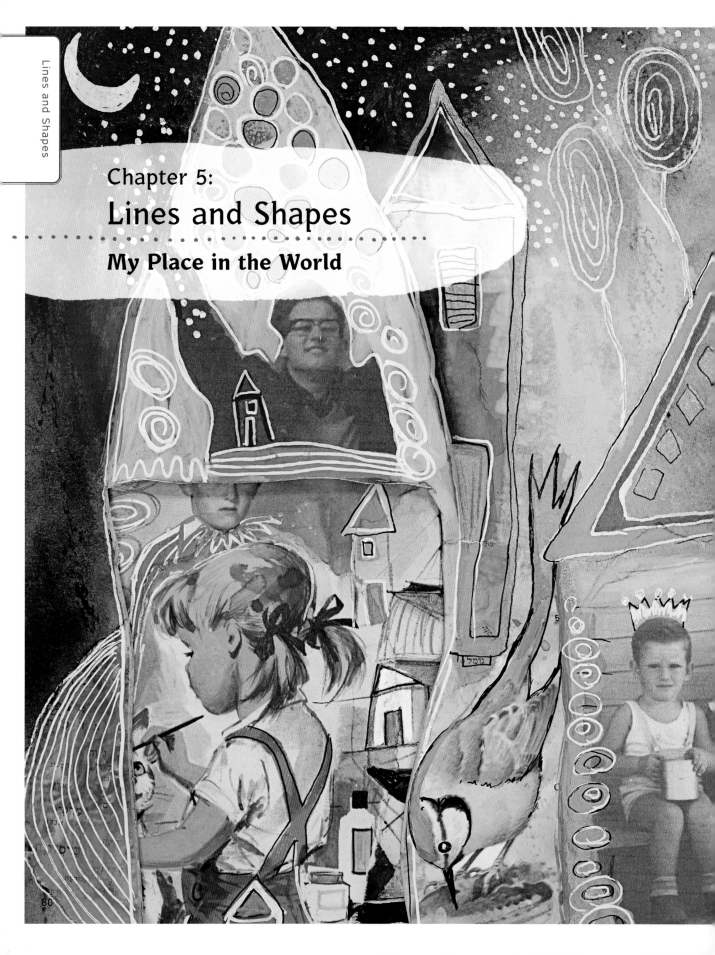

Chapter 5:
Lines and Shapes

My Place in the World

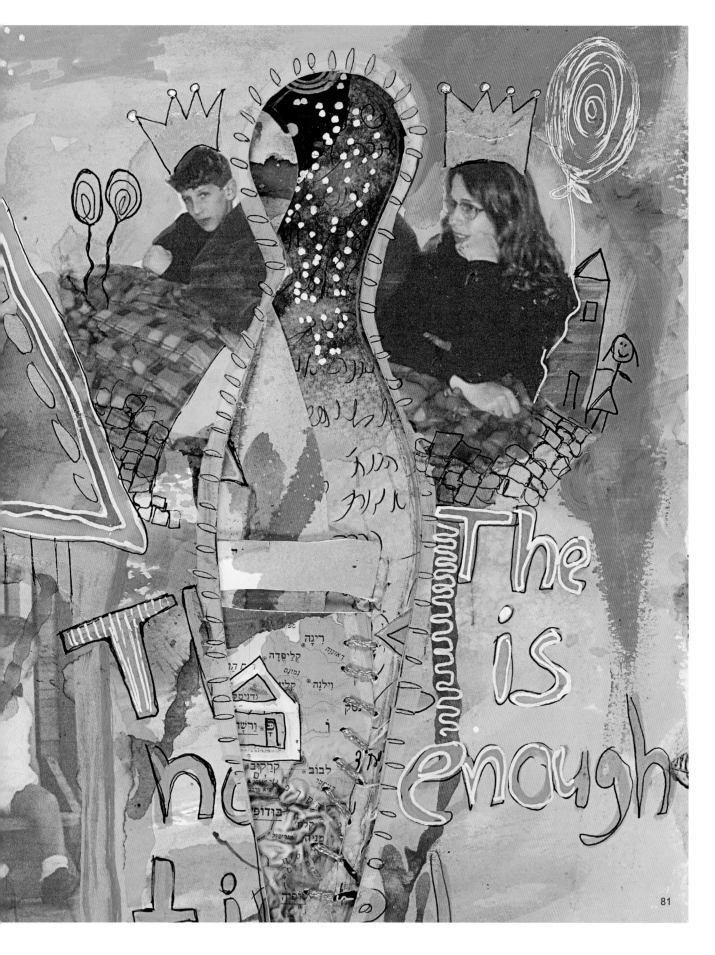

The line (which encircles the image) is the element that worries most people who start journaling.

"I don't know how to draw." "It's been years since I held a pencil." Many people expect that every time they hold a pencil or color, they will create beautiful, flowing lines that form an accurate imitation of reality.

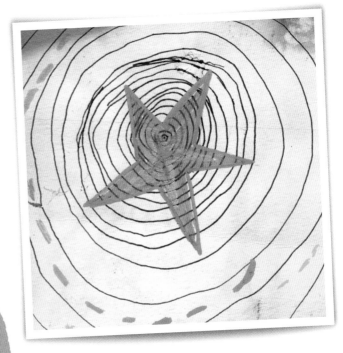

The most important functions of line:

✳ Create a composition

✳ Create connections between the various images in the spread

✳ Delineate the main image or images from the background of the spread to clearly distinguish the topic from the background

✳ Create an entire image with lines

✳ Lines can be created from different materials but mostly using pencils, markers, or hard crayons that enable control.

✳ You can also use paintbrush and color, but these lines will have different shapes and textures.

✳ Lines drawn with hard material are pronounced and strong, lines that express presence and personality.

Lines have some very significant meanings:

✳ Line is the clearest representation of individual personality in the journal. When you create symbols on paper, it says, "I was here; I created this." There's a reason people say that everyone has their own individual fingerprint on their artwork. The line created by an individual is one of the distinguishing features of human personality.

✳ A line can be sharp, soft and rounded, jagged, broken, parallel, twisted, closed or open, thin or thick, clear or blurred.

✳ The line leads to open or closed shapes.

✳ The line divides the space of the journal art and creates a near-far composition.

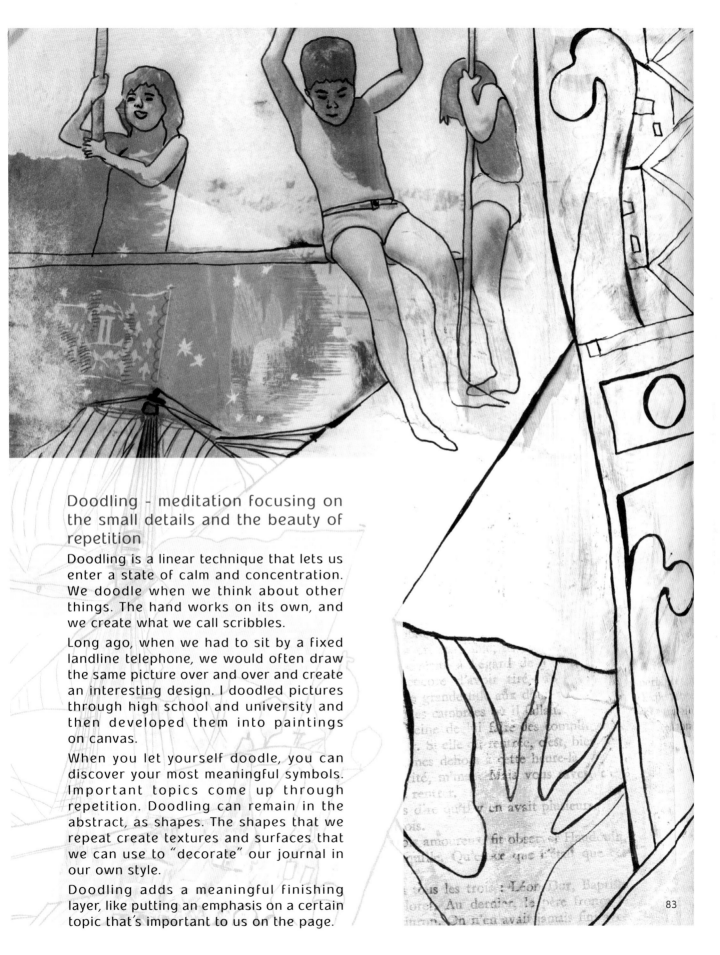

Doodling - meditation focusing on the small details and the beauty of repetition

Doodling is a linear technique that lets us enter a state of calm and concentration. We doodle when we think about other things. The hand works on its own, and we create what we call scribbles.

Long ago, when we had to sit by a fixed landline telephone, we would often draw the same picture over and over and create an interesting design. I doodled pictures through high school and university and then developed them into paintings on canvas.

When you let yourself doodle, you can discover your most meaningful symbols. Important topics come up through repetition. Doodling can remain in the abstract, as shapes. The shapes that we repeat create textures and surfaces that we can use to "decorate" our journal in our own style.

Doodling adds a meaningful finishing layer, like putting an emphasis on a certain topic that's important to us on the page.

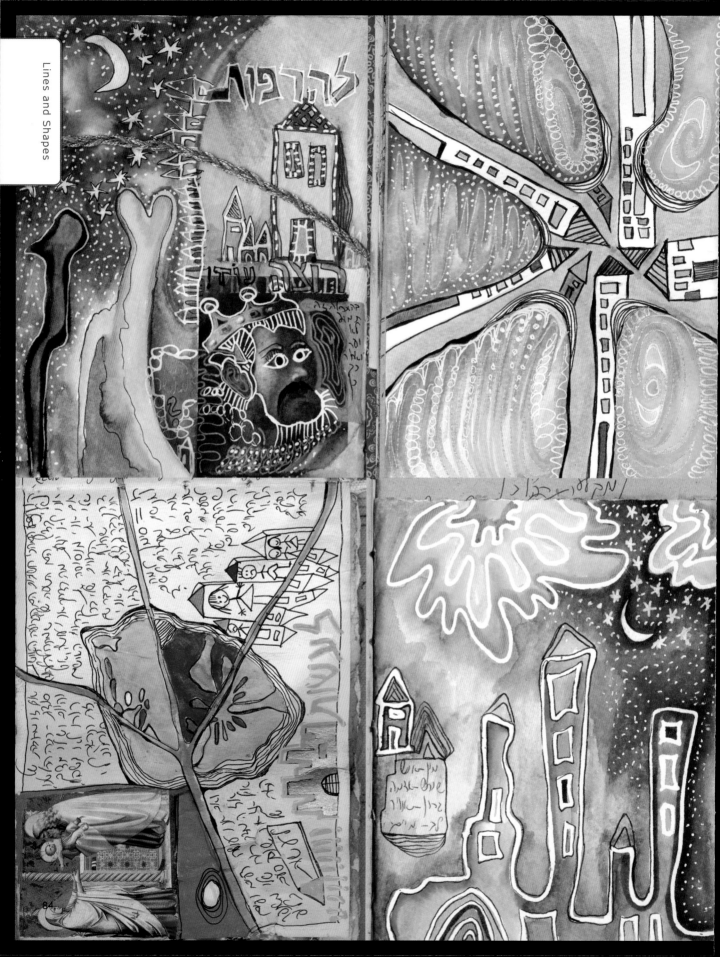

84

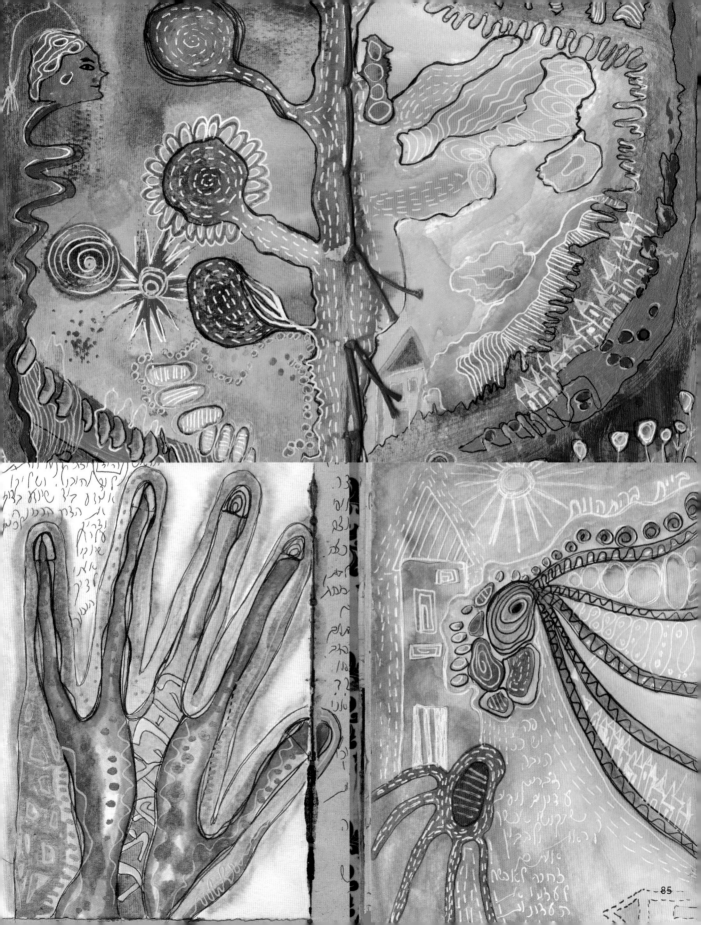

Exercise 1:
Create a linear composition

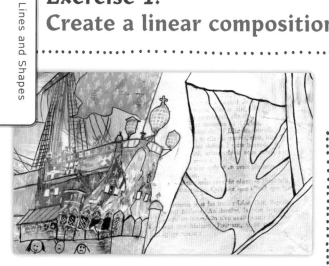

Select one of the pages in your journal. Using a black Pilot pen, divide the page to create different planes or even a landscape, according to the images already on the page.

Exercise 2:
Create connections between the images

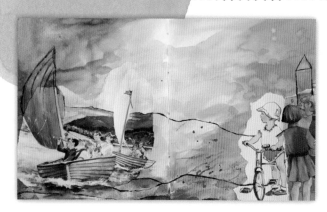

Using a black Pilot pen, add connections between the various images. Go from the image to the page and back.

Exercise 4: Doodling - The art of holding on to what we have ⟶

Exercise 3:
Integrate with lines

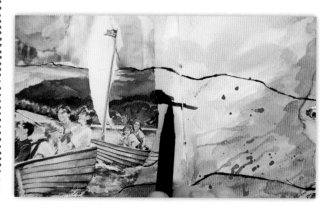

When we continue the line of an element already in the image, our eye completes the image, and it becomes part of the background. A line is the first part of the image integration process. You can integrate with lines using markers similar in color to the colors in the image we want to integrate.

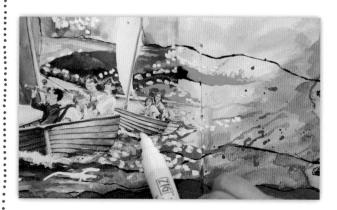

Look at the spread and search for interesting transitions between the colors. Find shapes just like a child sees shapes in clouds. Allow yourself to draw patterns that repeat themselves, or add small details like flowers, hearts, etc.
Doodle with very fine point pens, like Pilots or a white gel ink pen, which adds light to your work.

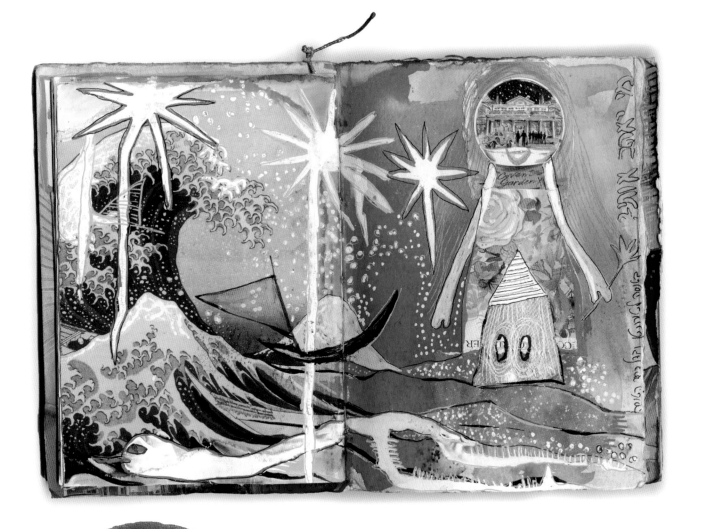

Something to think about:

Take a look at the quality of the lines you've drawn — what do they tell you about your place in the world?
Do they flow, are they choppy, hesitant, harmonious, or all of the above?

Look at the page and add some image from your imagination. It can be anything at all - a sun, moon, tree, house, or even a simple figure. Draw it in lines of varying thickness and then color it in with any color. Enjoy and have fun with it like a child.

Exercise 5: ⟶
Choose a page that you're working on and add an image from your imagination ↑

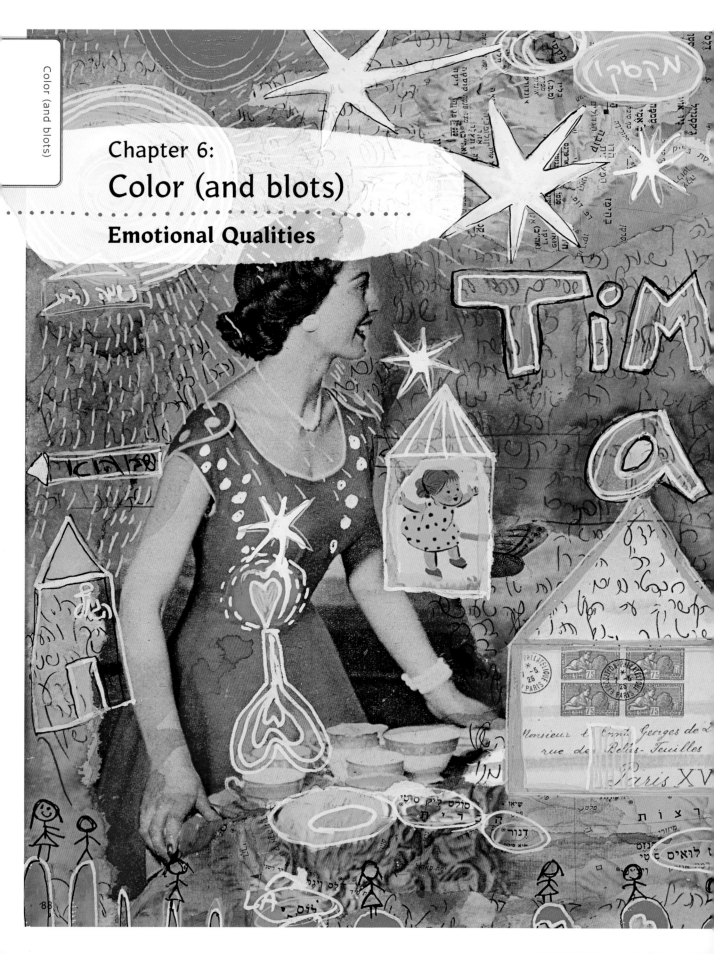

Chapter 6:
Color (and blots)
Emotional Qualities

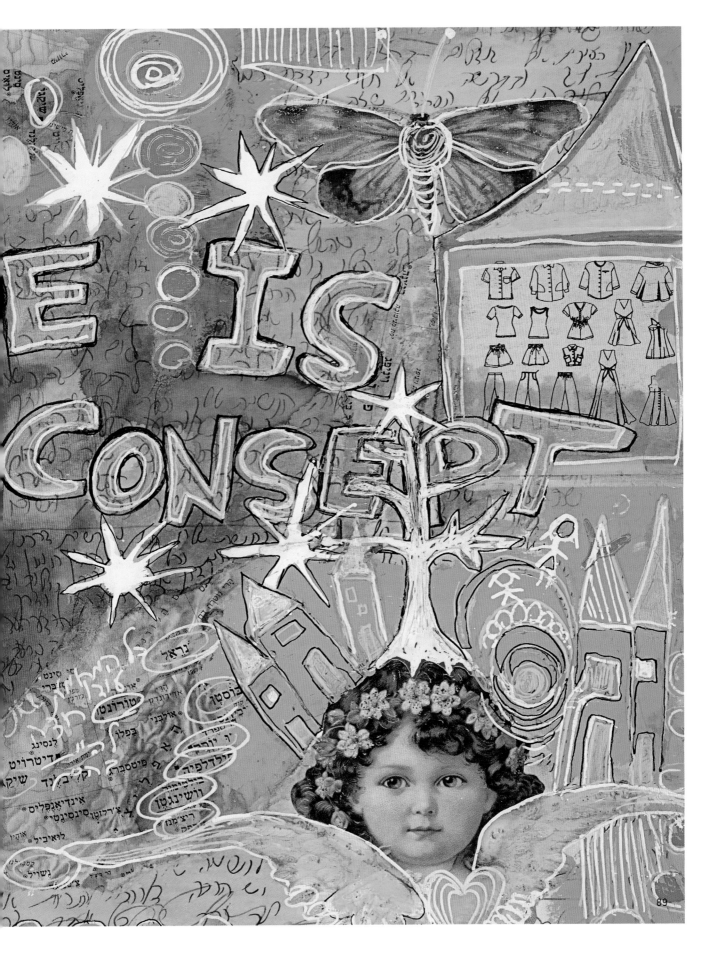

Color is probably the most significant element for me. Color dictates the atmosphere of the artwork. Different colors have a range of emotional impact on people. Colors symbolize different things in different cultures, and they have the power to create actual physical sensations.

Color combinations have a unique impact on the soul, and they create harmony or disharmony in your work.

The color element in the visual journal is key to the energies and qualities of each individual. You can "read" the pages of a journal and the energies of the person who created it by the color combinations and the way they are used, by the shape and size of the different blots and the way they are integrated. Of all the elements, color indicates the energy that emanates from a person.

One of the color metaphors for energy is the aura. There is a belief that every person has an aura that only a very few can see. The structure of the aura, its colors and their combination tell a lot about the person and the person's qualities.

Color theory – Basic concepts

Primary colors - blue, red, yellow

Black and white - additions with these five colors, you can create all the colors in the world.

Mixing primary colors creates complementary colors in the color wheel: yellow-purple, red-green, blue-orange. The color combinations are considered harmonious because they include within them all three primary colors.

Color blots

Blots of color are created by adding color in some way by some means. Any tool that we use to lay down color creates a different kind of blot: brushes, finger, or roller.

Line and color are the foundation of any kind of drawing, whether abstract or figurative.

It's important to note that abstract art, without images, also has a place in the visual journal. The elements of color and line are strong enough to convey emotions even without a clear image.

Warm colors - yellow, orange, red, pink

Cold colors - green, blue

Some colors can be both warm and cold. For example - purple is a combination of a warm color (red) and a cold color (blue), so purple can lean toward warm (more red), or toward cold (with a lot of blue).

Colors look different when they are next to other colors, and color combinations have the most impact on the eyes.

Harmony and contrast are two concepts connected to the use of color. Some colors create a soothing harmony when they are next to each other, and others create contrast.

Color symbolism

In modern culture, colors have symbolic meanings based on metaphors in language.

Red - fire, storm. It's proven that red is the first color that catches the eye, standing out from among the colors.

Blue - studies show that light blue facilitates thought and cognition. Dark blue impacts regions of the brain that are associated with order (e.g., blue uniforms).

Green - growth, renewal; we are programmed to feel good with green because it influences our brain in survival mode: food, green fields, which mean water and life. The color green calms the senses (hospital green encourages health and recuperation).

Yellow - sun, happiness, jealousy.

Every color has three attributes that determine its quality:

✳ Brightness - dark or light

✳ Intensity - transparency, strength, opaqueness, etc.

✳ Hue - each primary color has many shades

White - typically linked to snow, cleanliness, sterility (doctor's uniform) to minimalism. The eye is attracted to white and to every drop of color on white. In psychology, the color white represents absence.

Color exercises in the journal

Integrate with blots of color

Intentional blots of color connect and integrate images. One of the main techniques we use in visual journaling is the integration of images. This technique integrates images in the background by adding spots of background color onto the images and adding other spots of color from the image onto the background. In addition to being a visual technique, it also has important significance for the connection between the inner and outer self. Good integration creates spreads with harmony and depth.

Integration of continuous blots of color

Continuous spots of color that branch out from the image and extend into the background make a pattern that creates integration.

The image is a metaphor for our inner world, and the way we integrate it into the background is our ability to integrate into the world, to create connections.

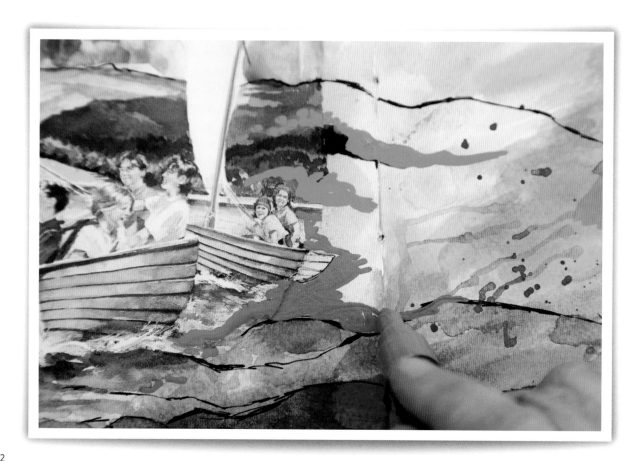

Integration with repeating spots of color

Repeating spots of color (dots, lines, etc.) create a connection between the image and the background in a way that gives a hint to the continuation of the image. In the example below, I pulled the sea into the background. The combination of continuous color spots in a repetitive pattern (white dots) is what creates the dynamics of the integration.

Creating a color contrast

Color contrast is one of the elements that affect the viewer on the emotional level. Contrast lets us send a message on what is happening in our artwork.

Deepening the background color and creating a color contrast

Deepen parts of your work by adding another, bright layer of the original color to create a contrast between the two sides of the spread. For example, I chose to darken the left side of the sea and the lower part of the land, which created an interesting contrast.

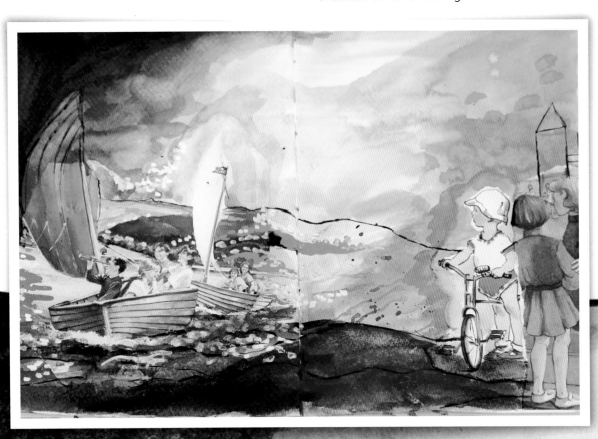

Work on a spread with an image you want to integrate into the background.

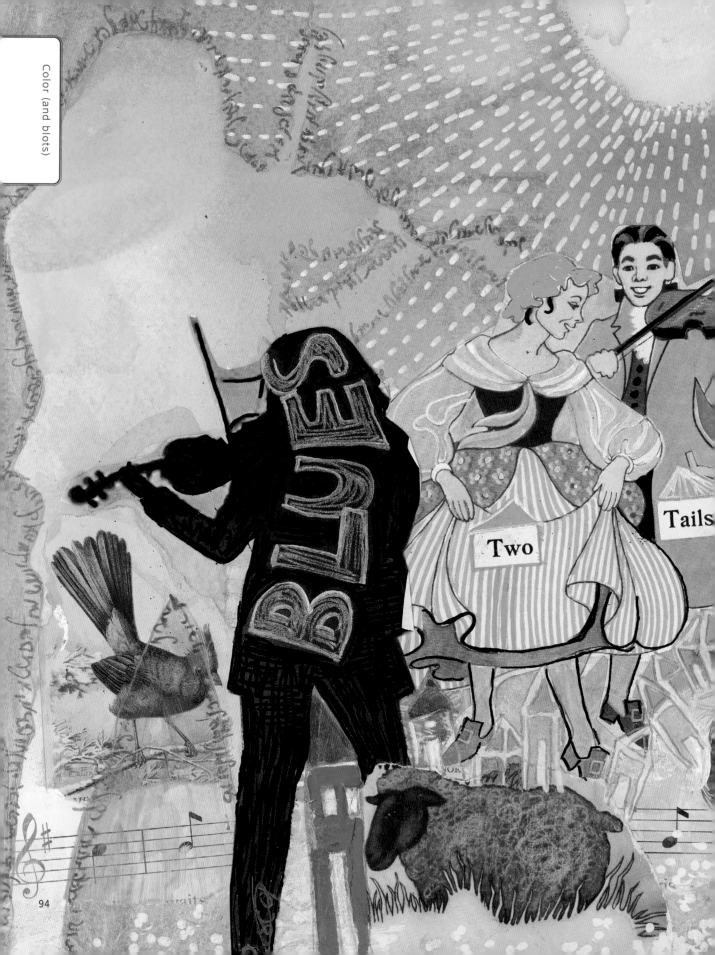

94

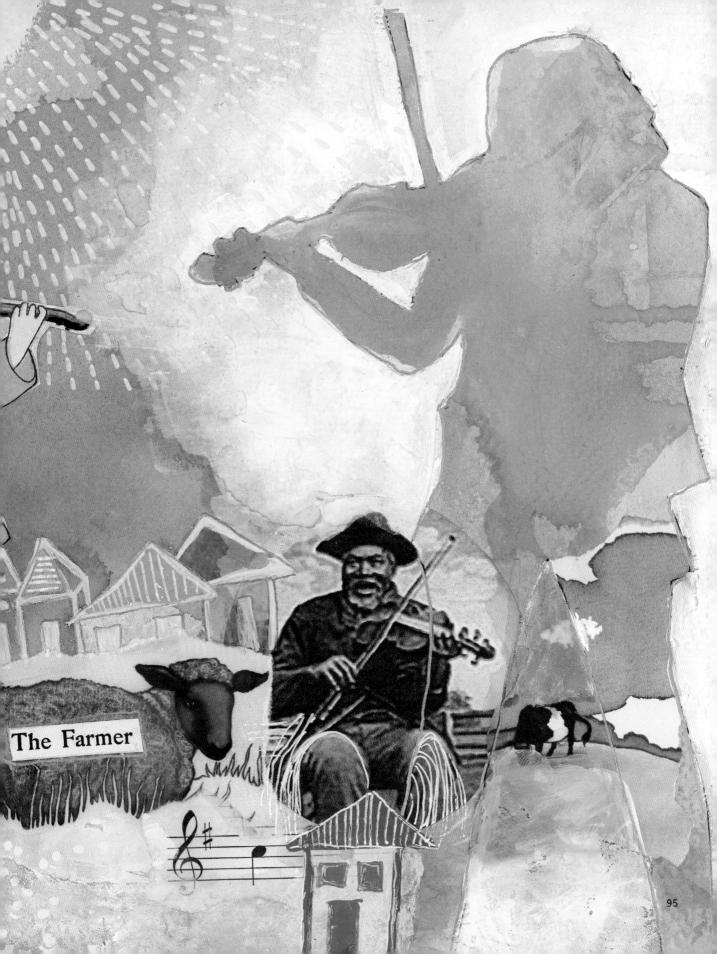

The Farmer

95

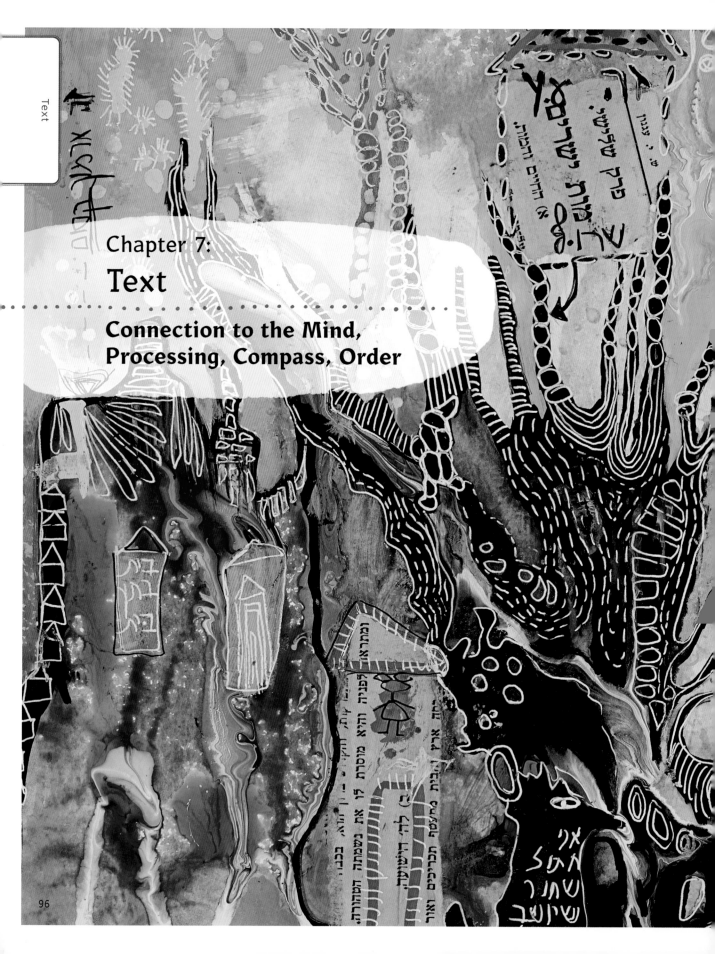

Chapter 7:
Text

Connection to the Mind, Processing, Compass, Order

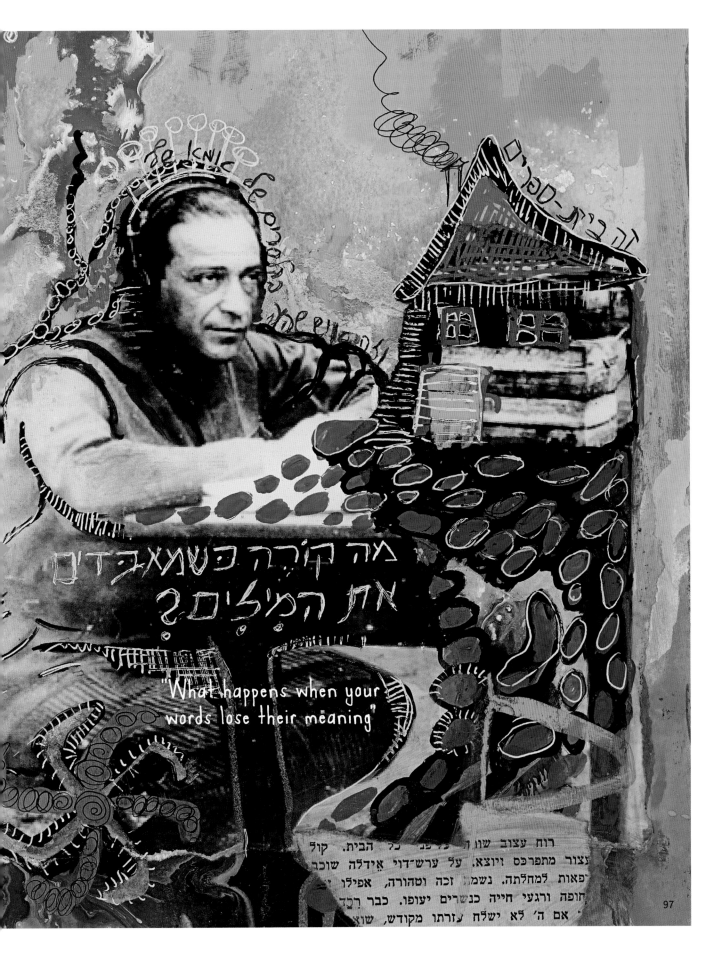

"What happens when your words lose their meaning"

Techniques - working with text

The layers of text in the visual journal play an important role to transcribe and provide meaning. When we create from a state of intuitive awareness, we are "calling" the topic that we want to tackle. At some point, we'll stop working and try to understand the theme or topic of the emerging work. When the topic becomes clear to us, we'll try to find the words that will capture it and add them to our work as another connection between the visual motifs and the meaning.

The text clarifies the element of intention and lets the spread "communicate" with others or with the artist when looking at the work later.

It's important to note that this element makes some people feel exposed, and it's hard for them to add text to their work. If so, then let it go. It's just one of the elements, and what makes journaling so special is that there is no obligation to incorporate all the elements.

The text is one of the motifs that appear in the different techniques, at different times and different layers of the journal.

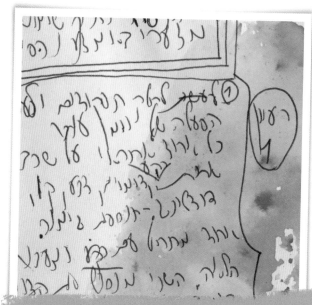

Intuitive writing as a starting point - then color the text or work with it using various techniques.

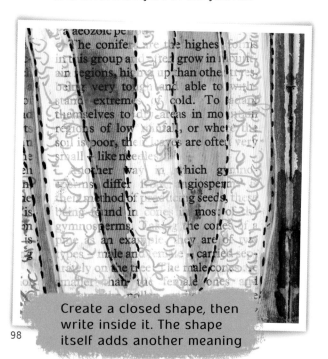

Create a closed shape, then write inside it. The shape itself adds another meaning

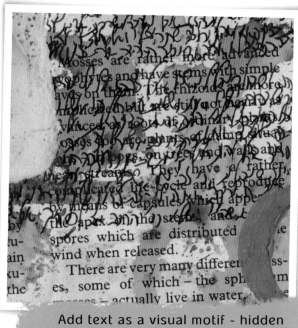

Add text as a visual motif - hidden writing in the journal (written in fancy script or in the layers).

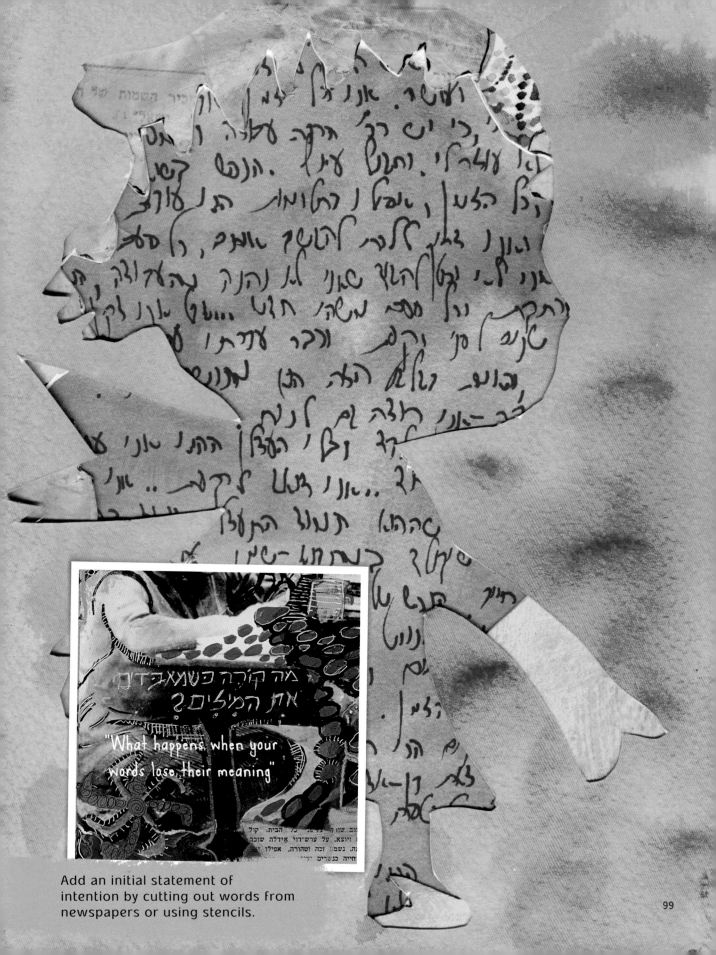

"What happens when your words lose their meaning"

Add an initial statement of intention by cutting out words from newspapers or using stencils.

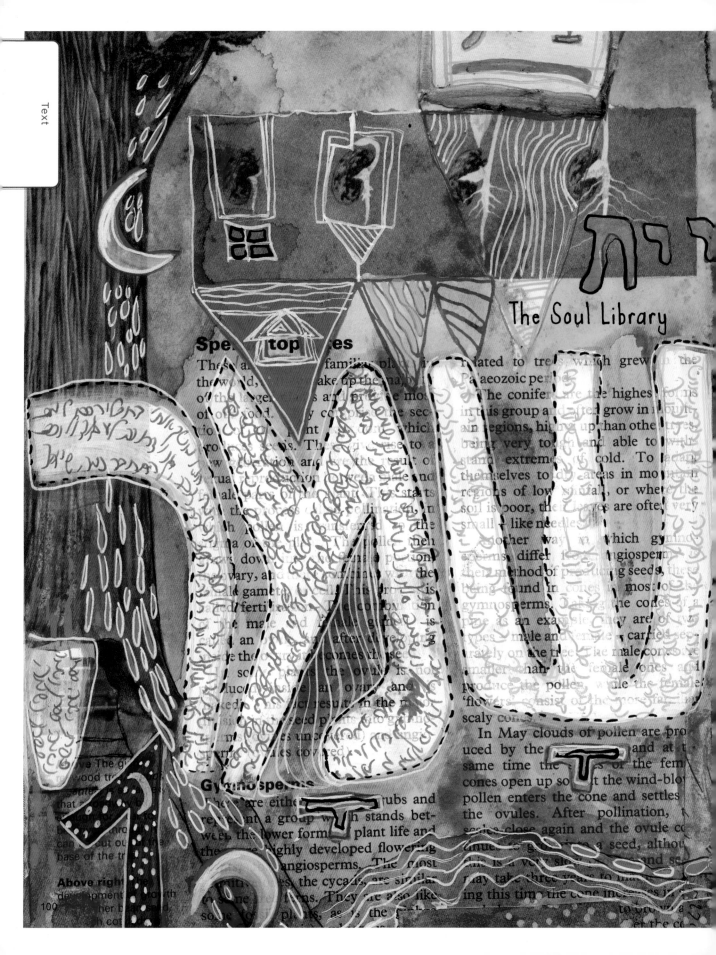

Spermatophytes

These are the familiar plants of the world, and make up the majority of the larger plants and provide most of our food. They comprise the second division of plant life, which produce seeds. These give rise to a new generation and are the result of sexual reproduction between the male and female parts of the plant. The plant starts the process of pollination, in which the pollen is transferred to the stigma or ovule. The pollen then grows down through the small portion of the ovary, and fertilises with the female gamete or cell. This process is called fertilisation. The combination of the male and female gamete is called an embryo, after developing in the ovary and becomes the seed. In some plants the ovule is not enclosed inside an ovary, and the seeds... This subdivides the seed plants into gymnosperms (seeds uncovered) or angiosperms (seeds covered).

Gymnosperms

These are either trees, shrubs and represent a group which stands between the lower forms of plant life and the more highly developed flowering angiosperms. The most primitive types, the cycads, are similar to some ferns. They are also like some conifer plants, as is the ...related to trees, which grew in the Palaeozoic period.

The conifers are the highest forms in this group and often grow in mountain regions, higher up than other trees, being very tough and able to withstand extreme of cold. To adapt themselves to dry areas in mountain regions of low rainfall, or where the soil is poor, the leaves are often very small - like needles.

Another way in which gymnosperms differ from angiosperms in their method of producing seeds, these being found in cones in most of the gymnosperms. For example the cones of a pine is an example. They are of two types - male and female - carried separately on the tree. The male cones are smaller than the female ones and produce the pollen, while the female 'flowers' consist of the more familiar scaly cones.

In May clouds of pollen are produced by the males, and at the same time the scales of the female cones open up so that the wind-blown pollen enters the cone and settles on the ovules. After pollination, the seeds close again and the ovule continues to grow into a seed, although this is a very slow process, and seeds may take three years to mature. During this time the cone increases in size to become a cone... at the co...

Above right: ...development of growth... her beans seed... ...con...

100

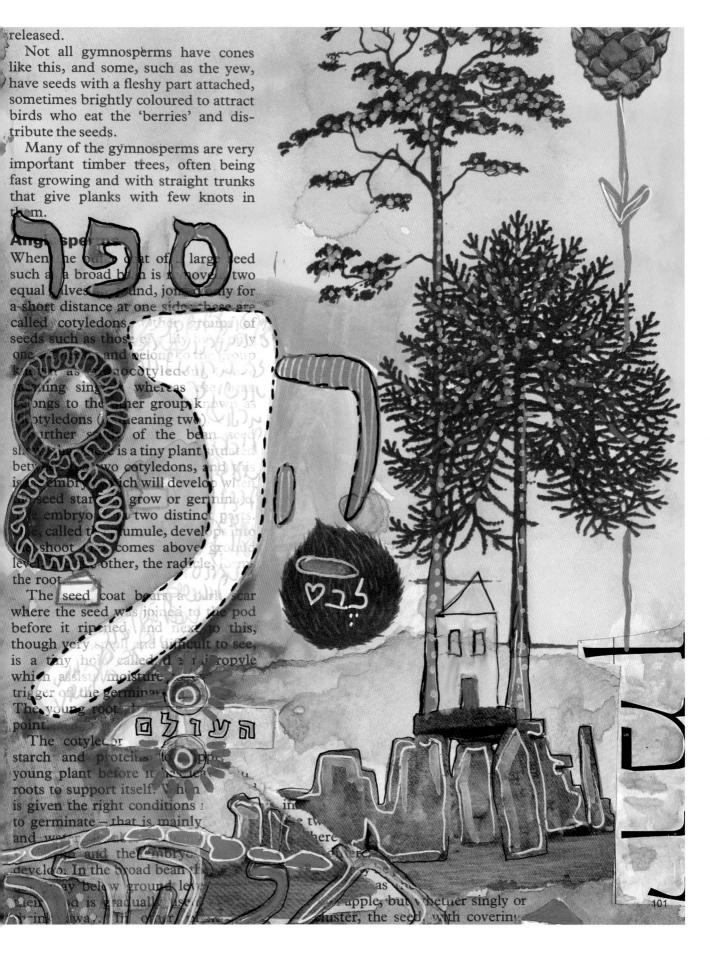

The Seven Elements - Summary

In this section, we worked on intuitive and parallel journaling on several spreads. We learned about the seven elements and created a few spreads in the journal composed of layers of different elements.

Since we worked intuitively and not in a linear, orderly process based on intention, we left a wide opening for magical coincidence. Now, it's time to look at the outcome and understand - what did we create?

Every person has a unique artistic language that connects them to their inner self.

Everyone has their own place in the world, their own individual style of dressing, behaving, and creating. One of the most significant processes that my students go through is to accept their individual "artistic language." The language of art is the unique combination of the seven elements. Some artists use mainly text, some enjoy working with black backgrounds, others need to create dense, detailed works of art, and still others feel a strong need to keep the spread "quiet" and create a tranquil composition.

It's important that you accept your individual "artistic language" and not try to compare it to others or criticize yourself. When you listen to your inner voice and work intuitively, you'll hear the true needs of your inner "dream child" - what does she need? What does she love?

It's important to give each spread of the journal time to understand what we can add so that we love what we created. Try to separate between "beautiful" and "connected." When we connect to ourselves, we feel that all our work is beautiful. Beauty is not a set of visual rules - it's an emotional quality that comes from inner connection to your work.

★ Final exercises

Look at the spreads you created; can you add another layer using one of the elements?

Add a title to every spread that you feel is finished — as if it's the name of a dream that you want to tell about. The title should be concise and explain in one sentence what you feel the work expresses in its main message.

Share your work with someone close to you and brainstorm together. What do others see in your work? Maybe they have an interesting perspective that can help you see things that you didn't see before.

For example: In the spreads I created after my mother passed away, I was drawn to the image of a big family and the feeling of having missed out, which I sensed my mother felt in having a small family. I chose to add a sentence that was a little vague to others but very meaningful to me.

"My mother had only 2 children."

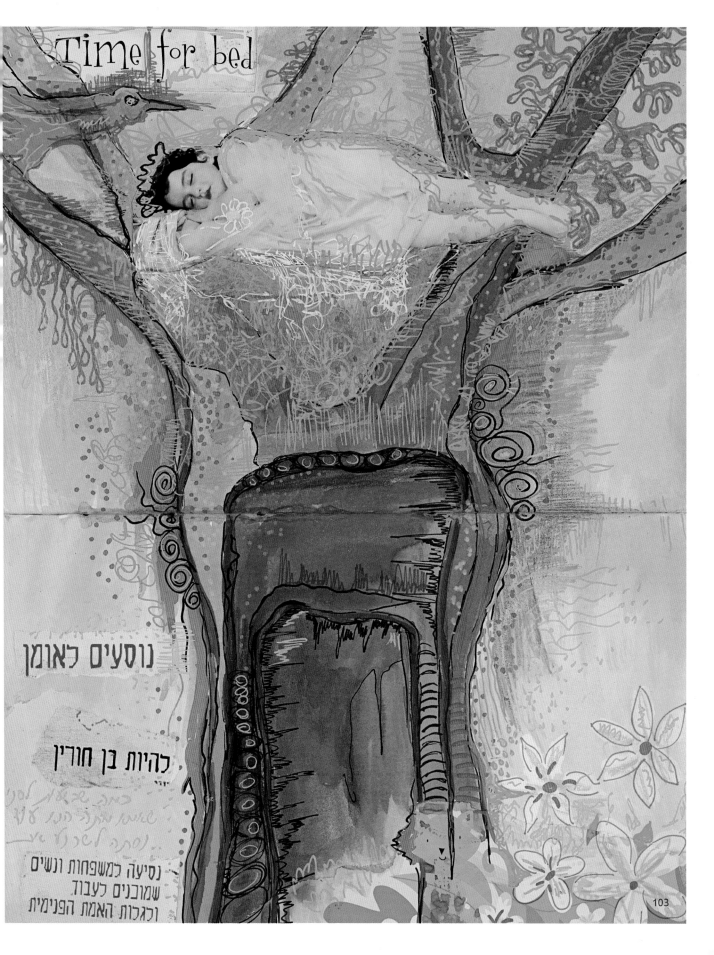

Time for bed

נוסעים לאומן

להיות בן חורין

נסיעה למשפחות ונשים
שמובנים לעבוד
ולגלות האמת הפנימית

Monet, Alice, and the eight children

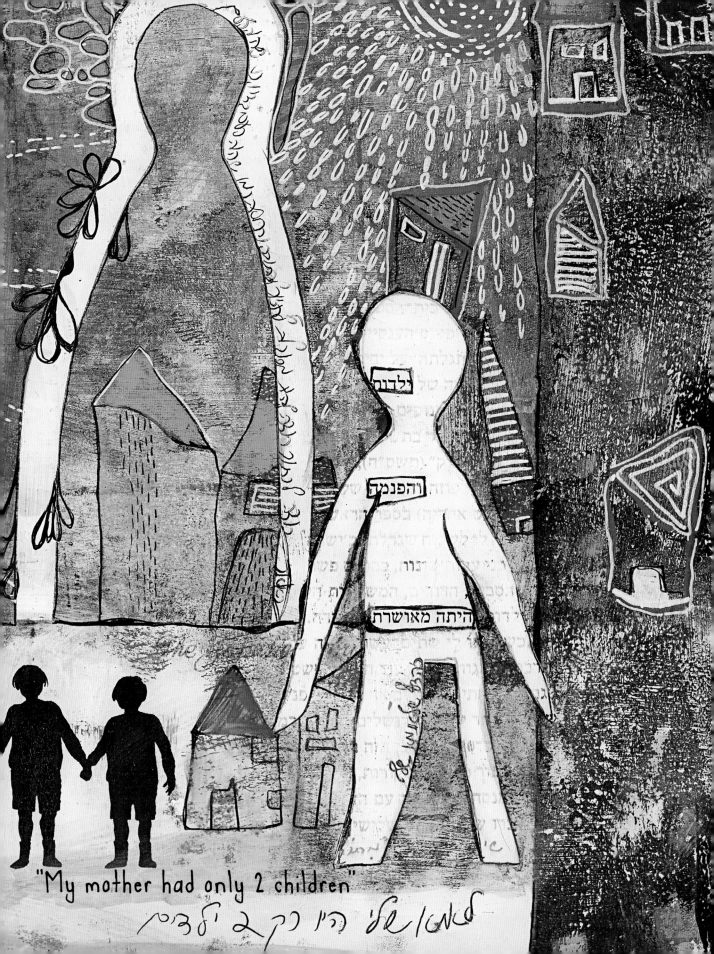

"My mother had only 2 children"

Part 2

· · · · · · · · · · · · · · · · · · · ·→

Processes of
Visual Journaling

In every spread, I use
a certain mix of elements.
You can follow the elements
with this special icon

The full artistic process of working with the seven elements

This chapter will illustrate a detailed work process, how to use all the elements to create an entire spread in the journal. The "alchemy" of an inner process and step-by-step guidance leads the artist toward creating a spread in the visual journal.

It's difficult to teach a journaling work process through written instructions and pictures. I believe that the best way to learn is in a group, where we set aside the time and have a framework in which to create. That puts us in a creative zone, a place that envelops us and lets us create through the connection to unique group energy.

This process of working with the seven elements step by step will give you a glimpse into the process that participants in a visual journaling workshop experience.

Using the seven elements is not linear; we use them synergistically; each element affects the others. Intention affects the choice of images and use of color; magical coincidence affects the way we integrate the images on the page. The elements do not stand on their own - together, they create an alchemy that leads to the artwork that has messages and meanings for us.

Intention - the language of meaning

Victor Frankl, the founder of logotherapy, believed that man searches for meaning. "In all my searches for healing, I realized that it only happens when we build our lives from the building blocks of meaning."

Many things at different times of our lives give us meaning: children, love, traveling, work, friendships, and purpose. Meaning is subjective; each person experiences it differently. Sometimes, we go through difficult events in life, and all of a sudden, our lives are drained of meaning; it's hard for us to see the light, and we experience life as devoid of happiness. We may know what will give meaning to our life, but we don't have the strength to work toward having it.

Sometimes, we simply don't know. We're searching...

Meaning can change through life, and it's important to accept the emotional changes that we go through. What once meant everything to me, today can feel meaningless and vice versa. The main question that I ask myself is - what will make me get up in the morning and feel excited?

The journal gave meaning to my life at a difficult time, and through journaling, I realized how meaningful art is to me and how it adds color to my life in more ways than one.

I developed this process to discover: What is my next path? What is my next dream? What is the next thing I should do that will grant meaning to my life and excite me?

✳ Intention - connection to meaning, a conversation with the inner dream child

You met the inner dream child at the beginning of this book. For me, that is the metaphor for my "higher self" - the part of me that knows me and my soul and has always been with me. The inner dream child speaks the language of meaning and knows what will excite me, what will give me satisfaction, what lessons I have to learn and, of course, - what is my next step.

The inner dream child knows that what is important isn't what we achieve but the path we take, and he has guided me all my life to meaningful actions, step by step.

It's not always easy to listen to him from among all the other voices buzzing within us, voices that tell us to get things done, to check them off the list, to make money, care for others, voices that tell us that we're not good enough, that we're weak, that we can't, that there isn't enough time, and more and more.

After we talk with the inner dream child, we can connect with our childhood dreams. Very often, these dreams conceal the seeds of things that will grant meaning to our lives.

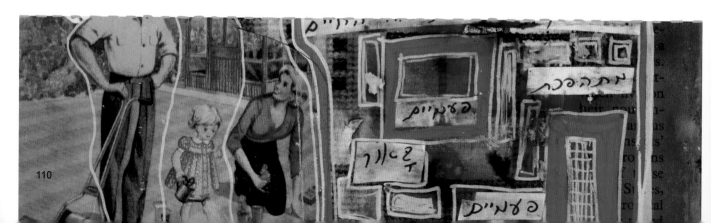

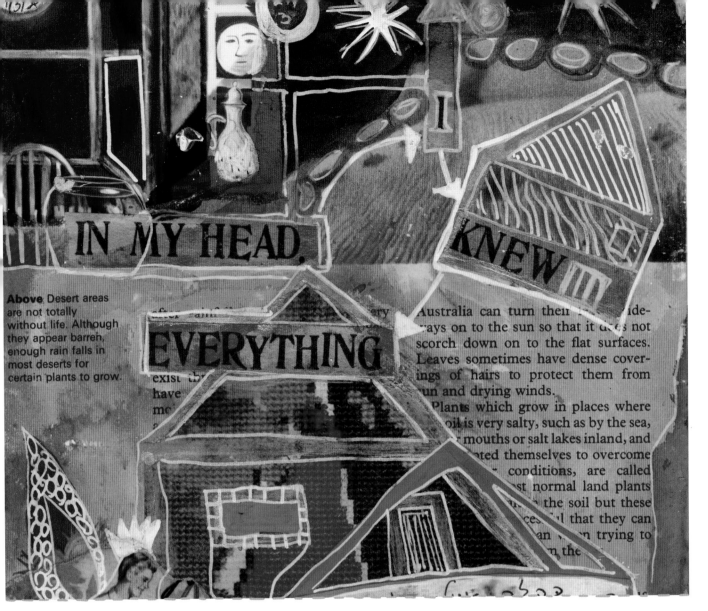

Above: Desert areas are not totally without life. Although they appear barren, enough rain falls in most deserts for certain plants to grow.

IN MY HEAD.

KNEW

EVERYTHING

Australia can turn their ... ide-rays on to the sun so that it d... not scorch down on to the flat surfaces. Leaves sometimes have dense cover-ings of hairs to protect them from ... un and drying winds.

... Plants which grow in places where ... oil is very salty, such as by the sea, ... mouths or salt lakes inland, and ... ted themselves to overcome ... conditions, are called ... st normal land plants ... the soil but these ... that they can ... trying to ... the

 ## The imagination as a frequency that lets us enter a state of channeling-drawing

Many of my students feel the gap between what they see in their mind and their ability to translate that into a visual piece of work. Some get "stuck" at the creative stage because they can't find the exact images for what they see in their imagination.

I use the imagination as a kind of "charger" for my creative frequency and to connect to higher knowledge. When I feel a link to an image and gain insights - I let myself work on my art on that frequency.

The work is intuitive; I let myself choose images that I have a gut feeling about and simply go with them. In the end, I get additional messages from my work that give me significant insights into the meaning of the journey and the first steps I need to take.

The journal is not a visual expression of what comes to the imagination. The work continues the channeling with those higher places within us that give us insights and in-depth knowledge.

I call working at this frequency - drawing-channeling.

To be in that state, we have to break free of the binding chains of aesthetics and beauty. We can't give space to the voices that limit us.

✳ Magical coincidence - writing with your non-dominant hand

Writing with your non-dominant hand lets you connect immediately with your unconscious mind and to insights that are hard to reach. In this exercise, we will write the questions with our dominant hand and immediately after, we will write the answers with our weaker hand. Studies show that continuous writing for ten minutes a day with the non-dominant hand facilitates healing and transformation. The slowness and difficulty of writing with your weak hand creates a delay of everything we know and lets us enter a meditative state.

Worth trying - no?

Let yourself enter a calm and quiet state. Even when it's difficult to use your weaker hand, continue writing and don't worry that the writing isn't legible.

In this technique, we will use writing as a kind of "background;" continue reading and then write these questions to the "dream child" and answer them with your non-dominant hand.

✳ Background - the first step in a spread

In many spreads, I use writing to stimulate creativity, and it becomes part of the spread even if I cover the writing with more layers.

The layer of text becomes the first step and part of the background. I then create more layers of background to enrich the spread.

Write the questions on a blank page and leave space for the answers:

Remember that you're asking your inner dream child, imagine him and "let" the dream child answer for you as you write with your non-dominant hand. This may be a bit confusing because you are actually having a dialog with a part of your inner self.

What were my dreams?
What dream will add meaning to my life?

Describe me as a child.

What did I love to do most?

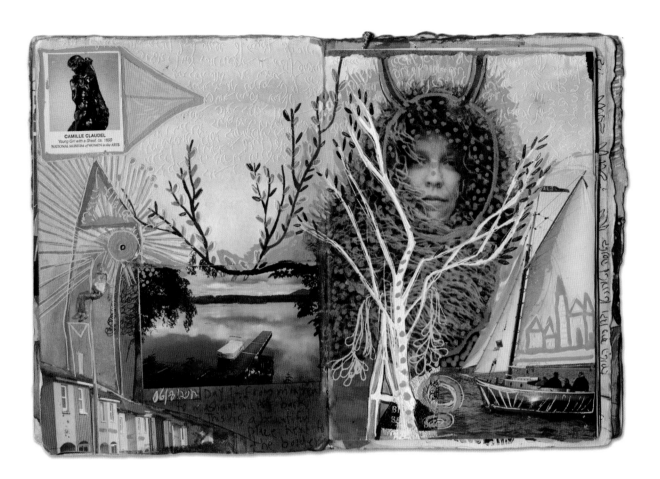

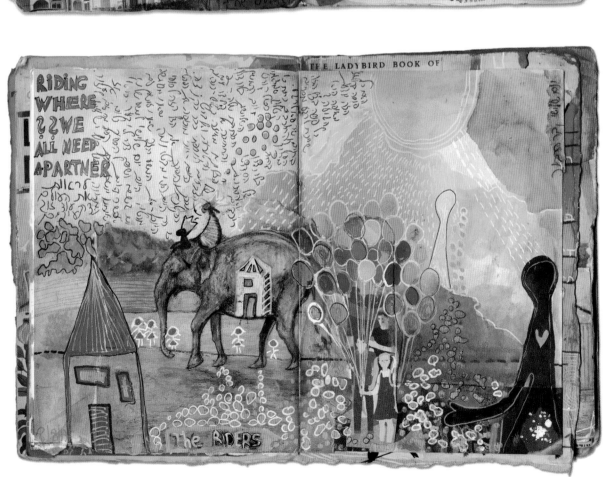

✳ Images

In this spread, we will use images from real photographs and other images to add meaning and association.

On one side of the spread, paste two-three photographs from childhood at different ages. Paste them side by side, so they look connected.

On the other side, paste a recent photograph. Make sure to leave in part of the background of the pictures, so you can integrate the photograph into the background.

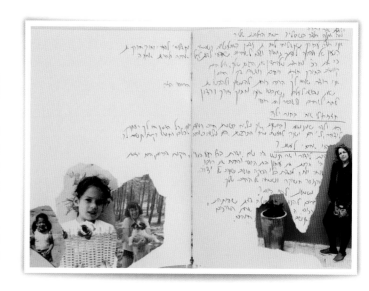

✳ Line (and more images)

Use a black Pilot pen to draw a path from the picture of you as a child to the picture of you today. Draw the path so that it creates a composition that divides the spread and creates depth.

Add more images that have associative ties to you or the topic that came up in your writing.

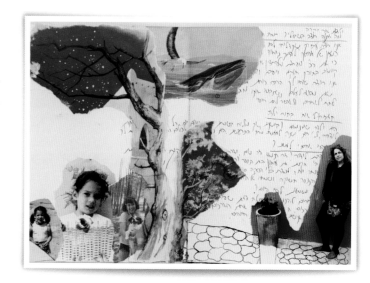

✳ Color

Use color to connect between the pictures to describe a process of change through color.

Mark a word or sentence from the first layer that relates to your dream.

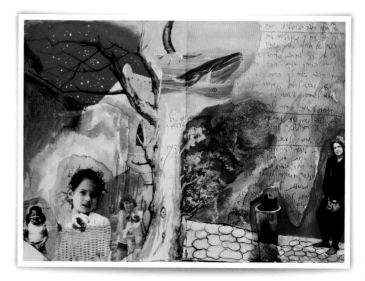

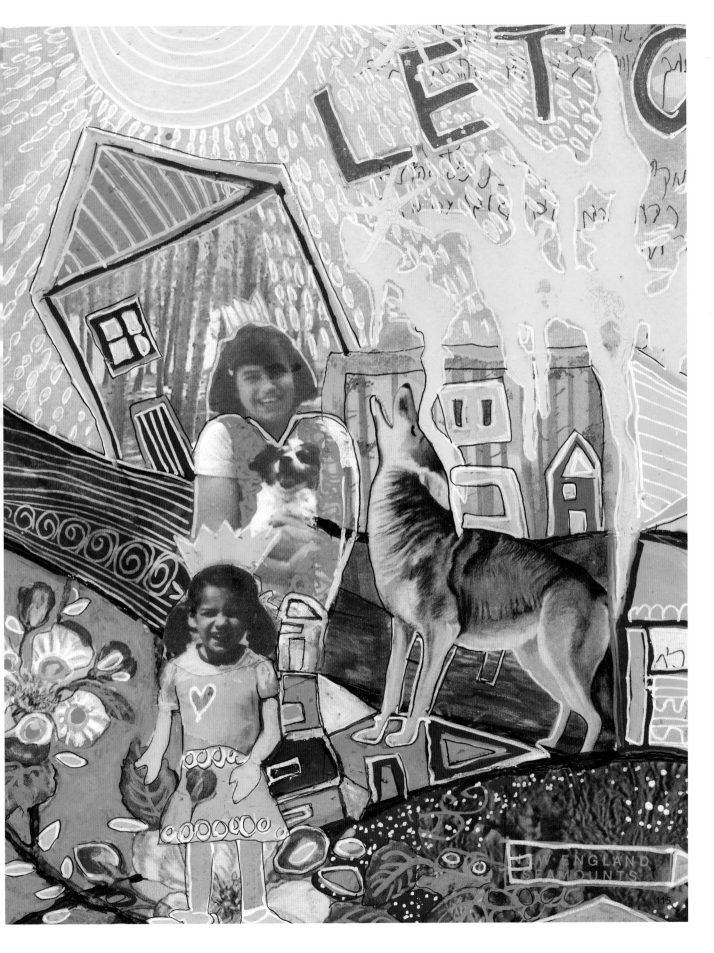

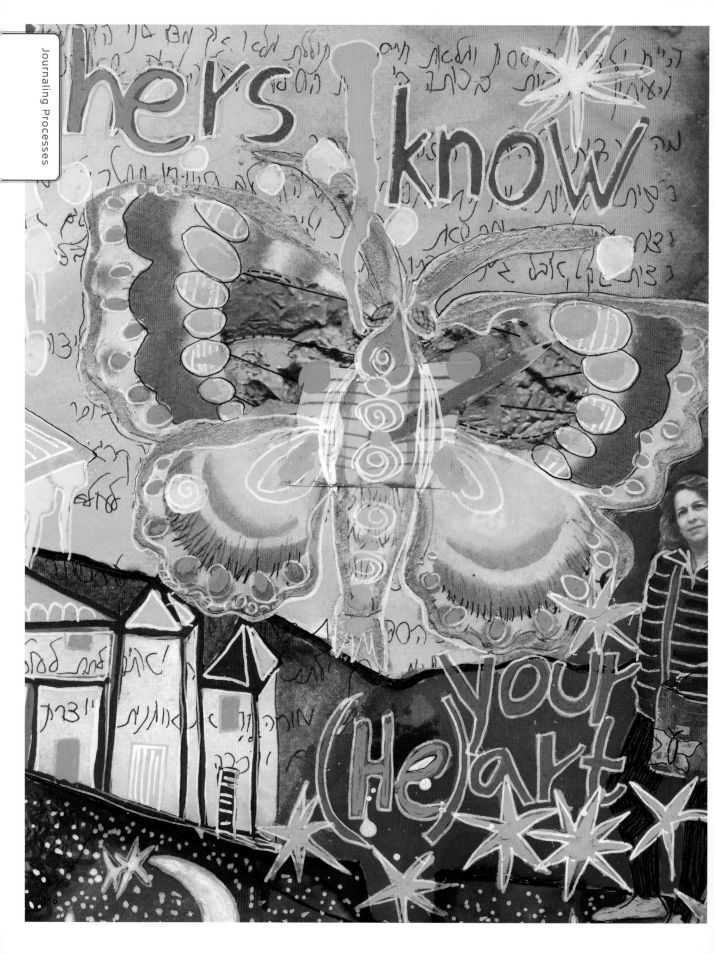

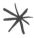

The heart of the work – connections between color and line

This is the stage in which the real work on the spread begins; creating connections between all the images by adding in all of the elements, especially line and color.

Insights can come up as you work. You can write them on the side or emphasize them.

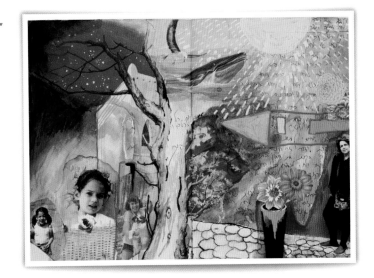

Doodling

The doodling layer is the last layer. It lets you get close to your work and pay attention to the small details. I usually use black Pilot pen, thin white Posca or metallic gel pen.

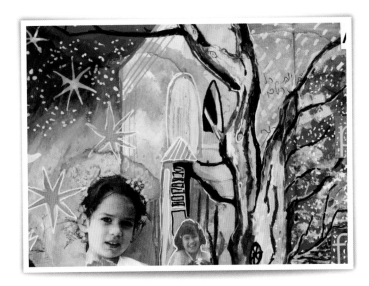

Text

From the word or sentence you marked before, create a motto or intention from which you'll continue your work. Write it in big letters somewhere else on the spread.

Additional images

Add more images that feel appropriate. Don't be afraid to overload the page and don't look for logic. If you use images from newspapers or new books, and you intend to show your work, think about copyright. I use images from old newspapers and books that I buy in flea markets or from my photographs.

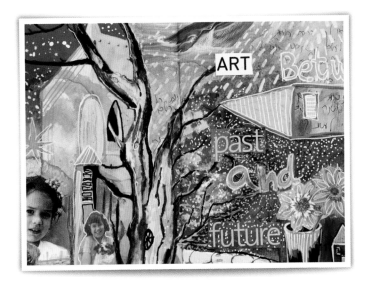

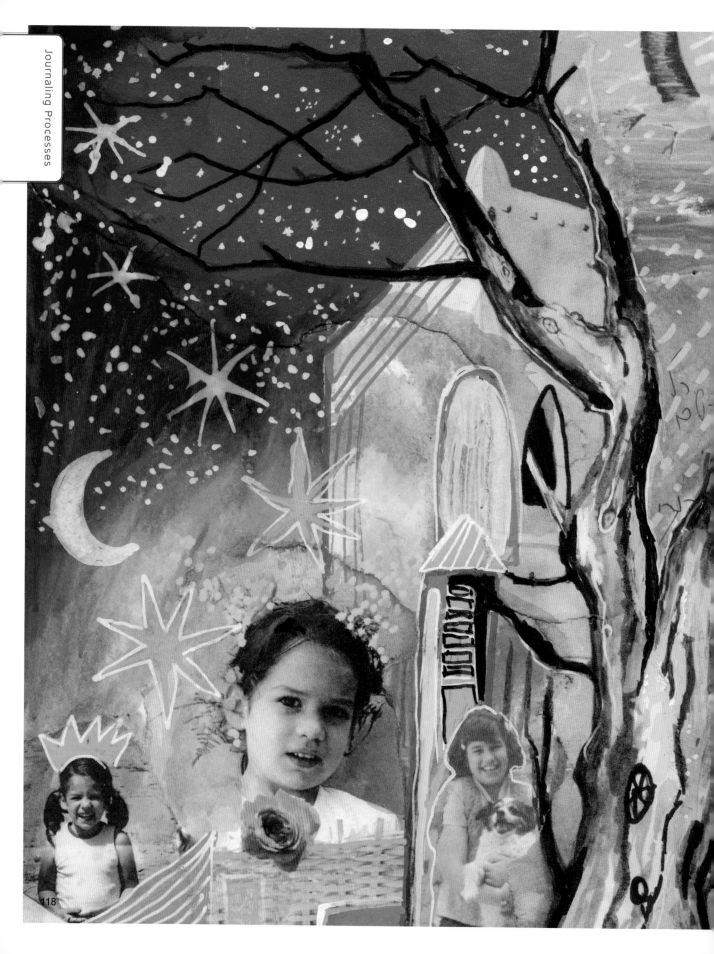

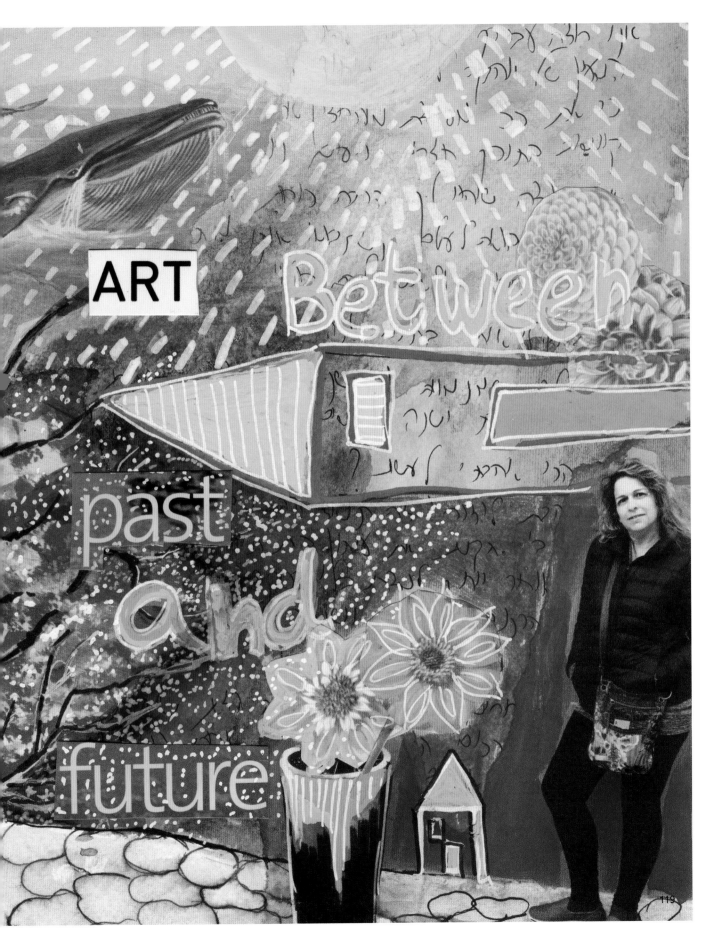

ART

Between

past and future

Creative tips

★

Connections - use line and color to connect between the parts of your work and integrate the pasted parts until you achieve harmony.

★

Emphasis - emphasize significant elements using line and color. In this work, I emphasized the child that I was and the woman that I am today facing the rest of the background.

★

Magical coincidence of color - go wild with color. Add a splash of color that you feel is missing and don't be afraid that you'll ruin your work.

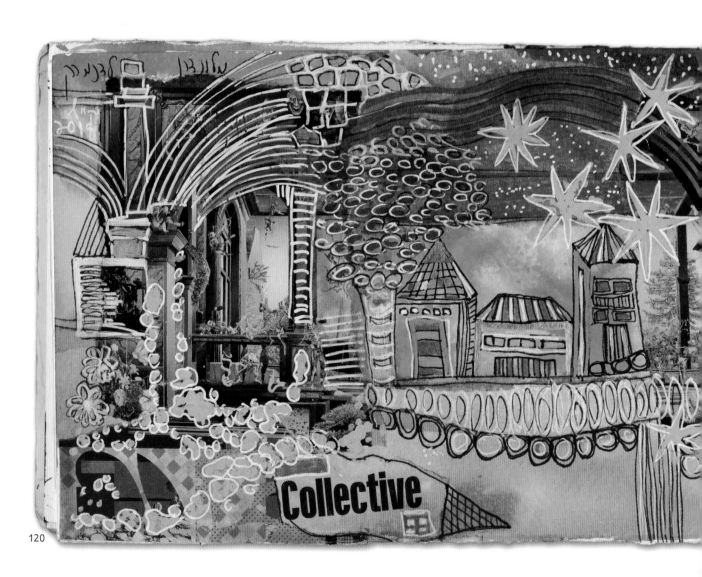

Draw on your images and make them your own -
don't hesitate to add color and line to images you've
pasted on the page. By going over parts of them and
making small changes, you're making them your own.

Letting go of parts of your work - since visual journaling
is mostly working in layers, we have to let go of some of
our work as we create it. Don't try to keep what you've
pasted in, allow yourself to let go and hide it.

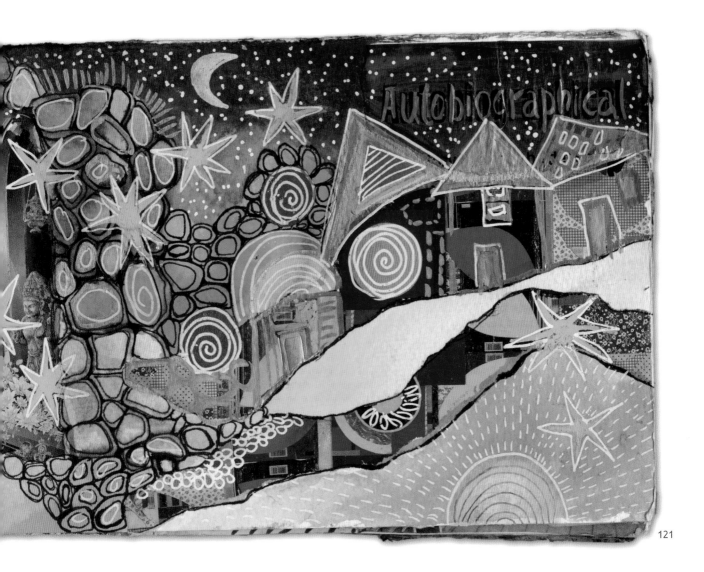

To start on the path toward meaning, I suggest another meditation in which we meet our future self. Our unconscious mind doesn't distinguish between imagination and reality. The minute we can see a dream come true, the unconscious will be convinced the future is already here and will start to act and guide us accordingly. Look ahead from one to three years; it's not a good idea to go more than three years into the future because that's too far for realizing dreams. We want to see a clear course of action that will lead us to our dream.

Meditation with my future self

Close your eyes and visualize yourself in a wonderful place, in nature. Take a deep breath and feel how each breath lets you relax and feel at one, surrounded by nature. Continue to take deep breaths for a few minutes.

See a path ahead of you with a figure at the end that's walking toward you. You stand, waiting to meet your future self. The figure comes closer, and as he comes closer, you can see that it's you; happy, glowing, and satisfied with life.

When the figure is close enough, ask these questions:

–Tell me about your life today.

– Describe the process you went through.

– How did you overcome difficulties?

– Do you have any advice to give me today?

Hug him and say goodbye.

Creating in the journal

After meditating, create what came up in your conversation in the journal. Add a recent picture of yourself in the spread.

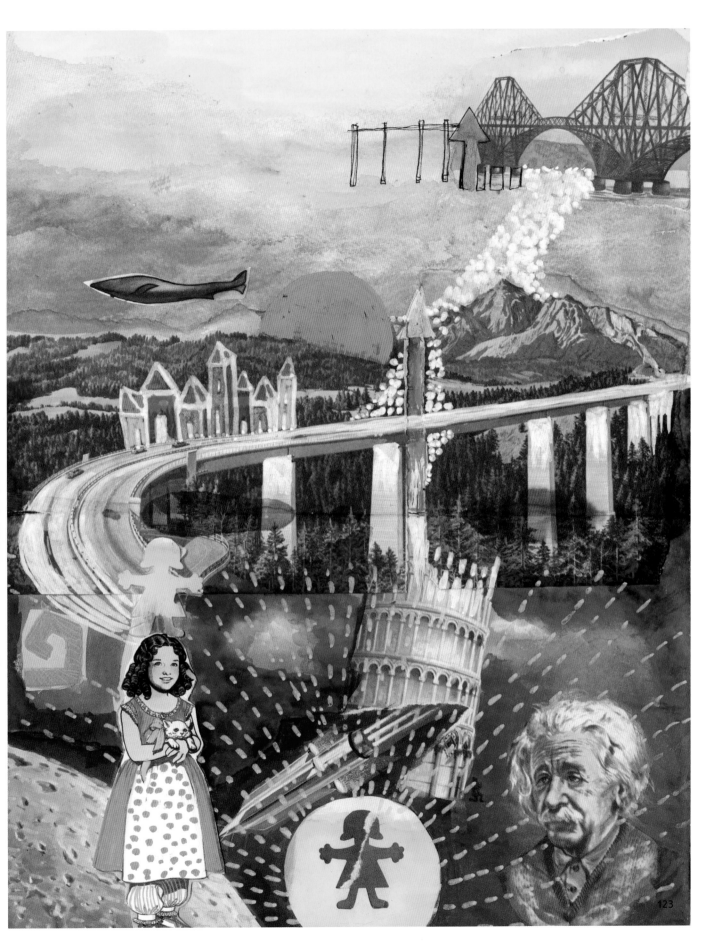

Part 3

························→

The Stories on the
Journal's Pages

The Stories on the Journal's Pages

As a little girl, I dreamed of being an artist when I grew up. I would fantasize for hours about the studio where I'd work, the solitude and quiet, the exhibits where I'd present my work. Night after night, I'd dream about the works of art I'd create.

I didn't realize my dream because every time I got close to the canvas, I'd think about the eyes that would look at it. I'd feel the need to create something beautiful and try to translate everything inside me to the outside, so that people would love and accept me and my art. It didn't work, and so I quit my art and my dream...

When I discovered journaling, I found that I could create art again.

Something about the small format, the freedom, the fact that I didn't have to create a finished product, the fact that beauty and aesthetics are not important, that it's okay to write what I feel and just try to understand what I'm going through - fascinated and drew me in.

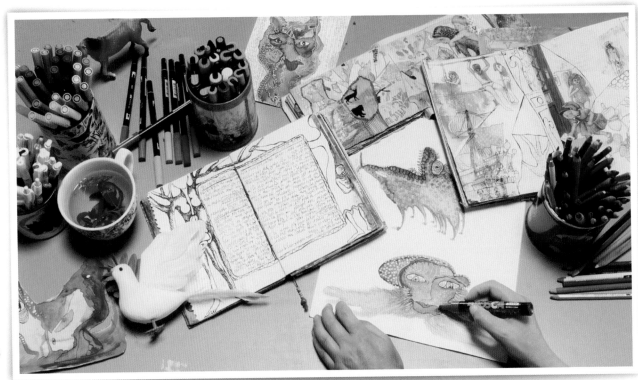

I take my journal everywhere, and so I create art without planning. I let my inner dream child take over and simply do what he wants.
I enter the state of awareness – everything is good, every mark I leave on the page is good, it's important, it's me.

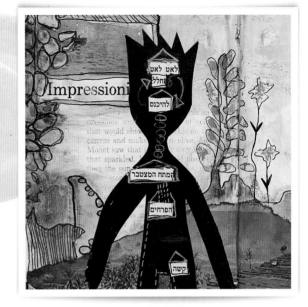

In these next seven chapters, I will describe more of the qualities of the journal, more uses that I make of the journal. I will display my artwork from the first journal until today, work that shows the development of my art. I hope that when I let the spreads in the journal tell their stories, you will be inspired and let yourself create in your journal from a feeling of freedom and passion.

At the end of each chapter, there are exercises and intentions for further journaling. And if your visual journal is already finished.... start a new one.

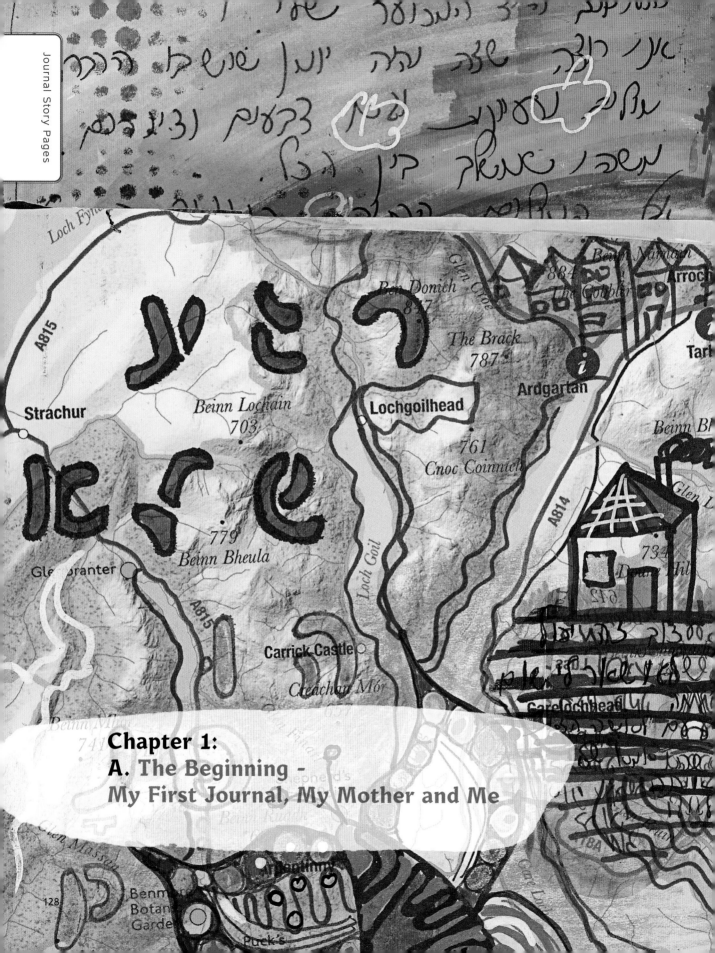

Chapter 1:
A. The Beginning -
My First Journal, My Mother and Me

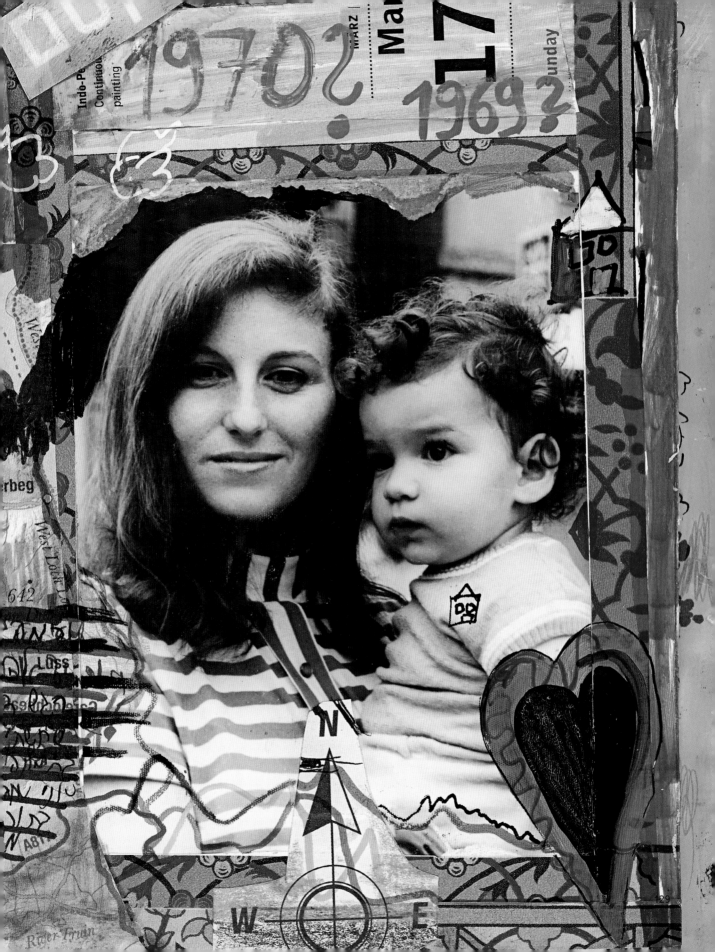

I discovered journaling two months before one of the worst periods of my life - my mother was diagnosed with terminal cancer and passed away following a few months of intense suffering. The journal accompanied me during the difficult time of her illness, and this is one of the first spreads I created in my first journal in an effort to connect with her.

My relationship with my mother was never simple. When I was 8-years-old, my parents went through a severe crisis after which my mother turned to religion, which "tore" our home apart. I left home with my father, and my sister stayed with my mother. The rift between us deepened over the years.

When my mother became ill, I felt that it was our last chance to mend fences. Something opened up inside me, and I wanted to heal our relationship.

In this spread in my first journal, I tried to find within me the love mixed with admiration that I felt toward her as a child. My mother was a beautiful woman, a young and talented poet. The change she went through as a result of turning to religion felt as if she were "kidnapped by aliens." I couldn't accept religion into my life, and so I chose to live with my father.

The symbol of a house appears in several places, and it will continue to accompany me in the years to come.

In the spread, you can see a glimpse of another spread on which I wrote my expectations and desires of the journal - "I want this to be a journal with many words and ideas, colors and drawings, something that combines everything."

The journal and its inherent possibilities became a place where I could create beauty and color from the sadness and pain that characterized that period.

During that time, I wrote a lot in the journal. The writing was significant in the transition from the written journal (that I had written all of my life) to the visual journal. Over the years, as my creative work in the visual journal developed, I felt less and less the need to add long texts, and code words were enough.

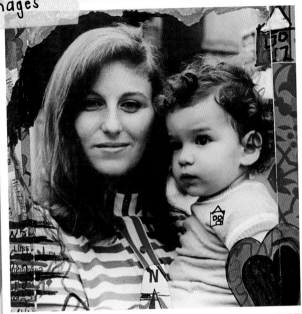

Images

★ After finishing the work

Creating in the journal, combined with the ability to admit to the rift with my mother, opened a place within me for the great love that used to be there. This work symbolized my return to being my mother's daughter, which enabled me to cope with the disease she was diagnosed with.

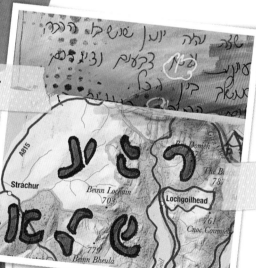

Color

Text

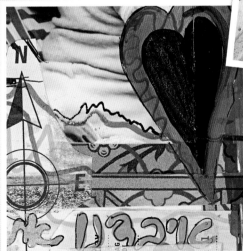

Lines

Techniques and materials
Integration of Images, background in acrylic markers, stenciled letters, collage work, lines of text, drawing on a map, different types of markers.

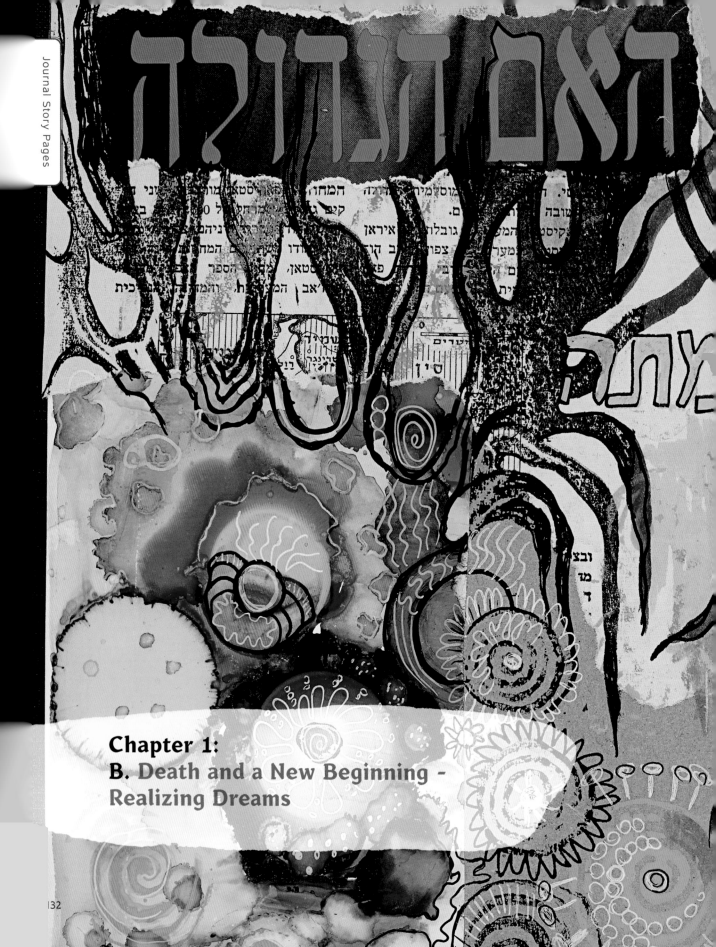

Chapter 1:
B. Death and a New Beginning -
Realizing Dreams

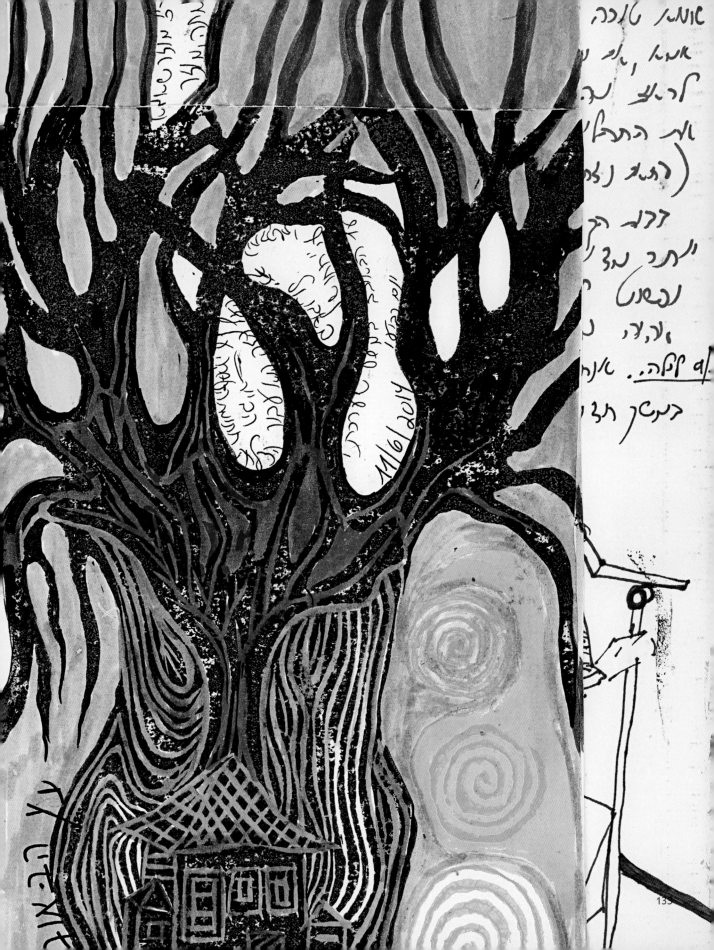

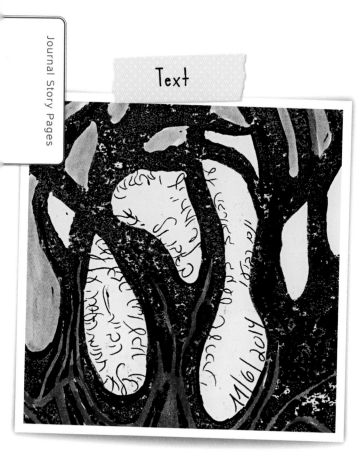

Text

Death and a new beginning - realizing dreams

My mother's suffering in the last few weeks of her life was difficult to bear. My younger sister and I took shifts by her bed at the hospice. The rest of the time, the journal was a lifesaver for me. I'd get home from the hospital and try new techniques. Trying out new materials and techniques made me feel happy.

Two months before my mother passed away, in a last effort to realize a lifelong dream, she signed a lease for a house in the country and prepared to move there. She enthusiastically told us about the big tree in the backyard and her dream to sit beneath it and write poetry.

Although it was not logical to move to the country when she was so sick, my sister and I agreed to help her. My mother hired movers. The move was planned for a few days after Passover.

Two days before the move, my mother was hospitalized and was never discharged. Her shattered dream left its mark on me and brought up all the dreams I had repressed of finding my true home, a place of inner and outer peace and tranquility.

In this spread, created one month after my mother's death, I tried to understand my dream of a home. I used new techniques, such as linoleum block printing and alcohol-based inks.

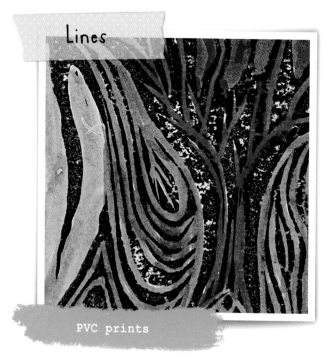

Lines

PVC prints

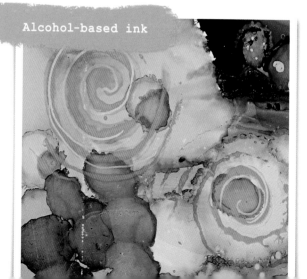

Alcohol-based ink

After finishing the work

The title of the spread - The Great Mother Has Died, expresses the grief I felt and my identification with my mother, who couldn't realize her dream. This feeling was like a powerful inner drive that pushed me to start to realize my dreams.

The great mother has died

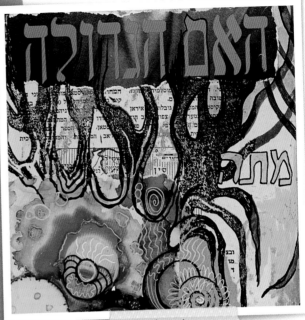

Intention

A year after I created this spread, we moved to a house we bought in Amikam, a village in the country surrounded by nature, quiet, and tranquility. I felt that the spread was the first step in realizing my dream.

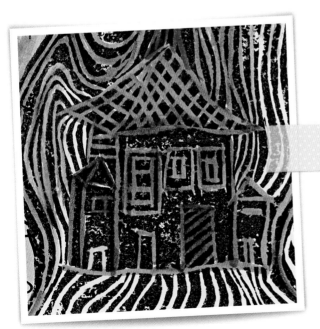

Color

Techniques and materials
Alcohol-based ink, linoleum block printing, markers, text cutouts, collage.

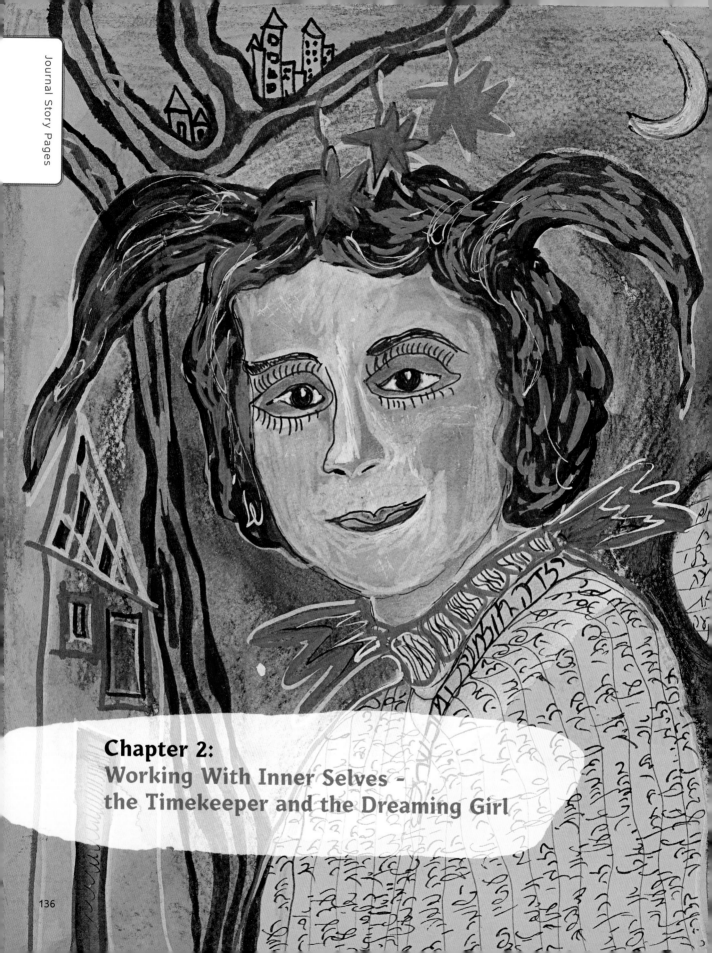

Chapter 2:
Working With Inner Selves –
the Timekeeper and the Dreaming Girl

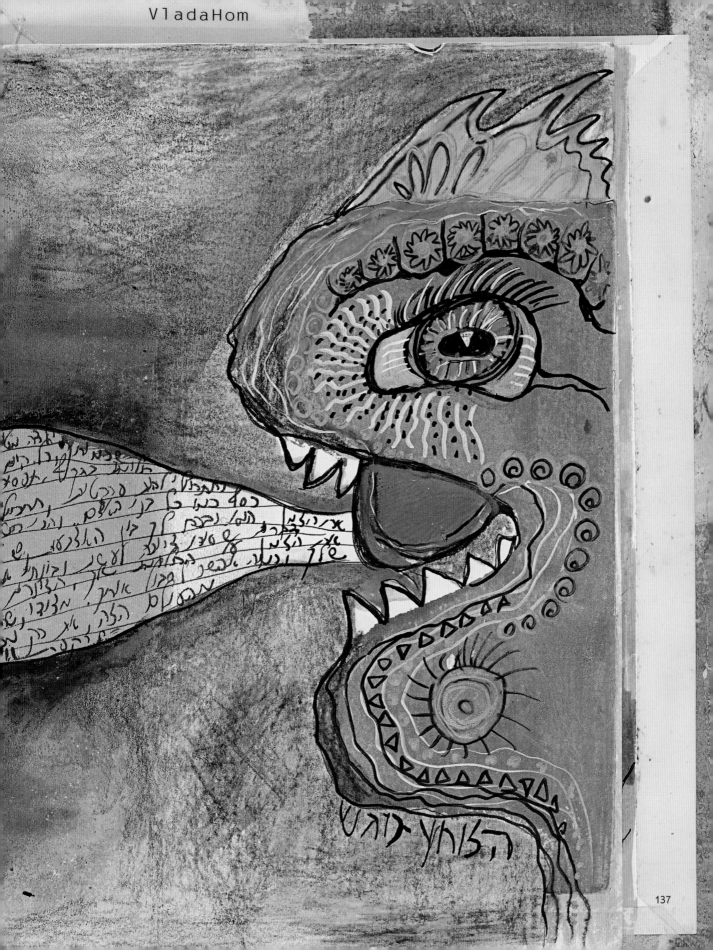

As part of the process of grief I was going through, I tried to connect with the memories and the feelings my mother had left in me, with her image within me. I started to work with the technique of "Voice Dialogue" developed by Hal & Sidra Stone. According to this technique, we have an entire population of figures (or inner selves) inside us that run our lives, and when we understand those figures and work with them, we can release some of the pain they carry.

I tried to work intuitively. I wanted the figure to "write itself," so after I pasted in a picture of my mother as a child, I continued her image on the page and created a body in which I wrote some lines of text. I called this tool a "word vessel," a place to leave for intuitive writing.

Text

"I have many ideas inside, so many dreams; if I could, I would dream from morning till night. I also love to write my ideas on little notes and save them all. Maybe, one day I'll do something with them, and maybe I won't. I left Rakefet almost 20 years ago; I've been far from her because the oppressive timekeeper won't let me get close. Now that her mother has died, I started to rebel; I'm sick of staying in the shadows. It's thanks to me that Rakefet has come up with so many ideas...."

Color

My writing revealed the image of a "talented dreaming child," a child whose existence I started to feel inside me only after my mother passed away, and I let myself reconnect with her inside me. My mother was a poet, and her dreamlike way of life often made me feel angry. In contrast, I was practical and down to earth, at the expense of the creativity that was trapped within me. The constant battle between the need to rest and wander in my thoughts and dreams, and the need to keep actively "doing" was a constant internal and painful conflict.

138

After finishing the work

This work was a significant breakthrough for me because as soon as I drew the conflict so clearly, I could accept those two parts of me with love and compassion; the practical and angry timekeeper, who looks out for me and wants me to realize my dream, and the dreaming child who, on one hand wants to rest and wander, and on the other hand is the one who gives me wonderful ideas.

I started to merge both energies, to give myself the respite I needed to recharge with ideas and also to implement them actively in workshops.

Working with the inner dream child was one of the most meaningful lessons in the first visual journaling workshop I gave six months after my mother passed away.

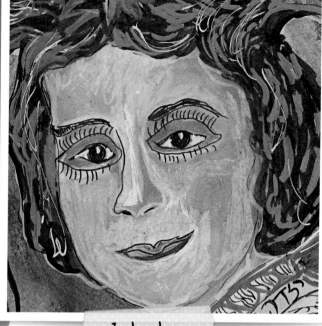

Intention

I discovered the image of the angry timekeeper on the right side of the spread. He came up out of the existing background. After I drew him as a merciless monster, I wrote his thoughts:

"Silly girl, daydreaming all day... stop dreaming and get practical... take advantage of the time; it will slip away... you have so many things left to do. As far as I'm concerned, you can disappear from this world; you're only doing Rakefet harm."

Techniques and materials
Drawing with colored pencils, metallic marker and acrylic on pictures, word vessels, doodling. Background - colored pencils.

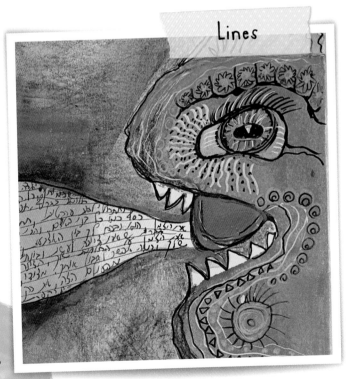

Lines

A Ladybird Senior

BRITISH BIRDS
and their nests

Chapter 3:
The Traveling Journal –
the Freedom to Wander, to Document, to Absorb

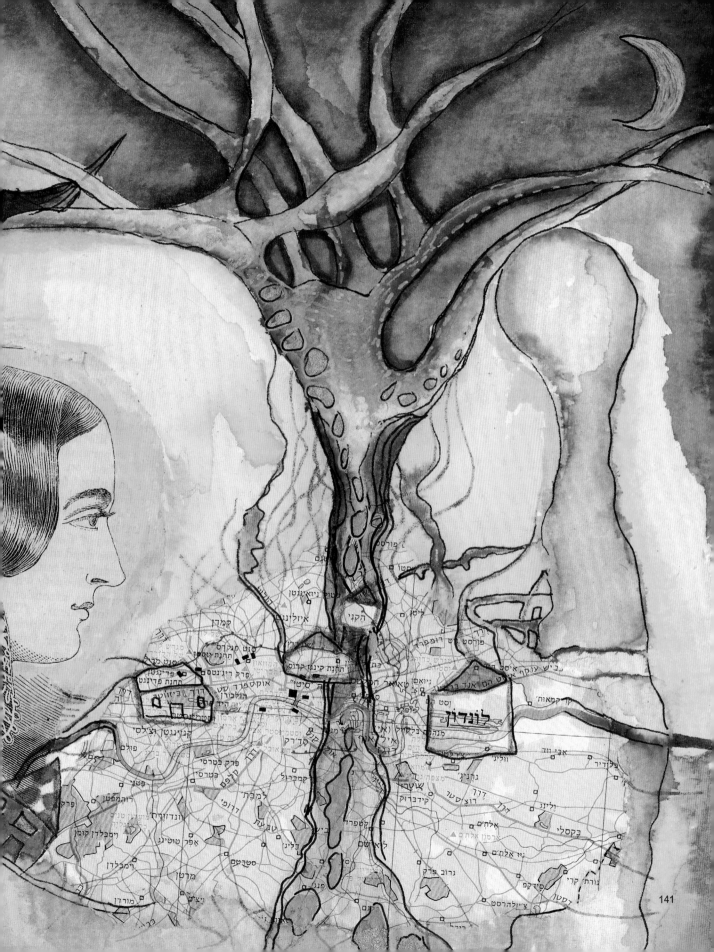

When we take the journal on our travels, we learn "through" it the most enjoyable way to have fun and create memories that stay with us forever. The journal enables us to process our vacation experiences in a way that become "engraved" within us.

In July 2014, I took the journal on a trip to the Canadian Rockies, one of the most beautiful places in the world. Every evening, I sat by the desk in the B&B we stayed in for the night, took out my pencil case with my colors and glue, and started to paste parts of brochures and magazines that I'd picked up during the day. The spread I created expressed the experiences that I went through that day, and I added insights and short texts.

Journaling while traveling doesn't enable working with many layers. It is quicker and more intuitive work, meant to let you stop and relax.

The journal and pencil case become a "traveling studio." Everything I need goes into one case, and I can stop anywhere I choose to work on it. The world becomes a wonderful place for endless inspiration, and everything I come upon can become a part of my journal.

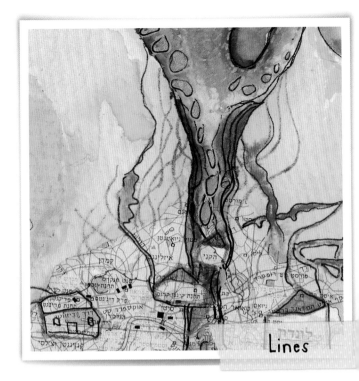

Lines

Wandering exercise – creating a daily spread of impressions

During a day of traveling, create short sketches of three to five objects or images or anything visual that left an impression on you - across an entire spread. Connect between them with lines and colors, add background and text next to each one.

When I travel, I like to enter into an internal wandering mode, allow myself to roam slowly, on foot, not looking for the classic tourist sites.

Wandering on foot enables a deeper observation of detail and simple pleasures, like a conversation with a restaurant owner, collecting driftwood on the beach, street art in narrow alleys, unique shops, a lazy cat napping on a windowsill, a vintage children's book in a secondhand bookshop and, of course, coffee and pastry in a mega bookstore.

In 2016, I started doing visual journal trips for women to different places around the world. On these trips, we focus on roaming, absorbing, and documenting in the journal.

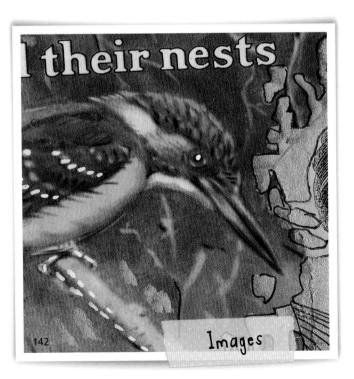

their nests

Images

★ Visual reaction to a work of art

The accessibility of the visual journal lets us "visually react" to everything we encounter on our trip, especially to works of art in museums. Reaction exercises allow us to process the impression that a work of art made on us. This reaction lets us learn from up close the language of the artist, feel it, learn from it, and react to it. In this way, we absorb works of art, remember and communicate with them and are not just passive viewers.

Images

Intention

Reaction exercise to works of art

In an art exhibit, choose one piece that makes you feel emotional; stand up close to it and try to create a "reaction" to it in your journal. The reaction is intuitive work on what the art makes you feel. Try to use the artistic language of the artist, but from that starting point, continue in your own language.

Techniques and materials

Technique of integration and connecting between collage images with colored pencils, watercolors, and markers, white gel pen, Posca and black Pilot pen.

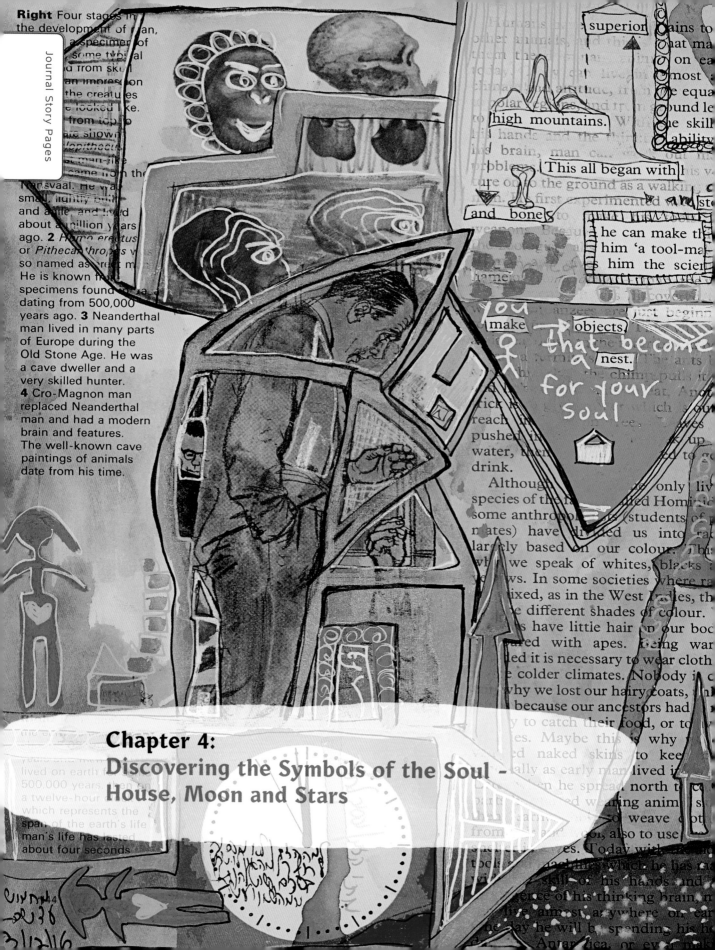

Right Four stages in the development of man, a specimen of some typical from skull an impression the creatures looked like. from top are shown *...pithecus* man-like came from the Transvaal. He was small, lightly built and agile, and lived about a million years ago. **2** *Homo erectus* or *Pithecanthropus* was so named as erect man. He is known from specimens found dating from 500,000 years ago. **3** Neanderthal man lived in many parts of Europe during the Old Stone Age. He was a cave dweller and a very skilled hunter. **4** Cro-Magnon man replaced Neanderthal man and had a modern brain and features. The well-known cave paintings of animals date from his time.

superior

high mountains.

This all began with ... ture on to the ground as a walking ... first experimented with ... and bones

he can make ... him 'a tool-ma ... him the scier

you make objects that become a nest. for your soul

Chapter 4:
Discovering the Symbols of the Soul – House, Moon and Stars

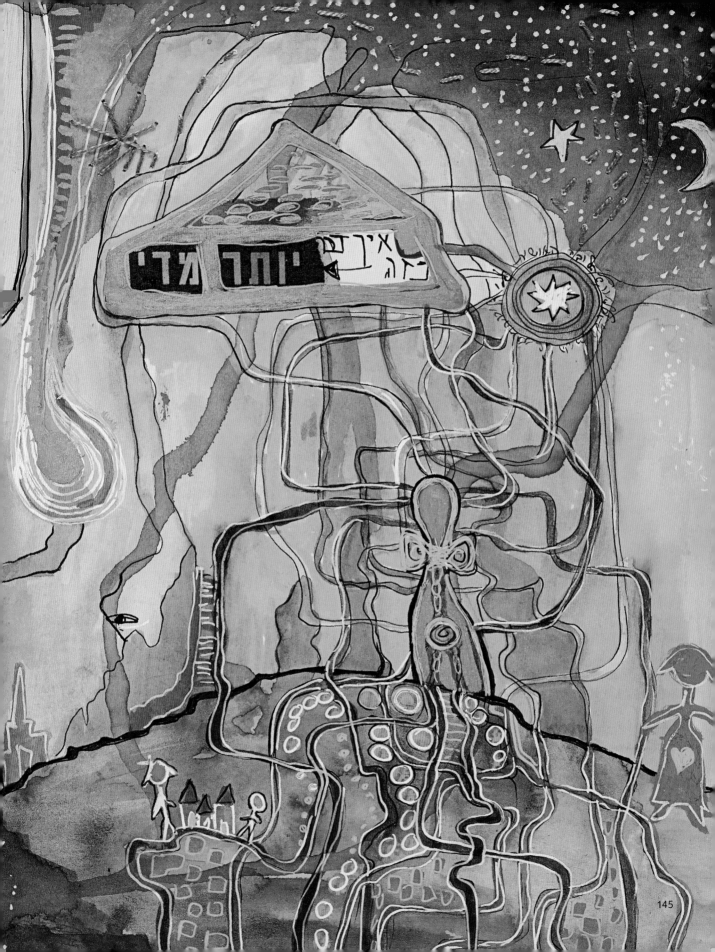

145

The symbol of a house is repeated throughout my work. The need to outline certain shapes to create a house with a roof is like a physical need for me, a need that I can't escape. Despite the repetition, I give myself over to this need and create more and more houses.

The combination of houses one next to the other gives me a feeling of closeness and order. When I create a "neighborhood of houses," I feel something inside me calms down and devotes itself to the process.

My parents were children in their twenties when they got married, both students of literature. I was born in Jerusalem, and at the age of two, moved for the first time - to Tel Aviv. From then and until today, I lived in 20(!) different houses; an average of a new house every two and a half years. The moves during my childhood stemmed from my parents' divorce, and then from moves that each one of them had to make. That led me to a continuous search for the perfect home for me; a home where I'd feel safe and peaceful; a home that I would never want to leave, that I would want to take care of.

The sense of home is a topic that I deal with often. It is the feeling of inner and outer harmony, between me and the place where I live.

Lines

My home is where I love to be and spend most of my time; my home gives me a sense of safety and peace. Home is also a commitment and dedication to stability in my life.

What does a house mean to me?

For me, a house symbolizes love and the fulfillment of dreams, a tranquil and creative life, and quiet happiness. Yet with the house comes another symbol - a symbol of wandering, which for me, is represented by the moon and stars.

The moon and stars, which we can see from anywhere in the world, symbolize the magic and mystery of the universe, open spaces, the beauty of nature, all the trips I didn't take when I was young, all the adventures I didn't experience, all the wild dreams that I never realized.

When I travel the world, I feel awake and alive; it's a different state of existence. My senses are sharper, I get impressions and feel full of energy. The moon and stars are a constant reminder that life is short, that you have to live them fully and not give up on your dreams.

In most of my work, you can find the moon and stars and houses in various compositions in the spread. Together, they symbolize the inner home and, on the other hand - adventurousness and connection to constant desire.

Color

146

What is the inner symbol/image?

Symbols are a representation in the inner world of something physical in the outer world - an event, an object, a memory, a person, idea, an emotion or experience from now, or that could be in the future.

The inner symbol is so embedded in us that we don't pay attention to its existence. Our unconscious mind thinks in pictures and symbols and gives meaning in the language of symbolism. Meanings have been given to symbols and images in our life over many years - as long as human life has been on this earth. The meanings are multi-cultural and change as culture develops and evolves.

A suggestion for artwork

Look in your "image box" (where you've gathered the pictures you've collected) and try to find your inner symbols. What has meaning for you? It could be expressed in a specific color, line, or image.

Try to express the symbol in a simple way, as if a child drew it. Don't hesitate to use universal symbols, like the sun, the moon, a tree, etc.

Symbols are the first and most natural language of the unconscious mind, so it's important to "speak" its language and understand the message that it's trying to send us.

It's not too much!

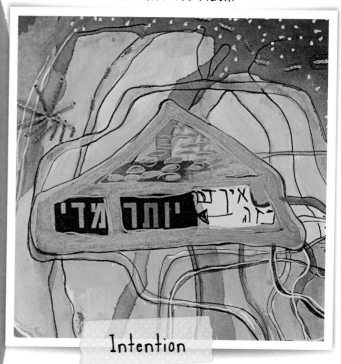

Intention

We meet our inner images throughout the day, all the time. However, we tend to see the stronger images, especially when we dream. In our dreams, we can see clear images, and we have more detailed access to them when we begin to examine our dreams.

Another way to encounter inner images is through reading. When we read, we tend to "draw" to ourselves the image of the main character, the plot, the landscapes, etc.

We all start to develop a language of symbols and images in childhood that continue to hold deep meaning for us throughout our lives.

In my work, many symbols repeat themselves - moon and stars, trees, certain shapes. However, the symbol that appears in every single one of my pieces is a house or a "neighborhood."

Techniques and materials

A spread inside an old children's encyclopedia.

Collage, markers, watercolors, gel pens, torn bits of collage from old newspapers, doodling.

147

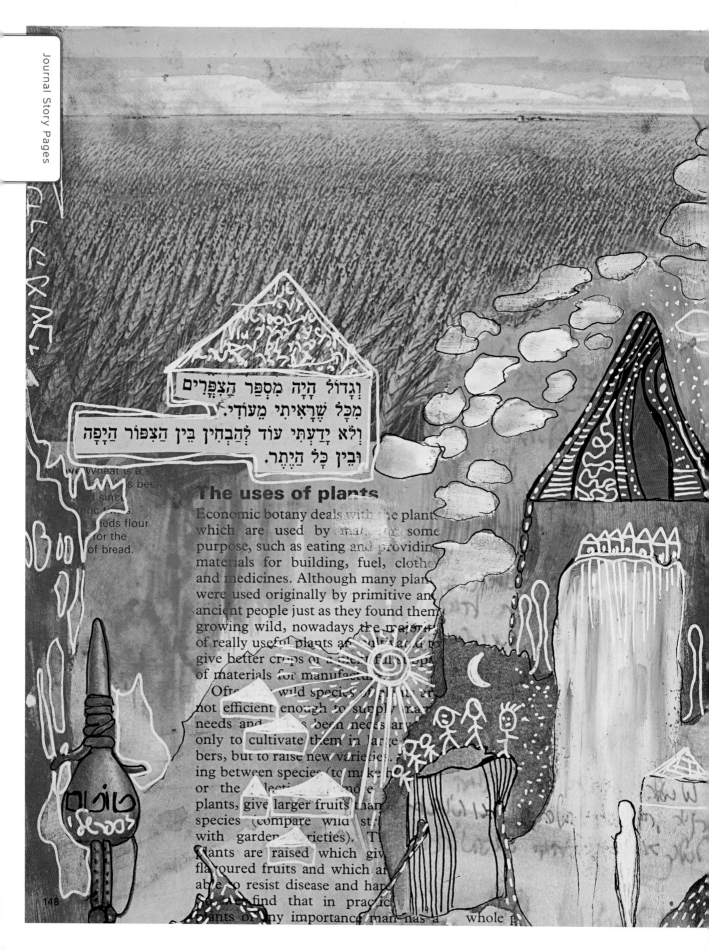

וְגָדוֹל הָיָה מִסְפַּר הַצִּפֳּרִים
מִכָּל שֶׁרָאִיתִי מֵעוֹדִי.
וְלֹא יָדַעְתִּי עוֹד לְהַבְחִין בֵּין הַצִּפּוֹר הַיָּפָה
וּבֵין כָּל הַיֶּתֶר.

The uses of plants

Economic botany deals with the plants which are used by man for some purpose, such as eating and providing materials for building, fuel, clothes and medicines. Although many plants were used originally by primitive and ancient people just as they found them growing wild, nowadays the majority of really useful plants are cultivated to give better crops or a steadier supply of materials for manufacture.

Often the wild species of plants are not efficient enough to supply man's needs and it has been necessary not only to cultivate them in large numbers, but to raise new varieties by crossing between species (to make hybrids) or the selection of more useful plants, give larger fruits than the wild species (compare wild strawberries with garden varieties). Then plants are raised which give better-flavoured fruits and which are better able to resist disease and harsh climates. So we find that in practice the plants of any importance man has as a whole p...

wheat is a ... has been ... and since ... me times. ... eeds flour ... for the ... of bread.

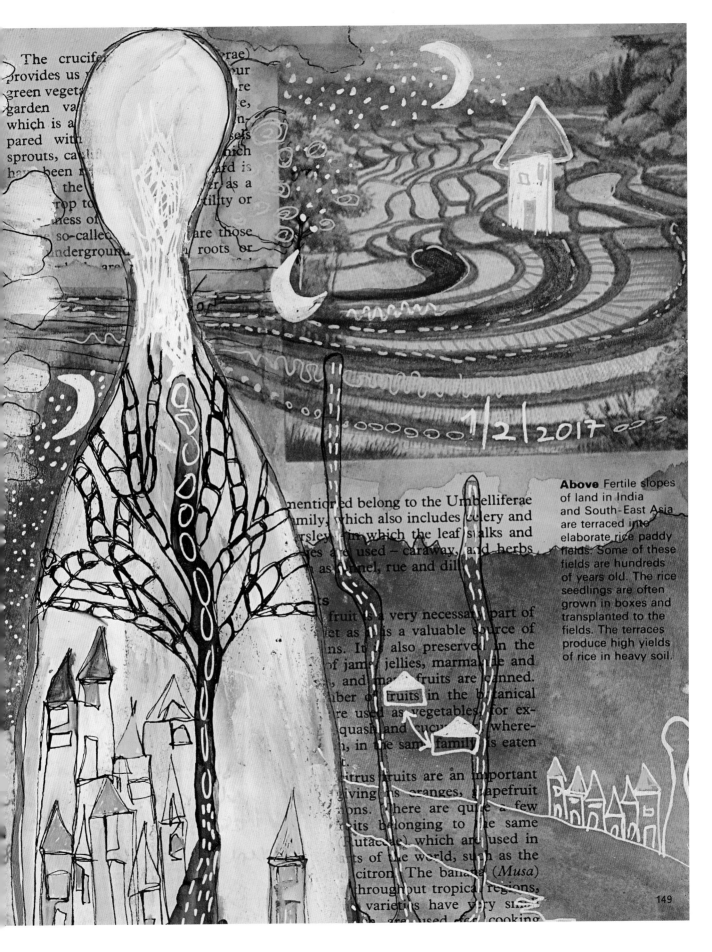

The crucifer... (...iferae)
provides usur
green veget... ...re
garden va... ...ce,
which is a... ...n-
pared withels
sprouts, ca... ...hich
have beenrd is
theer as a
...rop totility or
...ness of
...so-calledare those
...nderground ... roots or

...mentio...ed belong to the Umbelliferae
...mily, which also includes celery and
...rsley...in which the leaf stalks and
...es are used – caraway, and herbs
...as...nnel, rue and dill.

...s
...fruit is a very necessary part of
...et as it is a valuable source of
...ns. It is also preserved in the
...of jam, jellies, marmalade and
..., and many fruits are canned.
...ber of fruits in the botanical
...re used as vegetables, for ex-
...squash and cucumber, where-
...n, in the same family, is eaten
...t.

...itrus fruits are an important
...giving us oranges, grapefruit
...ons. There are quite a few
...its belonging to the same
...Rutaceae) which are used in
...ts of the world, such as the
...citron. The banana (Musa)
...throughout tropical regions,
...varieties have very sim...
...h are used for cooking

Above Fertile slopes
of land in India
and South-East Asia
are terraced into
elaborate rice paddy
fields. Some of these
fields are hundreds
of years old. The rice
seedlings are often
grown in boxes and
transplanted to the
fields. The terraces
produce high yields
of rice in heavy soil.

149

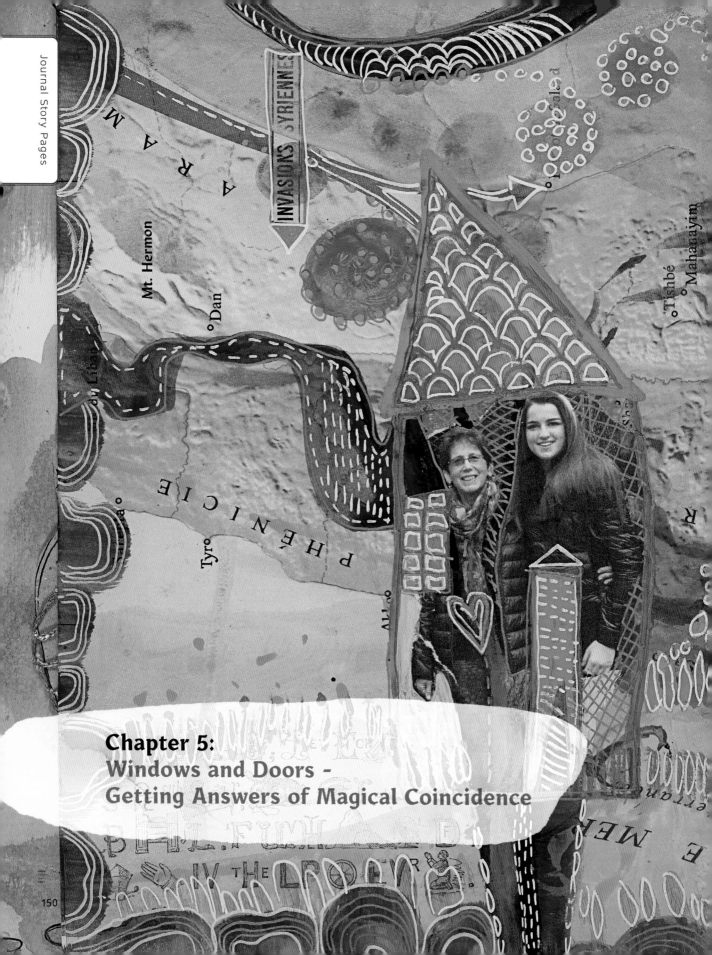

Chapter 5:
Windows and Doors –
Getting Answers of Magical Coincidence

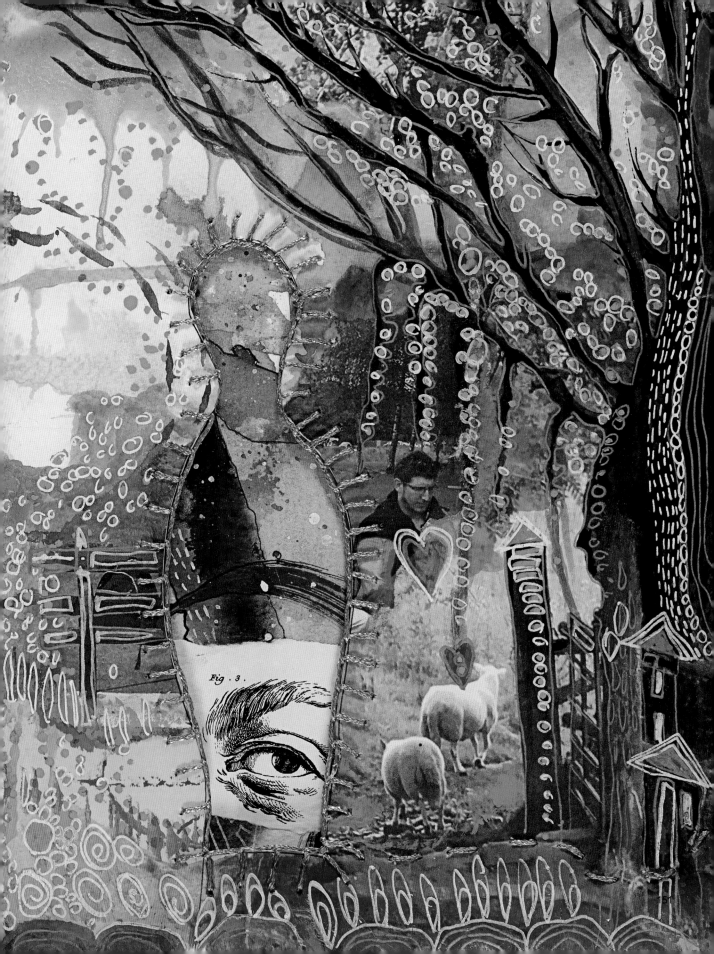

Fig . 3 .

When we work in parallel on several spreads in a journal, we let the magic of coincidence happen. When we are not limited by the need to finish a spread, we enter a playful space that connects us to passion and emotions.

Opening windows and doors lets us peek from one page of the journal to another, gaining significant insights that weren't in the original piece but perhaps in the previous one, or in the next one that you will create.

In this way, the spreads in the journal are not standalone; they are tied to other work you've done in the journal. Together, they constitute one meaningful work that you can see and understand in different ways.

There are three types of openings that you can create between spreads:

Door - a reversible opening that you can open and close for a dual perspective of the spread.

Window - a one-way opening, where you can see the spread behind it all the time. You can embellish the window to emphasize it.

Screen - an addition to the spread that can be lifted and lowered, enabling a different view of the spread.

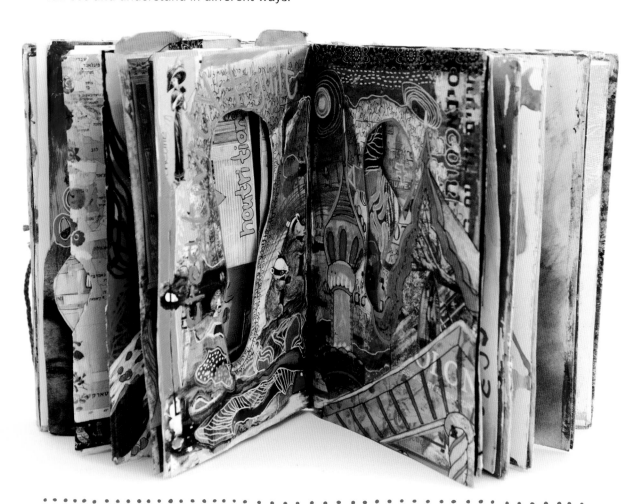

A hand-bound journal, with cutouts to other pages on each page (or folding screens), creating new meanings when rifling through it.

When a closed heart wants to open up - me and my two mothers

When I was 31-years-old, my first book came out, "Mommy Went Into the Closet," in which I used an imaginary story of metaphors to heal the pain inside me over the most significant figure in my life - my mother. As I've already mentioned, my mother became religious when I was entering my teenage years, and I couldn't or didn't want to follow her into her new world, which felt cold and foreign to me. I chose to live with my father and his girlfriend, who later became his second wife. My father's wife and I have had a complex and confusing relationship. Over the years, she answered to changing titles: stepmother, adoptive mother, second mother... many titles with the word mother in them, but the accompanying word undermines the essence.

My father's wife became the most significant person in my life; she gave me a family, siblings, and unconditional love. But from the pain and emptiness we both experienced after the traumatic death of my father at the age of 52, I could not adopt her as a real mother; I built a wall around my heart as I was growing up.

In these two spreads, I tried to process the need in me that came out of our relationship - to open my heart toward a person who means so much to me, to forgive the painful words and let the relationship flow.

I opened a window in the shape of a figure that revealed two eyes, expressing a profound and penetrating look into the relationship.

In the second spread, the window revealed only the image of my stepmother, and she connected with the large heart-shaped window that opened on the right. The message that I got from this work was that I had to open my heart to her. That enabled me to connect with her through feelings of love, caring and forgiveness, not from anger and settling of scores.

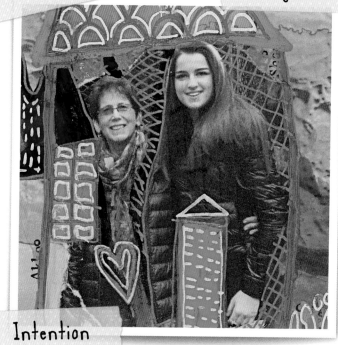

Lines

Images

Intention

Techniques and materials
Intuitive writing, watercolors, black ink, gold-threaded stitching, doodling, torn pieces collage, gel pen, Posca acrylic markers.

Art exercise
I use windows and doors when I'm working on an inner conflict that I want to resolve. I start with a question about the conflict, and then I look for images that I feel are related to the topic of my work. I look for an intuitive connection to the images, not a direct, deliberate connection. I start with the question and then choose images that I have a gut feeling about. Then, when I finish my work, I'll understand why I chose these specific images.

Write your question or conflict on one spread in big letters.

Create an intuitive background.

Paste as many images as you want on each spread and work on the two spreads guided by your intuition.

Open one window and one door between the two spreads; try not to think too much. Paste the window cutout somewhere else in the journal.

Look at the openings and try to understand - did you get a specific message from the place you opened up?

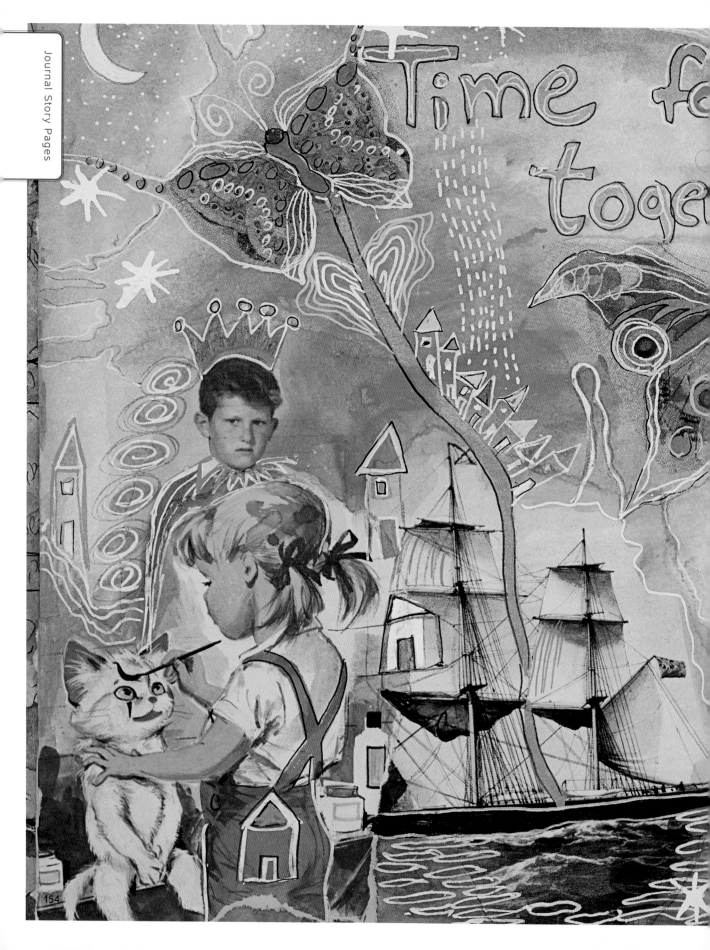

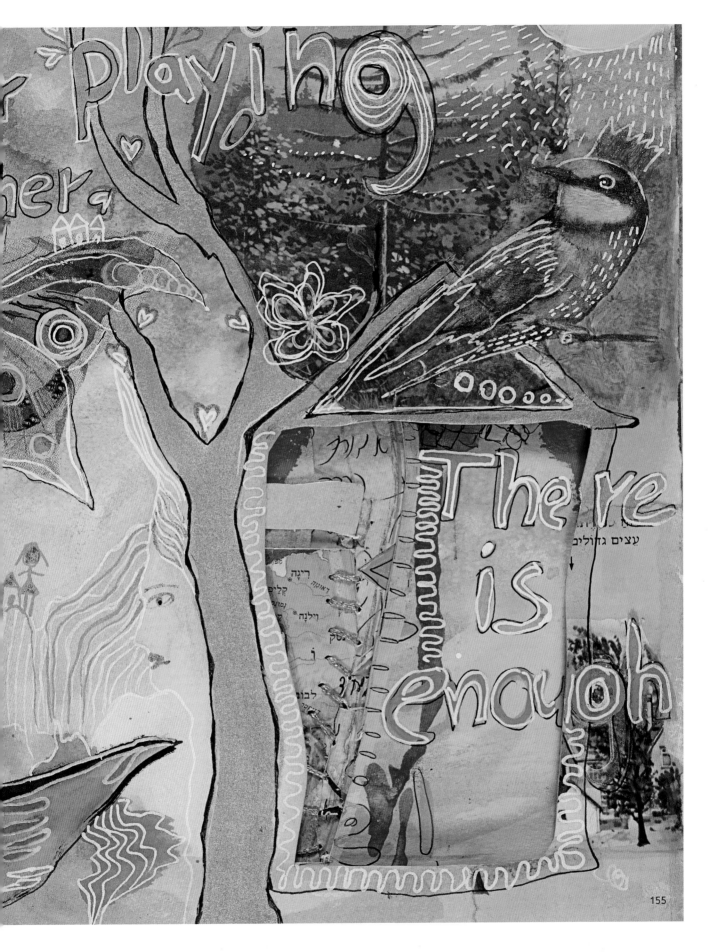

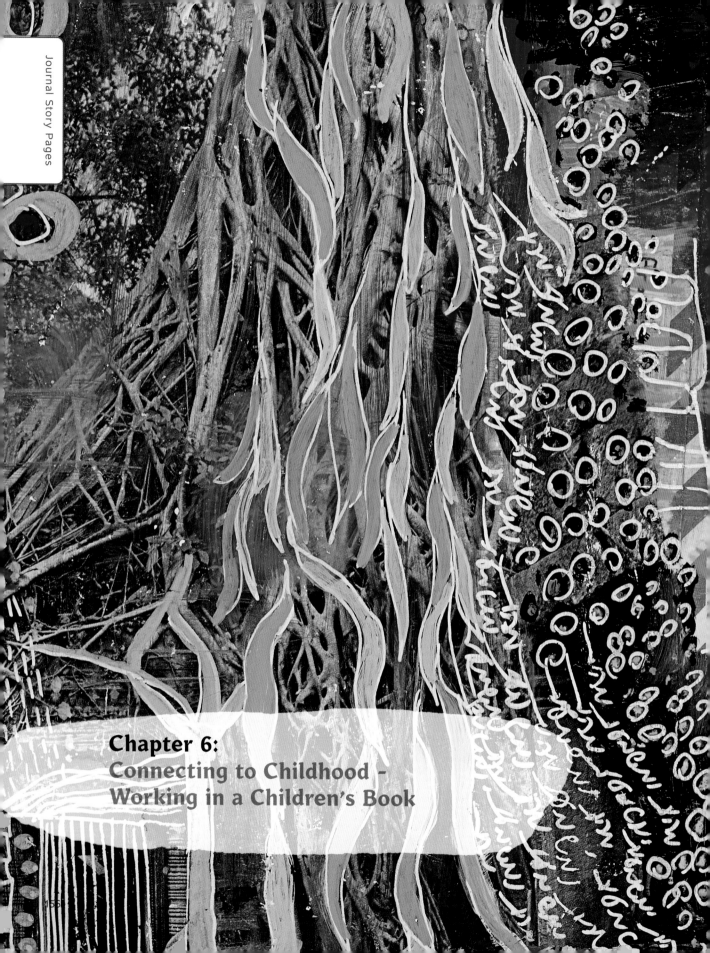

Chapter 6:
Connecting to Childhood –
Working in a Children's Book

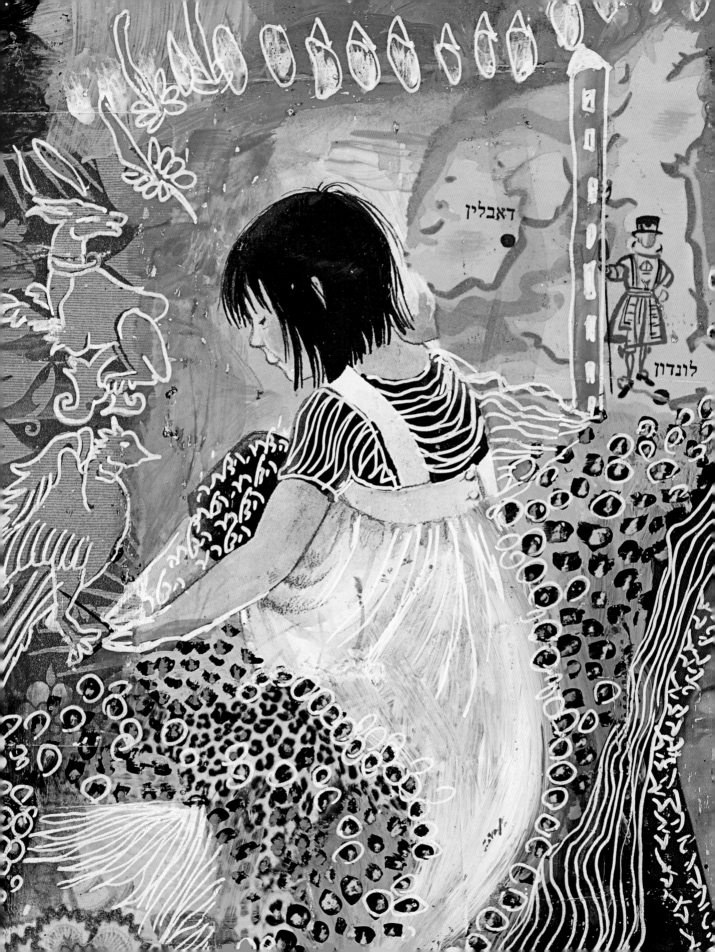

דאבלין

לונדון

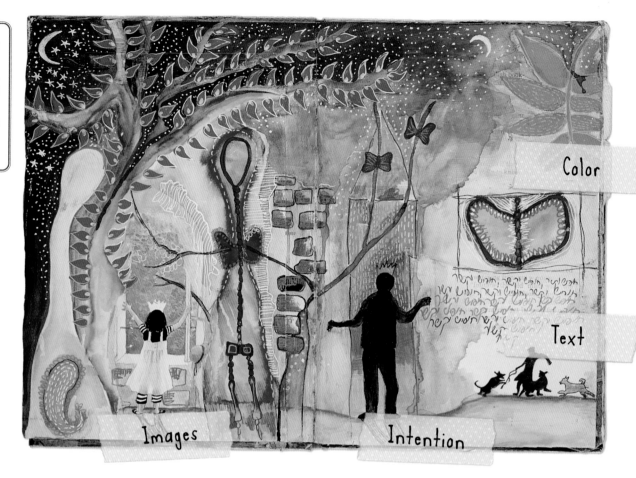

Color

Text

Images

Intention

True healing happens between the pages of a visual journal when we connect with our inner child. One of the most emotional methods that enable us to connect to a real sense of longing and yearning is using a children's book for a journal.

Children's books are an obsession of mine; I collect them and enjoy connecting with the childlike figures in them. Generally, I feel a connection with the main character's adventure in the book. In fact, I use the child's character as a kind of inner figure that I can connect with.

Techniques and materials

Cut-out images from a page of text and colored with black or white gesso, torn-out collage pieces, acrylic colors, black Pilot pen, white gel pen, text torn out from an old book of poetry.

When choosing a children's book, it's important that it be pleasant to the touch, the pages thick enough to work on and with images we can connect with.

In these spreads, I worked in a children's book that I found that someone had thrown out. The book is about a little girl who visits the home of the artist Monet in France and connects with his paintings and his work.

I chose to leave the image of the girl on each page, making her the main character of my book.

I worked on the book for six months, and through my work, I went through a significant process of connecting with the adventurous child inside me, a little girl that I knew as a young child and lost my connection with when I became a mother.

After I finished the book, I found the courage to realize another dream, and I started to take groups abroad for visual journaling workshops.

A journal's cover made from a children's book

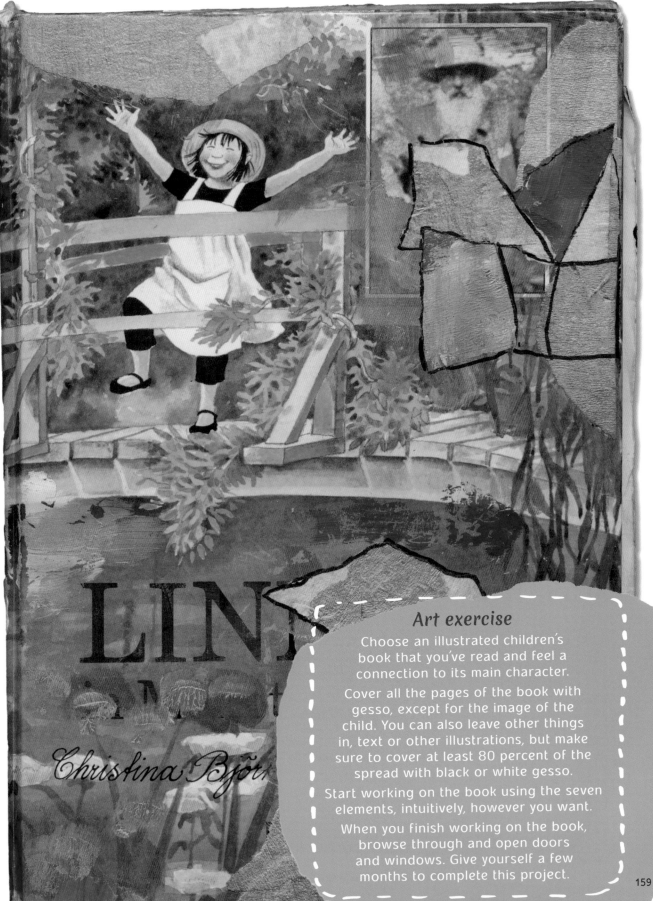

LIN...
...
Christina Björ...

Art exercise

Choose an illustrated children's book that you've read and feel a connection to its main character.

Cover all the pages of the book with gesso, except for the image of the child. You can also leave other things in, text or other illustrations, but make sure to cover at least 80 percent of the spread with black or white gesso.

Start working on the book using the seven elements, intuitively, however you want.

When you finish working on the book, browse through and open doors and windows. Give yourself a few months to complete this project.

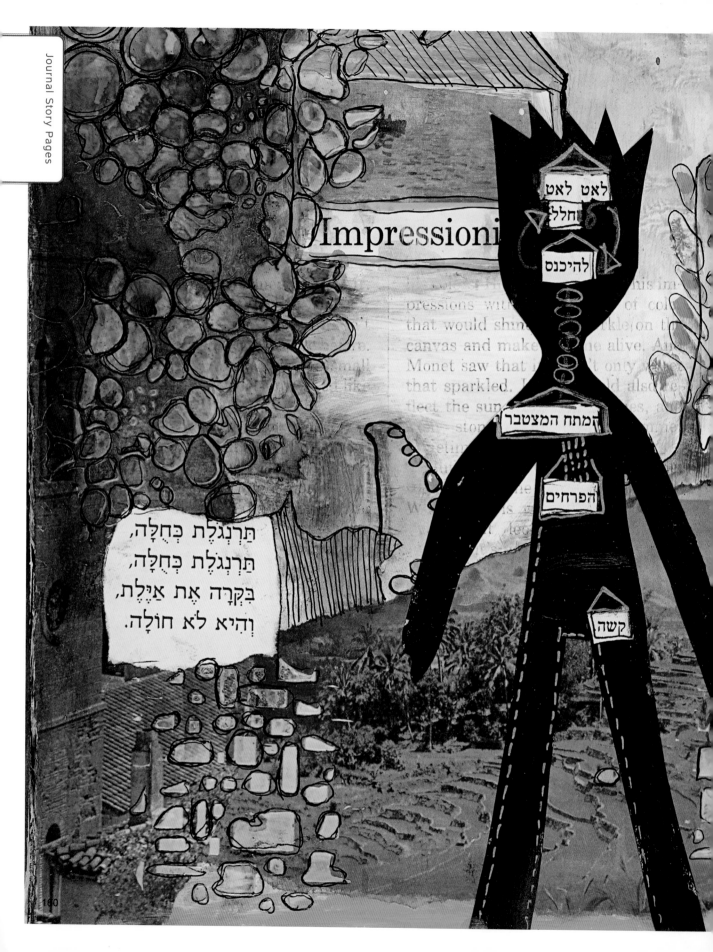

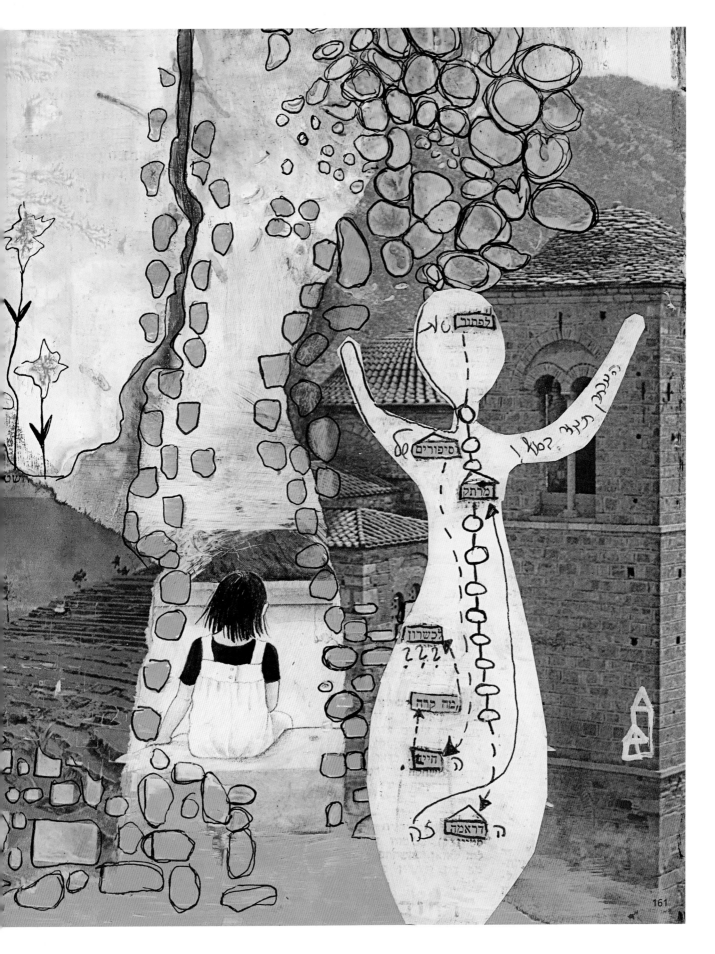

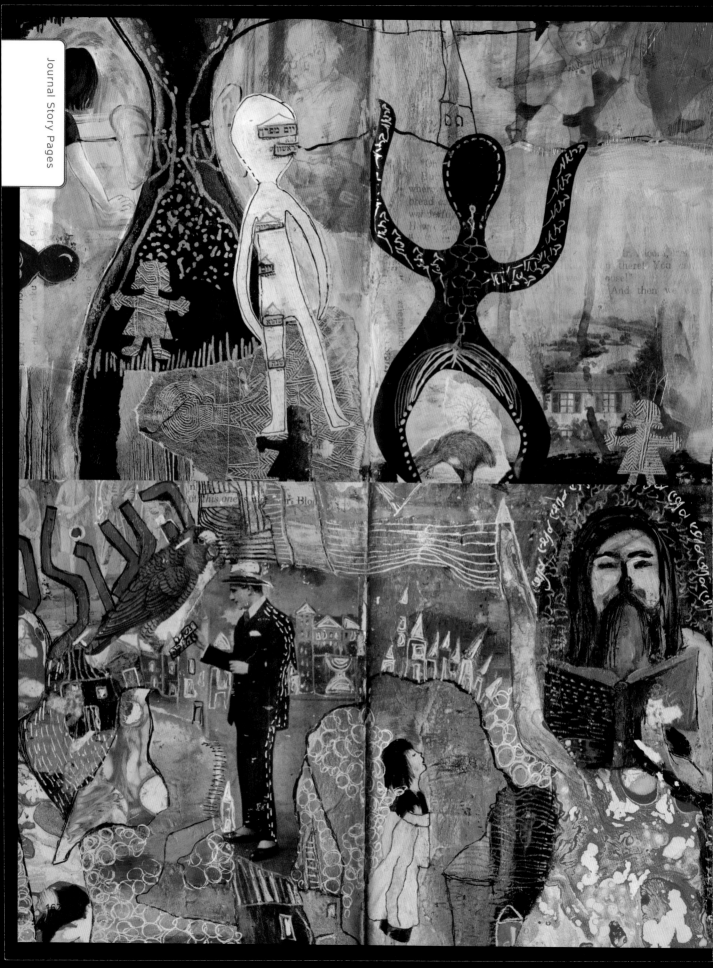

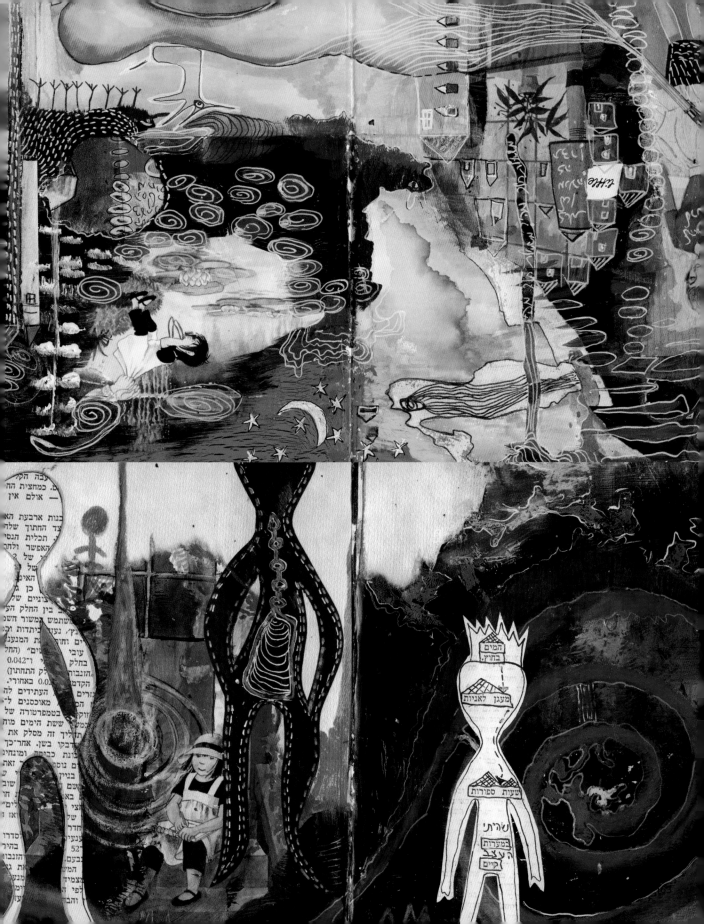

Now in the light / Tania Hadar

Now in the light, now
in the light of compassion, when my face reveals
its true expression, I
exhale choke cries of an animal
my feet stomp on the earth's surface
suddenly floating in a light greater
than my body greater than my breath
 shattered

Chapter 7:
"Visual Translating" of a Poem - Saying Goodbye

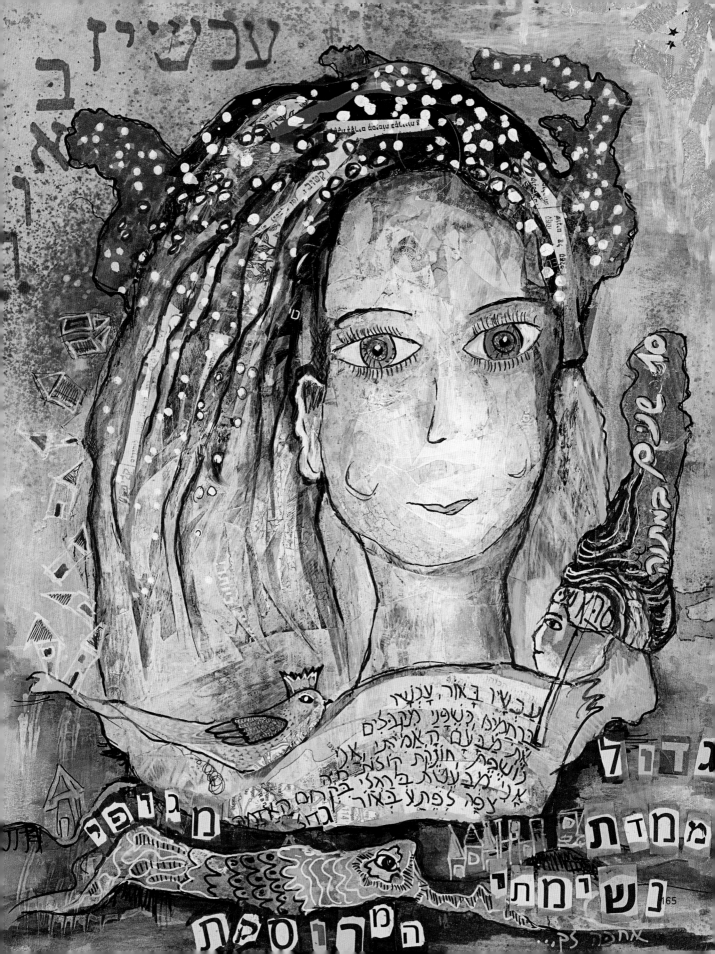

In my mother's last days, my sister and I speeded up the process of publishing her last book of poetry. We wanted her to see the printed book, but sadly, there wasn't enough time – she passed away a week before we had the first copies of the book in our hands.

My mother was a highly regarded poet, and her work has been taught in high schools in recent years. However, I wasn't able to read her poetry while she was alive. It was too hard for me.

After her death, I found piles of poems in her house, with comments and soul-deep insights written in her delicate handwriting in the margins. Through these poems, which were like an inner diary, I managed to connect with her and read all of her work.

A year after her death, I used her poems as raw material for the spread in my visual journal.

I cut out, pasted, and worked with her poems, using them to create her image within me.

"Visual translation of poetry"
became one of the most emotional classes I taught.

The concept of taking text and giving it intuitive expression in a journal is a way for many people to start their work with no constraints, with a sense of freedom.

There are two main ways to work with poems – translating by line or a visual translation of the entire poem.

Line-by-line translation lets you create a continuous and meaningful work that relates to the poem itself. It's a wonderful way to work within a group; each participant creates a translation for one line, and together, they create a complete book dedicated to that poem.

Another way is to use the text of the entire poem as inspiration for a spread to accompany the poem, but it's important to give your imagination the freedom to make associations and process the sensitive issues that it evokes. You can also start to work intuitively and find a poem that works with the art you've created.

"Now in the light" is one of my most significant works, created when I began visual journaling. It helped set me on the path of teaching visual journaling. This is the story of this spread.

Text

עכשיו
ב
אוֹר

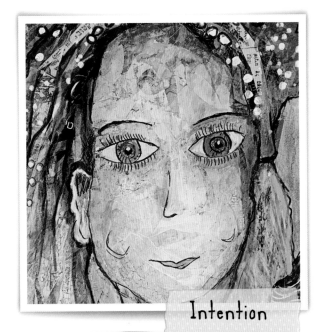

Intention

Techniques and materials
Collage pieces and a portrait, acrylic paints, watercolors, words cut out of magazines, silver chocolate wrappers, letter stencils, black Pilot pen and white gel pen.

Background

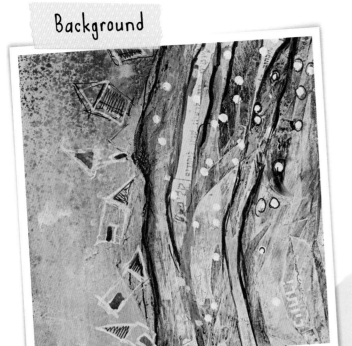

I started to create a collage on a photograph of my 15-year-old daughter. My daughter was very attached to my mother and went through a difficult time when my mother-her grandmother-passed away. I chose a portrait of her and worked on it with small pieces of collage. When I finished it, I noticed that the watercolors of the background created a blot shaped like a small boat, with a figure lying inside. I felt that the boat should be a "word vessel," and I looked for one of my mother's poems that would be appropriate.

The words of the poem "Now in the Light" matched the scene that unfolded, but I still didn't understand the connection completely.

Now in the light, now
in the light of compassion, when my face reveals
its true expression, I
exhale choke cries of an animal
my feet stomp on the earth's surface
suddenly floating in a light greater
than my body greater than my breath
shattered

I colored the collage pieces with acrylic paints, creating a figure that was a combination of my mother and my daughter, a figure that was illuminated, loved, and compassionate. Coloring the image gave the words another meaning. Instead of a poem about the pain of a living person, I felt that the meaning changed to a sense of moving on, to a world filled with light. Instead of the fear of death that accompanied all my life, I felt relief.

In the small boat, I discovered a small figure. When I drew it, I remembered a sad story that my mother told me that represented the acceptance of her impending death:

"When your grandfather was 86-years-old, he got very sick and almost died. I lost my mother at a very young age, and I felt that I couldn't lose him. I promised God that if he let my father live another ten years, I would be willing to give away ten years of my life. And so, it was. Your grandfather got better and died at the age of 96. Maybe these are the ten years that I gave him. Maybe, that's why this is happening now."

It was difficult for me to listen to her story, and I was sad to realize how she experienced her connection with God. But for her, the story offered comfort and acceptance - she died feeling that her death was justified, that she had given her father a gift. That narrative helped her to accept her own death.

After I finished the spread, I noticed that the words of the poem got the opposite meaning - my mother was finally freed of her suffering and was in the light, free to experience the world from other dimensions. When I look at this work, I see her essence - filled with light and free of pain, looking at me from above and watching out for me.

Lines & Text

167

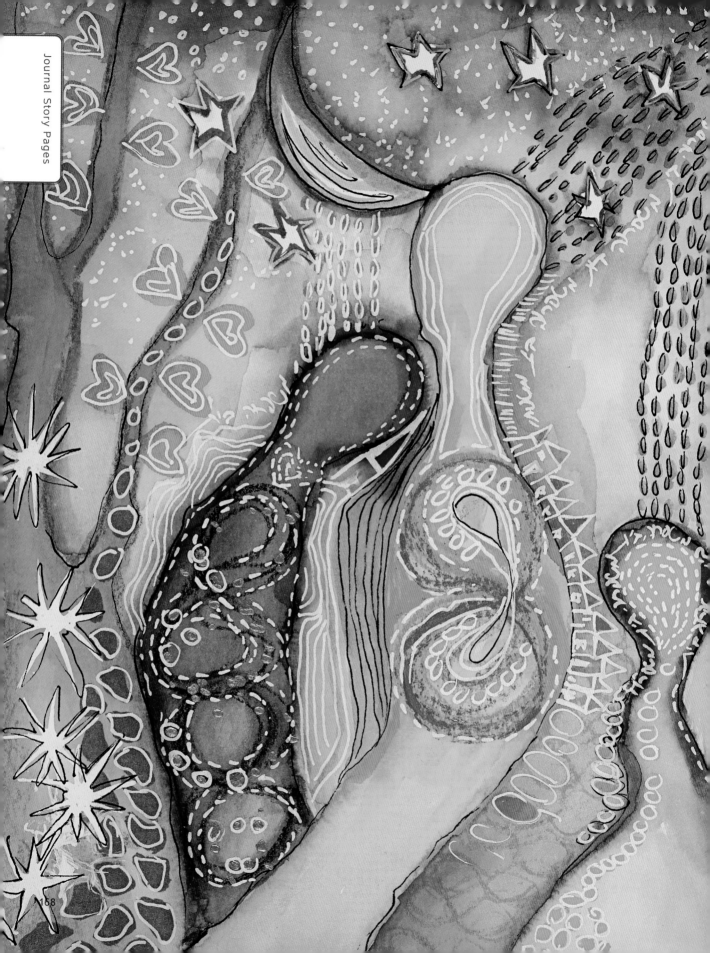

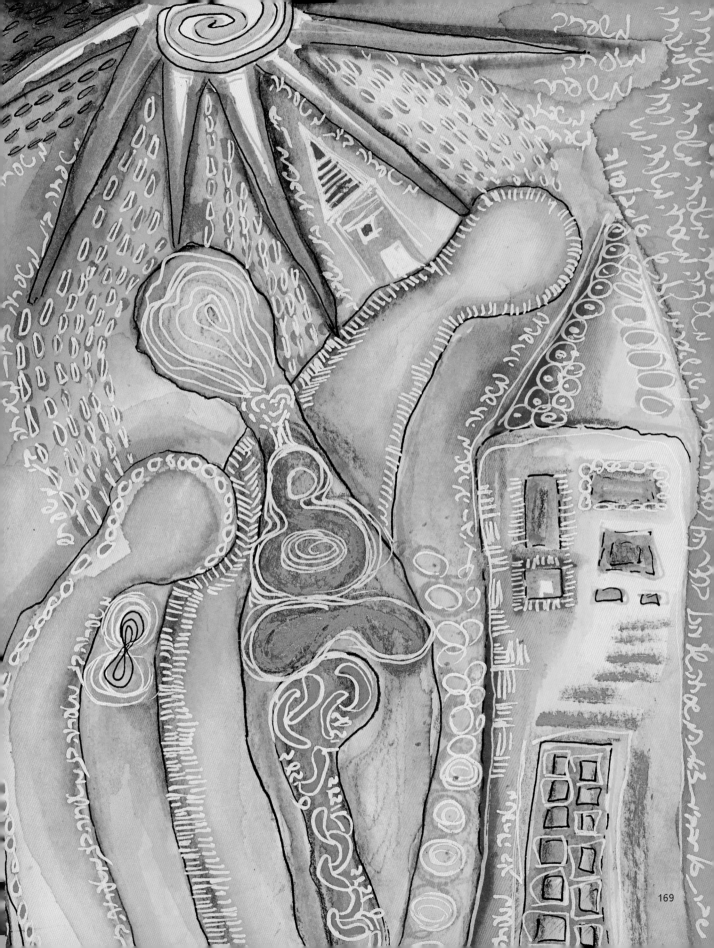

A few final words

In this book, I showed the way I create and teach the "Visual Journey Journaling" (VJJ) method.

Visual journaling is a wonderful practice that can be an addition to any type of therapy and any topic or inner content. It enables a connection to passion and revelation of "treasures" hidden in our unconscious mind.

I hope you tried some of the exercises and suggestions in this book and felt the special energy of journaling and how it can impact your life.

I'll close with a line from a poem by my mother, Tanya Hadar z'l, which to me expresses the magic of our inner dream child.

Feel free to upload your work to the "visual journal tribe" group on Facebook or write to tell me how the book inspired you.

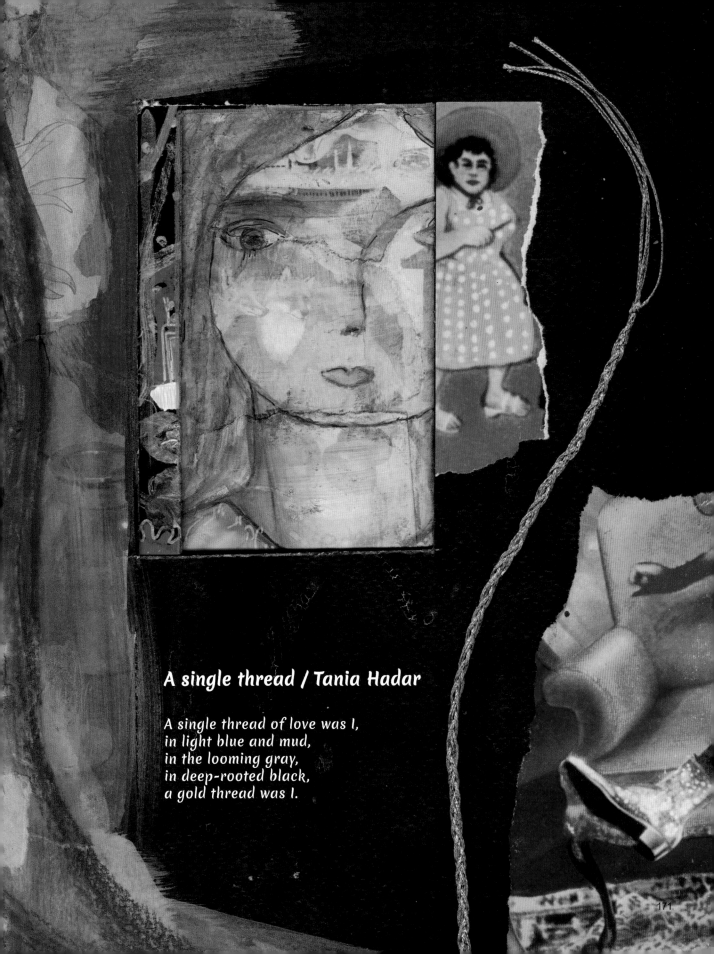

A single thread / Tania Hadar

A single thread of love was I,
in light blue and mud,
in the looming gray,
in deep-rooted black,
a gold thread was I.

Acknowledgments

This book would not have come to be without some people very dear to me.

Thank you to my friend Anat, who showed me the wonderful world of her visual journals.

Thank you to Rakefet Berger, who taught me the "courage to dream" and helped me to open my school.

And thank you Iris Gal for managing the school in the last two years.

Thank you to my many beloved students, who over the years have helped me to further develop the method and to continue the search for what heals.

Thanks to the translator, Dalit Shmueli and my good friend Tal Shimizu, who read the drafts, commented, and helped to edit them.

Thanks to the dedicated "Green Man" studio for the beautiful graphic work of this book.

Thanks to Lee Scop, my beloved eldest daughter, who photographed and produced the Headstart video and devoted hours with me in thinking how to make the visual journal accessible to the public.

Thank you to my good friends, who were the first to encourage me to get the visual journal out into the world, and a special thanks to my extended family that accompanied me during the project and donated money to fund the book.

And above all - thanks to my family, my husband and children, who have accompanied me over the years and were patient when I was totally involved with my work, which enabled me to devote hours to it, and shared my happiness with every step on the long path to the creation of this book.

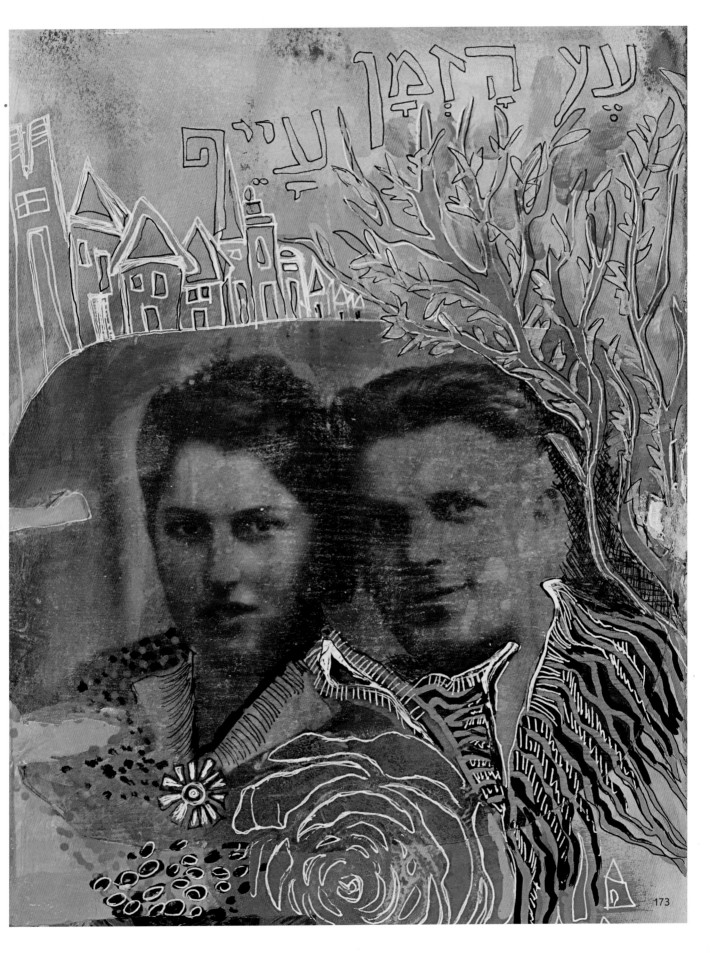

173

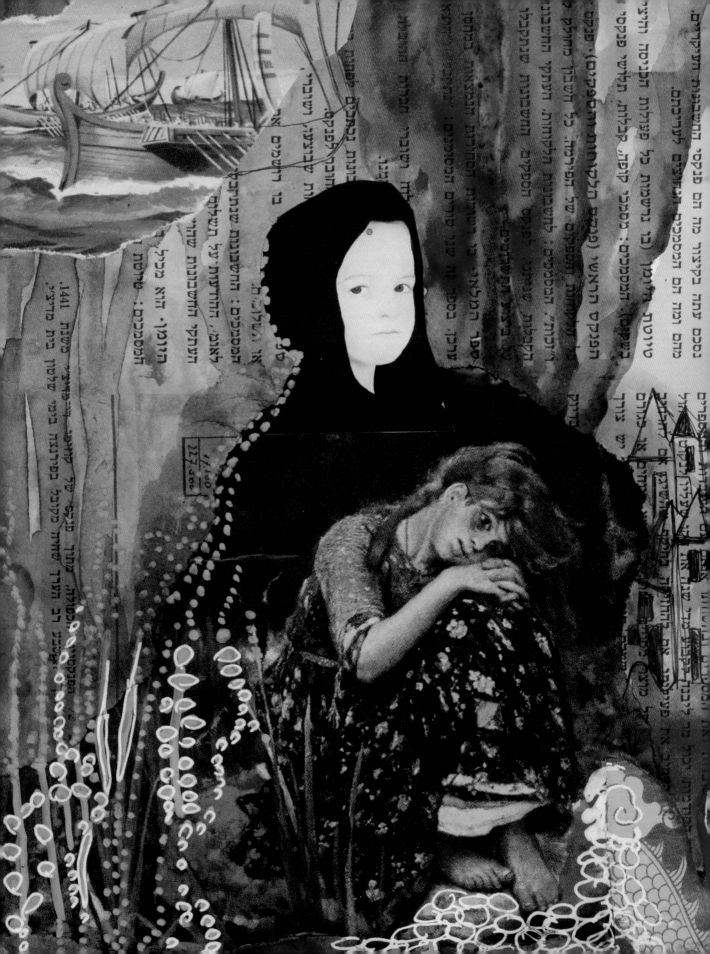

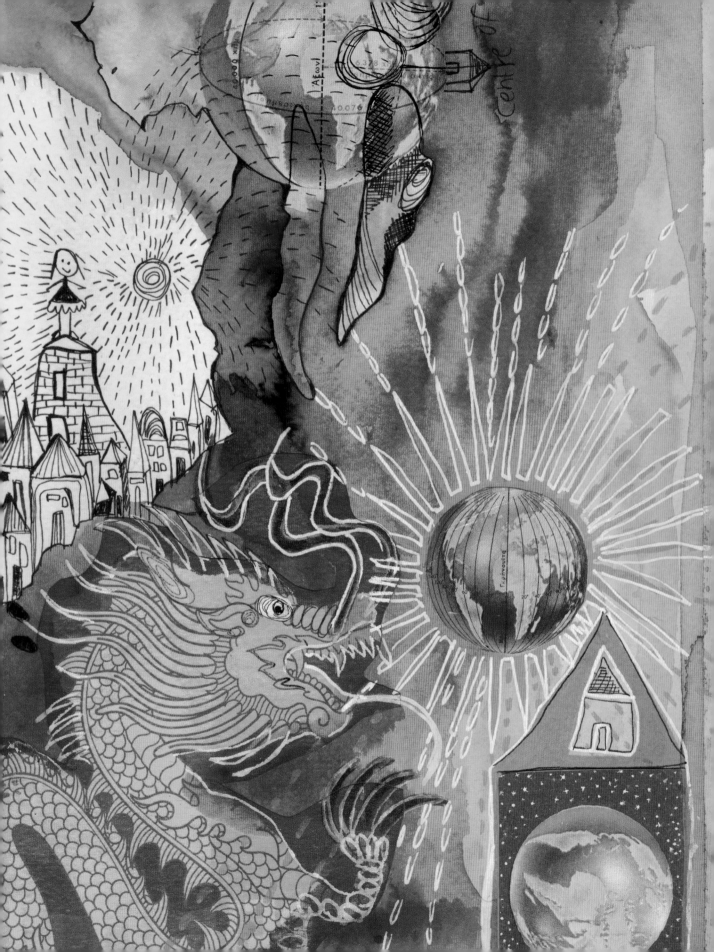